Swimming with th ˌ

Des Wilson was born in New Zealand and began his career as a newspaper reporter there. After coming to London in the sixties, he became a columnist on the *Guardian* and the *Observer* and a contributor to many other publications, from the *New Statesman* and the *Illustrated London News* to the *Wisden Cricketer*. He is also the author of two thrillers, *Costa del Sol* (recently republished by Santana), and *Campaign*. He has over the years been active in business, in politics and in the voluntary sector (he was the founder-director of Shelter, and also founded the Campaign for Freedom of Information). He now lives in Cornwall with his wife Jane, who is an artist.

♥ ◆ ♠ ♣

'The rich story of poker in Britain has never before been told. This is what Wilson offers, revealingly and compellingly, in a labour of love driven at a cracking pace . . . an action packed read'
Anthony Holden, *Observer*

'Engagingly, enthusiastically written and gives a very clear picture of the professional game – men and women at work – that non-poker players will enjoy and poker players will find studded with wisdom'
Financial Times

DES WILSON

SWIMMING WITH THE DEVILFISH

... *under the surface of professional poker*

PAN BOOKS

To Jane

First published 2006 by Macmillan

This edition published 2015 by Pan Books
an imprint of Pan Macmillan, a division of Macmillan Publishers Limited
Pan Macmillan, 20 New Wharf Road, London N1 9RR
Basingstoke and Oxford
Associated companies throughout the world
www.panmacmillan.com

ISBN 978-1-5098-2317-8

Typeset by SetSystems Ltd, Saffron Walden, Essex

Visit **www.panmacmillan.com** to read more about all our books
and to buy them. You will also find features, author interviews and
news of any author events, and you can sign up for e-newsletters
so that you're always first to hear about our new releases.

Contents

Book Two

'All-in' with 'the Usual Suspects' – life on the professional poker circuit

Author's note

I hope this book will be enjoyed by poker players and non-players alike, but if you don't know the game, it may help to begin with the simple guide to Texas Hold'em and Omaha on page 315. Hopefully, the glossary will also help.

Throughout, I refer to **cash games** and to **tournaments**.

Most televised poker is **tournament poker**.

In a **tournament**, each player pays an entry fee – a 'buy-in' – and is given chips and assigned a seat at a table. As, one by one, the players lose their chips, they're eliminated from the game until the survivors, usually either six or ten, form the 'final table'. One by one, they're also eliminated, until one player – the overall winner – ends up with all the chips.

Most tournaments are **no limit** (i.e. players can, if they wish, bet all their chips on one hand – this is known as going 'all in').

In **cash games**, players bring cash to the table, exchange it for chips and play only the others at the table . . . a maximum of ten. They can come and go as they please and can bring in more money whenever they wish. These games can also be no limit, but are often played to fixed betting limits or pot limits (i.e. the bet cannot exceed the sum currently in the pot).

I also refer frequently to the **EPT**, the **WPT** and the **WSOP**.

The **EPT** is the **European Poker Tour**, a series of tournaments staged at leading casinos throughout the UK and Europe.

The **WPT** is the **World Poker Tour** and consists of a series of major events staged mainly, but not entirely, in the United States, all forming part of a television series.

The **WSOP** is the **World Series of Poker**, a festival of poker staged in Las Vegas for several weeks every year. It is, in effect, the Olympic Games of poker, and consists of over forty events, more or less one a day, culminating in the $10,000 buy-in 'main event'. As well as the prize money, winners of these events receive a gold bracelet. This is the poker equivalent of an Olympic gold medal.

Des Wilson, *June 2006*

Cast of characters

'The Usual Suspects' – professional poker players

Dave 'Devilfish' Ulliott – Winner of WSOP gold bracelet, a WPT title and the first *Late Night Poker* final

Dave 'El Blondie' Colclough – 2003 European Player of the Year

John Shipley – Made WSOP final table 2002; won European Championship 2004

Lucy Rokach – European Lifetime Achievement Award 2003

Tom Gibson – Veteran Irish cash game player

Paul Maxfield – Runner-up in WPT World Cup Classic 2005, winning $1.7 million

Simon 'Aces' Trumper – Won second series of *Late Night Poker* final

Roy 'the Boy' Brindley – Dublin-based player/TV commentator

Carlo Citrone – North-east pro, winner of Australian and British Open events 2003

Paul 'Action Jack' Jackson – Midlands, Internet star, also active on live tournament scene

Joe 'the Elegance' Beevers – Member, the Hendon Mob

Ram 'Crazy Horse' Vaswani – Member, the Hendon Mob

Barny and Ross Boatman – Members, the Hendon Mob

Jeff Duvall – Mainly cash game player, third in 2005 WSOP event

John Gale – Winner of a WPT title, second in 2005 WSOP event

Stuart Nash – Vic veteran, high in European rankings 2005

Willie 'the Diceman' Tann – Won WSOP gold bracelet 2005

'Gentleman' Liam Flood – Top Irish player and tournament
director

Donnacha O'Dea – Top Irish professional for over thirty years

Charalambos 'Bambos' Xanthos – Veteran London
professional, high in European rankings

Andrew 'the Monk' Black – Irish player, fifth in WSOP main
event 2005

Mickey 'the Worm' Wernick – Midlands pro, top European
rankings December 2005

'Smokin'' Steve Vlader and Xuyen 'Bad Girl' Pham – Husband
and wife pros

Other professionals

Julian Gardner – Manchester, made final table WSOP main
event 2002

Neil 'Bad Beat' Channing – Vic-based pro, in the money WSOP
main event 2004 and 2005

Derek Baxter – Veteran Midlands player, runs the Western

John Duthie – First winner of Poker Million, now director of
the EPT

Mike 'the Man' Magee – Experienced London-based pro

Tony G – Australian player scoring consistently in Europe

Jon Shoreham – Player and also tournament director of
heads-up circuit

Tony Bloom – Winner of 2005 Victor (Chandler) Cup

Players/commentators/writers on the game

Mike Sexton – Veteran US player, presenter of the WPT series

Vicky Coren – *Observer* columnist, poker writer and player

Nic Szeremeta – Veteran player, managing editor, *Poker Europa*

Anthony Holden – Well-known recreational player, author of
Big Deal

Jesse May – American, lives in Europe, the best-known TV
commentator

Tony 'Tikay' Kendall – Player, coordinator Blondepoker.com

American players quoted

Doyle 'Texas Dolly' Brunson – Winner of record ten WSOP
gold bracelets

Phil Hellmuth – Winner of nine WSOP gold bracelets

Barry Greenstein – Winner of WSOP gold bracelet, WPT title

Howard Lederer – 'The professor of poker' – Winner at WSOP,
WPT and other events

Greg Raymer – World champion WSOP 2004

Chris Moneymaker – World champion WSOP 2003

Robert Varkonyi – World champion WSOP 2002

Chris Ferguson – World champion WSOP 2000

Dan Harrington – World champion WSOP 1995

Phil Ivey – Winner of three WSOP gold bracelets in one year
2002

Men 'the Master' Nguyen – Winner of six WSOP gold bracelets

Preface – Out of the shadows

Play to win or don't bother. Check friendship at the door.
A 'friendly' game is a misnomer. If what you are looking
for is recreation or to be entertained, there is the theatre.
If what you want is camaraderie, there is the bar. If what
you want is companionship, there are any number of
likely whores.

Doc Holliday; adapted from *Bucking the Tiger*, Bruce Olds

It all begins in an unlikely place – in a factory building on an
industrial estate on the edge of Cardiff.

A small Welsh television production company* has been
asked by Channel 4 to suggest programmes that will attract
viewers after the midnight hour. It proposes *Late Night Poker*.

What is exciting about *Late Night Poker* is its use of under-
the-table cameras, so that for the first time viewers can see
the players' pocket cards while they're actually immersed in a
hand. This may not sound revolutionary, but it dramatically
changes coverage of the game. Viewers can now imagine
they're actually in the hand themselves, can get *involved* in
the high-stakes confrontations, can share in the tension.

Another factor in its success is the use of a relatively

* Presentable Productions, run by Chris and Megan Stuart.

modern version of poker, Texas Hold'em. This could have been invented for television. Its format is simple, yet suspenseful. In a nutshell, each player gets two exclusive 'pocket cards', and then shares five community cards with everyone at the table. From those seven cards each player fashions what he (or she) hopes is the winning hand and then bets accordingly. Mike Sexton, host of the World Poker Tour, says, 'People love the drama – that you play until there's one man standing. And if somebody says, "I'm all-in" and then loses the hand, he's gone, together with his chance of winning millions of dollars.'

The programme is made in a disused factory converted into a television studio, and when it's screened for the first time it proves a phenomenal success. As *Time Out* magazine reports, '*Few would have guessed that poker could be so entertaining . . . viewers become mesmerised by the subtlety of the game and the intensity of the players.*'

It proves equally popular in the United States, where the new technology is quickly adopted. Poker programmes and series proliferate. These are then screened on cable television in the UK where two channels, the Poker Channel and Poker Zone, are now launched, entirely dedicated to the game. By 2005 it's actually possible on one evening to choose between seven poker programmes being screened simultaneously on British television.

Late Night Poker and the other poker programmes help make respectable a game Hollywood has always linked to Wild West saloons and gangster dens, with hot-tempered cowboys confronting suave card sharps in shiny waistcoats, with conmen trying to steal from cheats. It has, of course, over the years become more than that – in fact, the most played of all American games, albeit informally in homes (a

ritual well captured by the weekly game hosted by Jack Lemmon and Walter Matthau in *The Odd Couple*), as well as, often illegally, in the back rooms of bars and clubs. As many as 50 million Americans were playing poker even before the latest craze. But now it becomes a hugely *fashionable* leisure pursuit, increasingly involving women as well as men, with unprecedented sums of money generated by a unique inter-relationship between the Internet and television and by the insatiable appetites of both.

The online poker business becomes highly competitive, hardly surprising when the biggest company, Party Gaming, is valued at £5.5 billion when it floats on the London Stock Exchange. To sustain it, online poker needs players and the competing card rooms try to attract them by a variety of special offers, opportunities to play in tournaments and sat-ellites, and by sponsorship of television programmes. Glossy poker magazines emerge, with pages of full-colour advertising of poker sites, poker tournaments, even poker cruises. Huge card rooms like the Commerce and the Bicycle in Los Angeles are packed with thousands of players; the smaller card rooms of the UK and Europe have waiting lists every night.

Ironically, the explosion of professional poker owes much to an amateur, the financial controller of a small group of restaurants in Tennessee.

If any of us were to write a novel about a nearly broke accountant who enters a $40 satellite on the Internet, wins it, and gets a $10,000 entry ticket to the World Series of Poker main event, which he also wins, defeating all of the world's top professionals, turning the $40 into £2.5 million . . . and if we then named this unlikely character Moneymaker . . . Well, no publisher would accept it. It's simply not credible.

And yet in 2003 that's exactly what happens.

For a $40 entry fee, Chris Moneymaker wins online a $10,000 dollar seat to the World Series, together with travel and expenses. In order to pay off some debts, he trades $4,500 of it with his father and a friend, in return for them taking 45 per cent of whatever he wins in Las Vegas – assuming he wins at all, and this is highly unlikely, because he's never actually played in a live tournament of any size.

Furthermore, it isn't only Chris Moneymaker who's heading for Las Vegas – so is every top professional player in the world; in fact, no less than 2,500 players – a record – who create a prize pool of nearly $8 million with opportunities for sixty-three players to be in the money and the winner to pick up $2.5 million.

But after four days he makes it to the final table, and on the fifth day at 3.15 in the morning he has 5.7 million chips in front of him, and only one opponent left, the veteran professional Sam Farha, who has 2.7 million chips.

Millions who have seen it run and rerun on television can describe the final hand. Moneymaker is dealt 5-4, unsuited, and Farha has jack-10, unsuited.

Farha opens the betting with 100,000 and Moneymaker calls. The flop comes down jack-5-4. So, Moneymaker has two pairs, 5s and 4s, to Farha's one pair of jacks.

Farha bets 175,000, and Moneymaker raises it to 300,000.

Farha pushes his remaining chips into the centre of the table and says, 'All-in', and Moneymaker calls.

The turn card is an 8 and has no effect on either hand. Now comes the last card, the river card, and for Moneymaker to win he must get a 5 or a 4 to further strengthen his hand, or alternatively avoid the jack, 10 or 8 which would strengthen Farha's.

After what seems an eternity, the dealer turns over the

card. It's a 5. Moneymaker has a full house and wins the World Series.

Despite having to pass on 45 per cent of his winnings to his backers, he still walks away a millionaire with all the additional opportunities to exploit his newly acquired fame.

But whatever the benefits to Chris Moneymaker, they're trivial compared with the benefits to the professional game from what becomes known as 'the Moneymaker Effect'. His feat captures the imagination of millions, fuelling the dream that anyone can come from nowhere and become champion of the world.

This belief is reinforced the following year when Greg Raymer, a corporate patent lawyer from Connecticut, also wins entry to the World Series main event via a PokerStars satellite and also wins, collecting $5 million plus the gold bracelet.

All over the world viewers of the television programmes say to themselves, 'If they can do it, I can do it too.' They pay to buy a proliferation of 'How to play poker' books. And they begin to surf the net for poker rooms. The poker explosion has begun.

For PokerStars, the Internet site that both Moneymaker and Raymer played on, it's an extraordinary stroke of luck. The numbers playing on the site multiply, driving it into leadership in the increasingly competitive market. Both Moneymaker and Raymer give up the day job to become PokerStars ambassadors. At the same time, their televised achievements make the World Series of Poker the most popular programme on ESPN, the channel screening it in the United States.

In the meantime, over the Atlantic, in the UK and Ireland, and in Continental Europe, most notably in Scandinavia, *Late*

Night Poker, the other poker programmes and the feverish marketing of online poker, are all having a similar effect.

The old bar and saloon game of poker has hit the big time. Its astonishing growth proves once more the power of television ... and proves also how the Internet can change pastimes, industries and lives. Above all, it proves the absorbing nature, the unique fascination of the game itself – a game, they say, that 'takes a moment to learn, a lifetime to master'.

The television coverage also introduces intrigued viewers to a small group of people we didn't know existed – people whose lives up to now have been largely lived in the shadows: professional poker players.

Our *own British* professional poker players.

Here are real-life Lancey Howards and Cincinnati Kids, with stories to match.

These are not recreational players, but men and women who play to win because they *have* to win, because this is how they live. If they lose they could, at worst, become totally broke, possibly forced from their homes or made to suffer the pain and humiliation of letting down their loved ones. Did I say 'at worst'? Actually, worse, *far worse* ... they could be forced to join *our* world and *work* for someone, and, in doing so, lose what they value far more than money – their freedom, and their detachment from so many of the pressures and priorities of mine and your everyday lives.

And they *have* to win, also, because only by winning can they have the bankroll to play poker almost every day and night, and playing poker is what they do. Not *one* of the things they do – it is *the* thing they do. Because it's not only about money, even for them. As the late David Spanier wrote, 'It is a bit too simple to say that professionals play for money

and the rest of us for fun . . . professionals also play for "fun", because they like playing poker better than just about anything else they know.'

There are not many of them, these full-time 'old-school' professionals, but now we know who they are, because for the first time, on *Late Night Poker* and the other televised poker programmes, we meet for ourselves Joe 'the Elegance' Beevers and Ram 'Crazy Horse' Vaswani and the others in the Hendon Mob; we meet 'Gentleman' Liam Flood and Donnacha O'Dea from Ireland, we meet the fast-moving Paul 'Action Jack' Jackson and the volatile Roy 'the Boy' Brindley; we meet the ultra-cool Dave 'El Blondie' Colclough, the talkative Simon 'Aces' Trumper, and the likeable team of 'Smokin'' Steve Vlader and his poker-playing wife, Xuyen 'Bad Girl' Pham. We meet the big gamblers, Willie 'the Diceman' Tann and Mickey 'the Worm' Wernick, and the one-woman time bomb called Lucy Rokach. We meet the experienced Charalambos 'Bambos' Xanthos and the ambitious young gun, Carlo Citrone. And others.

And, of course, we meet Dave 'Devilfish' Ulliott from Hull, who, if transported back to Dodge City or Tucson in the late 1880s, or to Chicago in the 1930s, would, with his sharp suit, unshaven face, sleek black hair and hard stare – not to forget the gold Devilfish knuckleduster rings – have fitted comfortably into either age and either culture.

Some have been playing poker full time for forty years, in casinos such as the Vic in London or the Rainbow in Birmingham, or often illegally in spielers (unlawful games promoted in attics, dimly lit basement rooms or garages, in the back of cafes, and even, in one case, in the back of a van) across the Midlands and the north, in Dublin, and, of course, in and around London.

Now they display for all to see their combination of guile and skill, card- and people-reading mastery, discipline and patience, money-management and psychological insight – a range of qualities that takes top-level poker beyond nearly every other form of gambling. In fact, we ask ourselves whether the skill required to win is so great that it's not really gambling at all. (This has been argued with success in American courts of law.)

And just as we get used to these faces . . . just as they come blinking out into the sunlight, like rescued miners who've been trapped underground for weeks, just as they become 'respectable' for the first time in their lives, even recognized and feted, just as they see before them opportunities for winnings far in excess of those they ever dreamed of, we see them threatened by a wave of cash-hungry, unsentimental new-generation players from the Internet who, because of the speed of Internet play – without the time needed to deal cards, count and dispense money, gather up the cards and shuffle (all this done by the computer in seconds) – can accumulate more experience in twenty weeks than the old-school professionals have gained in twenty years.

Thus we've hardly got to know them before we find ourselves watching them battling to hold their own in the race for the first-ever poker sponsorships, the television fees and the million dollar tournament prizes.

Can they at last get a real return for their years in the shadows – years of endurance, of ups and downs, of despair and triumph – before they're swept away by this tidal wave of change?

Can they maintain their leadership of the game, cling on to their transformed territory, as it's attacked by this aggressive new breed of players?

This is the drama currently being enacted in the card rooms and on the television screens of Britain and Europe.

It's the 'old school' v the Internet kids, and no-holds-barred.

And it's being played out on a stage of growing size. Not only on the Internet, but in tournaments now taking place almost every day of the year, and in card rooms that are expanding within established casinos and that are even opening independently of casinos, more or less in defiance of antiquated gambling laws.

But who are these old-school poker pros? Where do they come from? Where have they been all this time? Why are they so good at a game that looks so simple and yet is so complex? Are they really winners, or are they losers? If they *are* winners, then who are the losers? What kind of lives do they lead? And, the biggest question of all: can they beat the Internet kids and reap for themselves the rewards now arising from the poker revolution?

I decide to find out. To do this I have to get close to the game and the lives of its players, so I spend half a year with them, in the UK, but also on the European circuit and at the World Series in Las Vegas.

So, join me as I take my front seat for this unfolding drama. And prepare to meet the actors.

And who better to start with than the man whose success and showmanship symbolize the poker revolution, the man they call 'the Devilfish' – Dave Ulliott from Hull.

BOOK ONE

A dangerous man . . . the making of a poker superstar – Dave 'Devilfish' Ulliott

1 / The 'super-aggressive poker master'

This is one big, mean fish.

Aquarist & Pondkeeper

The word I would choose for the Devilfish is dangerous . . .

US poker star Barry Greenstein

It's approaching dawn on a winter's day in the early seventies. An all-night wedding party is breaking up in a pub in the backstreets of Hull. In this area it's not unknown for such events to end in a drunken brawl, and this time it only takes a bunch of passing kids to whistle at one of the women for things to turn ugly. Across the road a nineteen-year-old is waiting at the bus stop, having spent the night in the nearby Golden Nugget pool hall. Spotting his younger brother in the group, and sensing danger, he quickly walks across, tells him and his friends to scarper, and stays alone to confront five men and their even more belligerent wives. He tries to persuade them the kids mean no harm but suddenly one of the women grabs him by the hair and begins to slash at his face with a steel comb. As he tries to break her grip, a man headbutts him. He falls to the ground. They surround him and kick him in the face and ribs. Somehow he gets to his

feet, but instead of running, he hurls himself at the lot of them, fists flying. Now it gets really vicious. Time after time they have him on the ground, and time after time he staggers to his feet and throws himself back into the fray. A witness (who calls the police) describes it as 'Terrifying – I didn't think anyone would come out of it alive'. By the time the police break the fight up, the wedding party literally has to carry two of its men away. Not one of the ten is unmarked.

The teenager crawls painfully home, his face a bloody mess, a tooth hanging out, ribs aching and developing ugly bruises from the brutal kicking. When his friend Kenny Hocking opens the door, he recoils in shock and tells him to stay out on the street until he warns his young wife what to expect.

They help him upstairs and he lies on the bed. He's hurting all over, and yet . . . and here's the thing . . . *he feels great.*

'I'm in a terrible state on the outside, but *inside* I feel so good and so proud. Because I was never afraid. I lie there and keep thinking to myself that *I was never afraid*. And I know now that I can't be beaten in a fight . . . not where it matters . . . not inside.'

It is a defining moment. It will influence Dave 'Devilfish' Ulliott's behaviour, good and bad, for the rest of his life. The man who will intimidate others at the poker table is born that day. He was fearless in that fight – and that's the way he'll play poker. He defied the odds – and he'll do that at poker, too. And it's all about a fierce, uncompromising, have-to-prevail pride that condones no criticism, means he must dominate, denies defeat as an option.

Those who know him best say the time to put your money on him is when his back is to the wall. Paul Maxfield, who

has played with him many times, says, 'Dave's strength is when he's broke, or for some other reason under real pressure to win. When he's broke, and I've seen this time after time, he plays out of his skin. He plays absolutely brilliantly. When he isn't broke he doesn't play as well as he can do, because he likes to gamble, but when he's broke I'd have my last £100 on him, whether it's to play in a tournament or a cash game, because he's absolutely fantastic.'

Dave Ulliott came from nowhere to become someone. His story is as compelling as his character is full of contradictions and inconsistencies, but in one respect there's no controversy; the collective verdict of the player's peers on both sides of the Atlantic is unequivocal: *the Devilfish is an exceptional poker player . . . in some ways, unique . . . On his day, capable of beating anyone in the world.*

But this should not surprise. After all, the record speaks for itself: you can't argue with a World Series of Poker (WSOP) gold bracelet *and* a World Poker Tour (WPT) title, nor with over $3 million earned from an impressive list of victories and final table appearances on both sides of the Atlantic over ten years. And, as Mike Sexton says, 'Those ten years matter. Devilfish has passed the ultimate test – the test of time.'

Mike Sexton is well qualified to judge the Devilfish as a player. He himself has played almost everyone who matters for nearly thirty years, is a World Series gold bracelet winner, and is now the presenter and lead commentator for the WPT on television. 'Dave is one of the best poker players there is . . . and I mean *real* players. He's a *real* poker player. I'm talking about both tournaments and cash games, and it's a rare breed who can do well at both. I rate Devilfish as one of the top players in the world . . . I'd put him right up there . . . and I rate a guy by whether I would take a piece of him in a

game . . . In other words, I would put my own money on him winning.'

Inevitably, the opinions of UK players are coloured by closer acquaintance. They know him from the early days when his speech – fast, in a dialect almost incomprehensible away from the backstreets of Hull – had only a passing acquaintance with English. They remember him learning the game and they've seen him lose as well as win. They know him both as a player and a late-night reveller, as loner at the table one night, as life and soul of the party the next. They don't necessarily separate their views of him as a man from their views of him as a player . . . and some like him and some don't. But despite the influence of their individual experiences – and most appear to like him in a good-humoured 'Well, that's Dave' sort of way – they concede little to the Americans when it comes to respect for his poker.

What are his strengths as a poker player? Aggression is one. A gambler's capacity for bluff and risk-taking is another. But at the heart of his game is a remarkable feel for what's happening in any given hand . . . an exceptional talent for reading cards and the way they're being played and to deduce from the evidence before him – often scant evidence – what other players have 'in the pocket'. Veteran Vic player Peter Charlesworth says, 'Devilfish, out of all of us, has got the knack for reading cards . . . he can read other people's cards, the like of which I've never seen.'

Jon Shoreman describes playing in an Omaha event at the Vic in 1997. He has an unbeatable straight flush. 'On the turn card Devilfish checks to me, so I bet the pot £400. He thinks for a while and then as he goes to pass his cards he says, "Show me the straight flush" . . . and he passes *four of a kind*.'

Jon goes on to comment, 'I don't think there's another player in the land who would have passed his hand.'

And Devilfish passed it, of course, because he had correctly read Shoreman's hand. But then, there was, too, the discipline to fold. One of the hardest things in poker is to fold a good hand. Having to fold four of a kind is a poker nightmare. Devilfish did it.

Today's poker tournament winners tend to be particularly aggressive, but Devilfish always has been. He is always seeking to impose his will on the game, to dominate. The tinted sunglasses, the over-the-top Devilfish rings on his fingers, the black leather jacket or pinstriped suit (according to the occasion), the whole presence cries out *self-confidence.* Joe Beevers, of the Hendon Mob, says, 'He's very good at manipulating people. One of the things that he uses very well is his image and presence at the table. He picks on people. He steals from right under people's noses. He takes their chips and puts them in his stack. I don't mean physically – I mean through playing poker. He really uses his strength.'

Ray Michael B, in his book *Poker Farce and Poker Truth*, identifies a special breed of poker player – what he calls '*super-aggressive poker masters*': 'Super-aggressive poker masters are without fear . . . the basic characteristic style of their play is an intense and sustained attack mode . . . the betting turbulence (they generate) tends to create palpable fear (and sometimes panic) in lesser hearted opponents consequent to which marginal hands are often prematurely released or laid down . . . if you have a weakish hand or are weak of heart, avoid getting caught in the middle of the cross-fire between two or more war-mongering super-aggressive poker masters. You will be steam-rolled flat: like flat broke.'

The Devilfish *is* a super-aggressive poker master.

Neil Channing, a popular younger British player, says, 'He's ruthless. I've had dinners with him and he's friendly company, but twice I can remember being in major events, and Dave and I were the only English players in them, and we found ourselves on the same table, and he was never afraid to attack me in the game and try and win all my chips. He made no allowances for the fact that we're both English players abroad; there's no camaraderie in that sense. In the bar or whatever it's fun, but at the table he'll rip your eyes out and you need to be careful of him.

'I remember we were at a tournament a couple of years back, and Dave had been having a bad time and was playing a small tournament that was worth only £10,000 . . . it may have been £20,000 . . . but this was small fry for Dave, but a really big thing for me at the time . . . and we reached a couple of tables out from the final table, and Dave was having a lot of trouble with hotel bookings, taxis and whatever, involving a lot of calls from his cell phone at the table. So I decided that this would be the moment to steal his blind, because he wasn't really concentrating, but as soon as I did, he immediately called, and risked his entire tournament on the hand over a series of bets and raises between the two of us. I didn't really have any hand at all and eventually had to fold. Dave then turned his hand over, and he had a 5 and a 2 . . . one of the worst hands you can have. He should never have been playing it. But he knew that because he was busy on the phone, I was trying to take advantage, and he turned it back on me and played an impossible hand beyond its worth and, of course, he won. A lot of people with less determination and flair would have thrown the 5-2 in the

muck where it belonged. It's just too difficult to get one over on him.'

Devilfish is at his best when he's the chip leader. Then he becomes a particularly effective poker bully. When it comes to exploiting a big stack he's completely fearless.

Poker Europa editor and experienced UK player Nic Szeremeta says when he's in the mood, 'he's like a golfer who comes to the last round, three shots down, and says this is my day, nobody can get me off this. He's got a kind of instinct which you can't teach anybody, can't quantify, can't explain in words, but basically if he gets down to the final table he believes he's going to win it and he knows what to do. He's been there before so many times it doesn't faze him.'

An almost unique feature of his game is that he constantly ignores all of the conventional wisdom about what hands to play. The winner of a remarkable nine WSOP gold bracelets, Phil Hellmuth, describes it in one of his books on Texas Hold'em:

'Devilfish thrives on coming into a pot, raising with almost anything before the flop. He may raise with 4-7 offsuit or 2-5 offsuit. He will almost always bet out at you on the flop, whether he misses the flop or hits it. This gives all the others a chance to fold their hands and gives Devilfish his second chance to win the pot with a bet or raise. (His first chance was before the flop with a raise.) He's very good at reading players . . . if you do hit something and call Devilfish on the flop, then the pot has only just begun. If he thinks you'll fold your hand before risking a big bet on fourth street, then he'll bet big on fourth street, trying to bluff you. If he feels you'll fold your hand for an all-in bet, then he'll risk the entire tournament and bet it all. Likewise he'll bet all your

chips when he feels he has the best hand . . . it's constant power-play pressure . . . if he wins a few hands before the flop, a few pots on the flop, and a few pots on the end with a bluff, he'll be way ahead of the game.'

As Hellmuth adds, 'This is a good theory of no-limit hold'em play, but if used wrongly it can be disastrous . . . if you use it well you'll accumulate a lot of chips quickly, but if you use it badly you'll cough them up just as quickly.'

The Devilfish has clearly decided he can 'use it well' often enough to ride out the disasters.

One of the top European players, Marcel Luske, the man they call 'the Flying Dutchman', says, 'There's not many people out there who have the guts to dare to do what he is doing. He doesn't hesitate to raise you and when you get a reraise to reraise you again, with a stone cold bluff, to get you off the hand. He's done it many times, and I've seen him doing it, and I think it's great. He has an amazing instinct for where people are at . . . knows when to put pressure on. He'll put them on the edge, and, if he doesn't think they want to go all in, he strikes, either pushing them over the top, or frightening them into a fold. It's no wonder he's called the Devilfish, because he gets into situations and then he gets out of them and people look at each other, as if to say "Well, what happened?" and then he ends up with the money.'

One of the better known women in British poker, commentator and player Vicky Coren, says, 'He has a very good sense of people's fear. Like a bloodhound, he can sense when someone's scared and bully them accordingly. He's got the right chat. He knows what to say to establish what people's hands are. He's a great reader of other people, in poker terms.'

Devilfish bluffs more than most, and occasionally too

much. But on the whole, there's a keen intelligence behind the bluffing. No matter how aggressive or apparently deliberately reckless he appears to be, there is still a keen tactical mind at work as well. He can play more conventionally, especially if the going is rough. This is in no way inconsistent with being a *'super-aggressive poker master'*. As Ray Michael B goes on to say: 'Super-aggressive poker masters are flexible enough, when the situation demands it, of being "geared down" or "screwed down for the night" when they are running rough . . . these are the times that they righteously sense that it would be ill-advised to strongly contend for the pot . . . they have that uncanny (sixth sense) instinctive ability when to lie low . . . (Then) when the cards turn their way, their basic style of play is reactivated.'

Of course, the image of someone who'll play with any cards works for him when he does get a good hand. In poker, lack of predictability can be a real strength. Devilfish may sometimes go out spectacularly when a bluff doesn't work, but he also wins spectacularly by capitalizing on his reputation for bluffing and engineering a rash call.

Apart from table cunning, strength of personality and skill, the basis of his game is nerve and lack of fear. Surviving an event like the five- or six-day WSOP main event, or a WPT event, and beating thousands of quality players, will increasingly become a bit of a lottery, luck and stamina playing a bigger part. But at the end of the day, it will always come down to nerve, the readiness to put the whole lot on the line, a disrespect for money as the main objective . . . above all, lack of fear.

As Richard Sparks says in his *Diary of a Mad Poker Player*, 'To be a good player, you need more than just the skills of card knowledge and people knowledge and odds knowledge.

You need the gambling instinct. It is revealing that it is a *compliment* when a professional poker player says of another, "*He's a gambler.*" It does *not* mean that he throws his money away on reckless high-risk plays: it means that he has the heart, and the courage, and the confidence to use his stack as a weapon. The term is one of respect – like one boxer saying of another, "He's a fighter."'

As suggested earlier, with the Devilfish it ultimately comes down to will-power . . . to wanting to win enough. He's a big occasion player. These days, with money in the bank and a reputation established, he can run short on motivation, even get bored. And poker, when the cards aren't falling for you and you just have to ride it out and control the damage until either luck turns or you come up with an inspired move to win a hand despite the cards . . . poker *can* be boring. And Dave has a low boredom threshold. So, to overcome this he needs a reason to *want* to win – because there's extra prestige at stake, or extra money or extra attention.

Ask anyone in British poker about Devilfish and one particular word will always come up. Ego. Some of them say it's his one major flaw . . . that he'll act recklessly because his ego can't tolerate anyone, especially anyone he perceives as a weaker player, to prevail; that he grandstands; that his ego affects his judgement and the objectivity of his game, especially in cash games.

The word 'ego' can mean self-conceit (or, equally, deep insecurity), and the Devilfish is not totally lacking in ego as so defined, but that's a narrow definition. Look to the best in many fields – actors, sportsmen, politicians, business leaders, you name it – and it's clear that central to their success has been ego in the form of a sense of self: confidence and self-belief. After all, who but someone with abundant self-confi-

dence dares to assume they're capable of being the best, the best in the world, world champion? What drives them on, to practise, to rehearse, to train, and then to compete at the highest level under colossal pressure except iron will and self-belief? Without ego thus defined, you can't and won't win. It's exactly this, at times apparently outrageous self-confidence, that has enabled the Devilfish to achieve more consistent success at the tougher poker tables of the United States than any other British player . . . to sustain his position at the top of the game for over a decade and still be there today. It's this sense of self that's enabled him to survive in the human jungle, ride out cruel and depressing experiences, fashion a life from the worst of beginnings.

The truth is that nothing that can happen to him at the poker table can be worse or more testing than some of the things that have happened to him in real life.

Mike Sexton places the Devilfish's personality and approach in a historic context, because Sexton comes from what he calls 'the old school' of poker – because Sexton was around when poker was still illegal in many of the places where it's openly played today.

'He's truly one of the unique Damon Runyan characters of the poker world. Or, alternatively, he would have fitted right into the Wild West; in fact, it would have been a better era for him, living in the Wild, Wild West. Because he wouldn't be afraid to shoot a guy down, because he's a very tough guy . . . I don't think players realize what a tough character he is . . . physically, mentally every which way . . . he's been through it all, done it all.

'Young guys, they're a new breed of players, most of them well-educated; they're not guys who were school dropouts, tough back room poker guys. They've come into a poker era

now where all they see is multimillion dollar tournaments and lavish casinos. They don't know what it's like to play in back poker rooms and pool halls and this kind of thing, whereas the Devilfish does. Guys that are out on the road and playing the home games – it's tough. The legendary Johnny Moss, called the grand old man of poker, and maybe the greatest player of all time, used to play that Texas road circuit, and he and I would sit down and chat and he would tell me that the easiest thing about poker in those days was beating the games. The toughest thing was to get out of town with the money.

'I always think of Devilfish in that category a little bit; he would fit right in with that. Younger players are highly educated – many of them college-educated, and very bright mathematical whizzes, and every one of them has read every word of every top poker book that's out there. But guys like me and Devilfish, when we came on the scene there were no poker books. You learned by the seat of your pants and you went out and you played and if you got broke you came back and scratched your head and asked, "How the hell did I get broke? What did I do wrong today?" and you figured it out for yourself. But these guys study and learn and analyse hands consistently and put them through computer simulations and do all the stuff that far exceeds their experience in the world actually playing poker.'

'Well,' says Sexton, 'let's see if some of these young guys are winning in ten years from now. Or whether they are one- or two-fluke wonders. Devilfish has lasted.'

Above all, when the Devilfish is at the table with the younger guns he looks like a grown man. This is no juvenile star. You can tell he's lived, that he's done and seen and knows things the younger players probably never will. If this

is a dangerous man, it's because he spent years operating in a world where such qualities as aggression, self-confidence, nerve and timing have been about much more than ego in the conventional sense of the word – they've been about survival.

It's not a pretty story. He has come from a mean place. He has done some bad, albeit not terrible things. But this has to be known and understood if Devilfish, *'super-aggressive poker master'*, is to be understood.

The Dave Ulliott who stands at the top of British poker today has come a long, long way from the bookies, the back-alley gambling clubs and the prison cell.

To appreciate this fully we have to go back to the beginning – and that means to the tough and unforgiving back-streets of Hull where he was born in 1954.

2 / Starting hand

> . . . I'll not return;
> There's nothing there I haven't had to learn,
> And I've learned nothing that I'd care to teach –
> Except that I know it was the place's fault.
>
> Philip Hobsbaum, 'The Place's Fault'

The coastal city of Hull is off the beaten track. If you're driving from London on the M1 to the north-east or Scotland you will bypass it by some fifty miles, so to get there you have to *want* to get there, and not that many people do. In the early seventies its population is 285,000, and of those who can work, nearly 10 per cent are unemployed. On the Springbank estate it's probably 15–20 per cent – and the teenage Dave Ulliott is one of them.

The son of Stanley, a truck driver, and his wife Joyce, Dave has grown up in a rough working-class area where the kids play on the street and, if you can't take care of yourself, you best stay indoors. The family lives in a small council house, Dave sharing a room with his sister Janet with whom he's close (she dies of cancer at only forty-nine). There isn't much money about. Later he jokes about their finances, e.g. 'The house was so small we had to paint the furniture on the walls.' But there's not a lot of laughter in his life at this time.

At the local school he's an unmotivated pupil and leaves as soon as he can, at fifteen, without so much as an O level. It isn't that he's beyond education . . . more that, for some reason, perhaps lack of hope, he just doesn't care.

Is this lack of motivation the place's fault? It's too easy to totally blame background for behaviour, but there's no peer or even adult pressure to succeed at school because few in this area expect to get far in life. And with his truck driver father away much of the time and unable to impose day-by-day discipline, and with no colour or culture in his surroundings to open his eyes to any alternative, Dave begins life's journey on a discouraging note.

Yet, for all that, he does try at the beginning. For nearly two years he earns his living at the local firm of GK Beaulah's making trophies – presentation cups and shields – and he likes it. He likes the work and his workmates. Even so, the best hour of the day is the lunch break, when he and the others either pore over the *Sun* racing pages picking 'winners', playing poker. Dave loves this; it's the beginning of a love affair with gambling that never ends.

Then, after about two years, he decides to take an afternoon off for the races at Beverley. One of his friends, realizing where he is, 'clocks' him on – i.e. posts his attendance card. No doubt he thinks he's helping Dave, but the effect is catastrophic. Next day the boss takes him to one side and asks who 'clocked' him in. You don't betray your mates, so Dave won't say. He's given twenty-four hours to name his friend, or be fired himself. So he's fired.

The loss of that job is a real blow, especially as it follows shortly after his leaving home. Dave will end up on good terms with his father Stanley in later years, but in these teenage years there are difficulties. Stanley has himself led a

tough life; he too left home just after leaving school, joining the army and spending the Second World War as a paratrooper. He has worked hard ever since and, not surprisingly, relationships with Dave are not helped by Dave occasionally coming home with a bunch of fivers in his hand, having won on the horses in a few minutes what Stanley's earning in a week. So Dave decides to leave home. He's now without the two things that help anchor a youngster to the community – a home and a job.

His first flat has the barest of furniture and just a communal bath upstairs. 'I only took it because you could eat the mushrooms off the bathroom door. It was rough – and rough for that part of Hull was really rough.' He becomes particularly friendly with another teenager called Kenny Hocking, an even more fanatical gambler than Dave, and moves into a rough-and-ready flat with him, but his real home becomes the local bookies.

Ironically, his betting on horses had begun under the unintentional influence of his father. Stanley Ulliott was not a real gambler, but like everyone in this community he liked to bet a fiver or tenner at the weekend, and one day Dave had joined him at the bookies. 'He let me back a horse. It was a race at some minor course and there was a horse in it that was fourth last time. I didn't understand the form and it was 50–1 and I thought, well, that's a good price, and I put a ten bob note on it, and it duly won. This was a miracle because I later find out that in the earlier race it had been fourth in a four-horse race and was beaten by about fifteen lengths! They always win when you have your first bet, just like there's someone up there sucking you in. And I won twenty-five quid, which was about three weeks' wages when I'd been

working and, naturally, I thought, this is an easy way to make money.'

Inevitably there are many days when he loses, but there are days when he wins, and wins well, because from the start Dave is not a petty gambler. He will always bet to the hilt. And the winnings are reinvested in gambling – because, together with Kenny, he's now addicted to it. 'I would gamble on anything – poker, pool, horses, car-racing, two flies climbing up the wall . . . you name it. It's what we did – it's all we did.'

Then one day Dave meets a couple of latter-day Fagins. There's Fred, not too bright, a bit seedy: 'He looked like a fox.' And there's his friend Dave, 'big and hairy, built like a gorilla'. They're both in their thirties, twice Dave Ulliott's age. These villains see in this bright, tough and clearly opportunistic teenager the accomplice they've been looking for.

It's a fateful meeting, because Dave may be a teenage gambler and small-time hustler, but up to this point he is not a criminal.

Fred, in particular, takes the teenager under his wing, captivates him with stories about safe-cracking and the kind of petty robberies he and Dave (to avoid confusion, I will call him Dave the Elder) engage in. He even argues that there isn't a lot wrong in it – that Dave will merely be another link in a chain involving almost everybody. They tell him they receive inside tip-offs of where the money is and where the keys are left . . . sometimes from the shopkeepers themselves. They show him newspaper reports of their robberies, revealing how the shop-owners double the value of the stolen property to get more insurance money. 'One time when we went back for another load, we saw a police car outside the

shop and while we were watching a copper came crawling out of the panel we had removed from the door with a box of cigarettes and put it in his own car boot.' For Dave, this completes the circle . . . even the police are involved.

Dave would later defend his activities in similar terms: 'You found out in the newspapers the next day that the shops were claiming a lot more stuff had gone than we had taken. They were claiming more back off the insurance . . . If you took 70,000 cigarettes, it suddenly became 100,000, and so on. They were making money. Everybody was making money except the insurance companies, and who cared about them? No one was harmed; we never actually hurt anyone. We didn't really think we were doing much that was bad. We never took things off Joe Public – the normal run-of-the-mill people like ourselves, working-class people. We always considered people who owned off-licences and stuff as people higher up the ladder. It seemed that everybody was happy; in those days it was like a way of life: if a lorry was parked outside the bookies, everyone would come out and take something off of it and go home with it. I don't think anyone saw any big deal in it.'

Joining this two-man gang leads to him becoming a member of the club, a community of hustlers and gamblers, petty criminals, every one of whom either makes a living, or supplements their living, ducking and dodging on the fringes or beyond the fringes of the law. In this world no one makes judgements about anyone else; everyone's on the same side, albeit not the side of the law. Crime becomes a way of life. Night after night, Dave is out there with the other two, removing panels from the doors of shops, usually tobacconists or off-licences, creeping in by torch-light and emptying the shops of their contents or cracking their safes.

It is all too easy. And all the time, as Fred and Dave the Elder keep assuring him that they're 'doing no harm', the teenager is becoming immersed in crime, albeit as a petty criminal, rather than a serious one . . . There's no violence, and the team's ambitions fall well short of banks or big company payrolls. In fact, at times the activities of the three could come directly from an old black and white movie – possibly *The Three Stooges Meet the Keystone Cops*.

There is, for instance, the van they steal to rob an off-licence. It breaks down. (This is always happening – they may be good at picking targets for the robberies, but they have no talent for picking a getaway car!) This one breaks down near a cemetery. As it isn't far from where they're headed, they decide to carry the box-loads of bottles across the busy road where the sorry-looking van has to be abandoned, cut across the cemetery and eventually down a side street to one of their homes. They don't want to use their torches in the cemetery, even though it's pitch-black, in case they're seen from out-side. While they're walking, Dave hears a terrific thud and turns round to discover Fred has disappeared. Eventually he hears a cry of 'Help!' and he and Dave the Elder find a panic-stricken and terrified Fred lying six feet down at the bottom of a freshly dug grave, surrounded by bottles.

Another occasion, they decide to crack the safe in a garage. The fence around it is high, with barbed wire at the top, but they manage to clamber over and into the compound and set about working on the metal door at the back. Suddenly, an upstairs window in a nearby house opens, and a woman starts shouting at them that she's phoned the police. The three scarper as fast as they can move, but after the two Daves are back over the fence, they hear a shout from behind them. They look back to see Fred hanging from the barbed wire by

his coat, swinging backwards and forwards – 'just like those parachutists you would see hanging from trees in old black and white war films'. The two fold up laughing, but go back and grab his coat and pull him down. The coat rips, and Fred ends up standing there in his sleeves, with the remainder of the coat still attached to the barbed wire. When the police arrive, all they find is a coat in the shape of a man attached to the fence.

Then they're told there are easy pickings at a bicycle shop. Apparently it has no alarm. They climb over another high fence, on to the roof and slip into a small backyard. Having removed the bars and opened the window, they begin to walk down a rubber mat between the rows of bicycles, but there is obviously a pressure pad under the matting, because not only is there an alarm, but it's the loudest alarm they've ever heard. It is terrifying – like a war siren, becoming louder and louder. So they race back to the windows, all three trying to get out at the same time, and the two Daves go back the way they came, but Fred, in a panic, decides to climb over an asbestos roof. The other two turn round to see the hapless Fred in a dreadful state: 'He kept on disappearing, first one leg would disappear, and he would pull himself up, then the other leg would disappear. It was like watching someone trying to run through three feet of snow . . . I went round to his house the next day, and he was lying on the couch all bandaged up where he had torn his legs falling through the roof.'

Once, Dave loses about £5,000–£6,000 at the betting shop on a Saturday and decides he will have it back, so that night he returns to the bookies, manages to open the window and climbs in. But he can't move the safe without help. Fortu-

nately there's a key in the back door, so he closes the window, locks the door and goes round to Fred's house at about three in the morning. Together they phone a youngster they don't know too well, called Les, who has a little truck. He waits outside while it takes them nearly two and a half hours to remove the safe, but by the time they have it in the back alley, the kid's got bored or frightened and vanished. So they're stuck with the safe just as it's beginning to lighten up at 5.30 in the morning. They spot a pram on a building site across the road, and manage to lift the safe on to it, and roll it four and a half miles to where Dave is living – 'which is a fair distance to be pushing a pram with a safe on it in what is becoming daylight'. Once more the cemetery comes into play. They're walking alongside it, when they see a police car in the distance. Assuming someone has spotted them, they abandon the pram and it immediately tips over and the safe goes bouncing along the pavement. The two of them scarper over the wall, into the cemetery, running for their lives. Then Dave thinks of all the money in the safe – money he believes to be his – and stops and creeps back to see what's happening. Unbelievably, the police car had just passed by, missing both the safe and the pram. Dave claims back his £6,000. Only to lose it to another bookie the next day!

Somehow, in the midst of all this, he finds time for two significant relationships, one with common-law wife, Diana, with whom he has a son, David, and later with Susan, whom he marries, and with whom he eventually has two children, Darren Paul and Kerry.

So it goes on, laughter and looting, days in the betting shops, evenings in the local pubs and clubs, dark nights on unofficial trips to the off-licences and tobacconists, and given

the fun he's having gambling with his ill-gotten gains, and the sense of self he's developing within the Hull underworld, life seems good.

But, of course, it's too good to last.

Fred is caught by the police, and decides to grass on his mates. He fingers Dave for robberies at three shops. They come to the house with a search warrant. Somehow, Dave escapes and goes on the run for about a week, sneaking over a factory roof and on to the wall of his house and in via the back bedroom window to spend the nights with his wife. One night he's in bed and hears the clatter of policemen's boots on the stairs. There's no way out, and he's arrested.

He's remanded by magistrates and spends three weeks alone in a tiny cell at Hull police station before being sent to Leeds prison. He's driven in a police van from Hull to Leeds. 'They wouldn't put animals in them because it would be too cruel; they sit you in a box and your knees are actually touching the door and they close it and there isn't an inch of room either side of you . . . and the smell of the petrol fumes is almost overwhelming. Anyway, they drive us to Leeds in one of them and that's bad enough, and remember, I've already been in the Hull cells for twenty-one days, but now I'm in isolation for twenty-three hours a day in the remand cells in Leeds . . . for another two months. I remember it was so bad in there that there was one guy decided to ask someone to jump on his leg and break it, so that he could be bailed out of there. He said he had fallen over in the cell.'

And that's where Dave spends his twenty-first birthday. In prison, alone in his cell, reading and rereading two cards, one from his wife and one from his mother.

When he's released after nine months he makes a real effort to look for work, but unemployment is still high, and

by now he has a prison record and a reputation for being a young villain. It doesn't prove easy. 'I always felt . . . always in my life . . . that I would find something better. I always thought there was something better waiting for me round the corner, but unfortunately, what happens is the first time you get on the wrong side of the law, they don't allow you back. The police could more or less do what they wanted once they had a bit of form on you. At the time I was living with Diana, the police burst in on her birthday and arrested me at gunpoint because someone had staged an armed robbery at an off-licence down the road. I was eventually cleared but I got locked up for two or three days by a regional crime squad for no reason. That's what it was like.'

Later, when he's married to Susan, there's a timberyard nearby renowned for being a slave camp by everybody in the area. Nobody wants to work there. But Dave wants to prove to Susan that he can do it. He's fit and strong from using the prison gym, and it is at least a job.

'Let me tell you about this timberyard: it was covered in mud and it was like two-feet-deep puddles and you'd have to walk through those puddles to your machine. And I was one of the few people who could lift these pieces of wood up, because they were wet through and really heavy, and put them on the machine. And we started work at seven in the morning and they worked us till seven at night, and gave us two ten-minute breaks and a thirty-minute break for lunch. And they paid virtually nothing. I was aching like mad after the first day and it was freezing cold, but I went back the next day, worked straight for another twelve hours and went back the next day, and I was sitting there at the tea break when the ten-minute bell went off. It was like a siren – an order to get back to work quickly. Anyway, I hadn't had any

tea because someone had slipped out for a bottle of milk. The foreman said what was I doing there, and I said I was waiting for the milk, and he said I had ten seconds to get back to the machine or I was fired. You can imagine what I said to him. I did try, but I probably landed the worst job in Hull.'

Then Dave the Elder gets back in touch. By now, Fred, having stitched the rest of the team up, has disappeared and Dave the Elder needs the younger Dave more than ever. So, now he's back safe-breaking, and doing the off-licences and tobacconists. Life returns to the way it was – a mix of crime and gambling – with bursts of honest toil – working on building sites, acting as a doorman – in between, with week following week, month following month, year following year, until Dave, now twenty-eight and a firmly established member of the Hull underworld, finds himself back in prison, after a fight outside a nightclub. He gets eighteen months, partly spent in Leeds, partly in Durham. This has a well-earned reputation for being one of the toughest prisons in the country and his time there is the hardest Dave has experienced: 'I did a few weeks down in the isolation block at Leeds and in Durham and they are terrible places. In Leeds they used to take the bed away at seven in the morning and they'd bring it back at half past five so you couldn't sleep. All you had was a little wooden chair and if you can imagine a filthy, concrete floor, plastered walls but with the plaster all falling off, and it was below ground and there was a moat outside and the window looked into the moat, so there was no light, and you were stuck in there twenty-three hours a day. People killed themselves in there. You've got to be tough to sit in there for two weeks and come out with your head held high.'

However, while serving this sentence, he becomes friendly

with a man called John, 'a hardened villain', who is on remand while awaiting trial for bank robbery (he was subsequently cleared). Unlike Dave, who, despite nearly ten years operating outside the law, is still a minor criminal, John is the real deal – a professional and purportedly vicious criminal, who's 'earned' himself a Jaguar and an expensive home. John reads Dave's depositions, and is impressed by Dave's refusal to grass on his accomplices, no matter how they've behaved towards him. He's also seen Dave win a fight in the gym, and knows he's fit and tough. He decides that Dave would make an ideal accomplice. He visits him in prison, smuggles him £100 in a matchbox and is there at the gates when Dave is released.

Dave is now approaching thirty. Somehow his twenties have slipped away; his marriage has now broken up and Susan has moved to Liverpool with his children, he has a criminal record, he's served time and, with at least a third of his life over, seems destined to spend the rest of it in a vicious circle of gambling, crime and prison.

John asks him if he would like to form a partnership, and Dave sees no other option. If he's destined to be a criminal, he might just as well get into the big league. After his release from prison and return to Hull, John comes to see him. They play snooker (the man who ran the snooker hall says that John was the most vicious-looking person he'd ever seen). Dave is now in seriously bad company.

But, with still no other options that he can see, he arranges to meet John to rob a bank the following day.

Dave turns up, but John doesn't. Eventually he telephones John's home, and his wife tells Dave that John has been picked up that morning by the regional crime squad. She says

to Dave, 'Look, they want him so bad now, you're far better off just leaving him. They're chasing him all the time. This won't work for you. Get out while you can.'

This has a considerable effect on Dave. He sits in a pub near the planned meeting place and takes stock. If John, who he knows is a much more experienced criminal than he is, is now almost permanently on the run, what chance does Dave have? John is clearly too dangerous a proposition. But reuniting with his old accomplices, Fred and Dave the Elder, is out of the question – they've both grassed on him. They're beyond the pale. So, he's alone – and fed up. The fact is, he's had enough of prison, and he's becoming a bit disillusioned with going out at night, creeping around in the darkness, breaking into premises, living life on the edge. Is this all there is going to be to his life?

David needs a new friend.

And he finds one.

Because it is just after that missed meeting that he meets Mandy.

Amanda Ashby is twenty-three. Born into a middle-class family (her father is a pilot on the Humber estuary), she's working in the laboratory at British Cocoa Mills. They meet at a local pub. Dave has never met anyone like Mandy, and Mandy has never met anyone like Dave. For him, the pub is a second home. He's self-confident, tough, experienced. His girlfriends to date come from the same hustling, backstreet crowd as his male friends. They fit right into the clubs and pubs he frequents. And there isn't a lot of subtlety about the relationships. Mandy, on the other hand, has hardly ever been in a pub, has been persuaded to come by friends. She is quiet-spoken, shy, inexperienced.

Yet, despite the differences, this is close to love at first sight.

'Mandy wasn't the type to be in bars with her mates, but her friends talked her into it; she was a very quiet girl and I was impressed by the fact that she wasn't like the rest of the girls – she was quiet and nice and sweet, and I got talking to her. With the other women I met, I never hid who I was and what I did, but I found myself telling her a lie – that I was a long-distance lorry driver. I never used to care what anyone thought about me, but from the start, I did care about what she thought. I was hardly going to tell her I was a safe-cracker, was I?'

Mandy, too, is instantly impressed: 'I asked one of my friends about him and they said he was all right. And I let him walk me home . . . we didn't live far from him, and we went home and listened to some Simon and Garfunkel records I had . . . and . . . well, we've been together ever since.'

It would be neat to say that Dave immediately abandons crime and goes straight, but he's been in the business for thirteen years, and doesn't know what else to do. So for a short period it goes on. But his heart is no longer in it, and he hates lying to Mandy about what he's doing, and so, as they become closer, and they start planning to marry, he takes a crucial decision. He will go straight.

And like an alcoholic abandoning drink, he knows that it has to be 100 per cent. And that's what he appears to have achieved. There's no evidence that from that day to this, some twenty years later, he's ever committed another crime.

Now he starts mixing with people who live in the real world and getting the encouragement and help he never had before.

He's helped by Mandy's father John, who reads in the newspaper that the last pawnbrokers in Hull are closing down.

Dave knows all about pawnbrokers; he's often left some item with a pawnbroker when he's on a losing streak. 'Kenny Hocking's brother Don was a skipper with the trawlers and he had about ten suits and the moment that Don set foot on the trawler, Kenny was down to the pawnbrokers with Don's suits. He would pawn all ten of them, and the day before Don was due to land back, he'd be running round like a lunatic, trying to find the money to get the suits back and into the wardrobe.'

So Dave knows about pawnbrokers and knows that one is needed in Hull. He suggests to Mandy that they should buy a little shop and open one.

By now Dave has come clean and told Mandy that he has been to prison. It's just as well, because they discover that his criminal record imposes limits on what he can do. For instance, he can't get a licence to lend more than £30 at a time. (He eventually gets over this by lending money in £30-lots!)

Dave has a big win on the horses, and they buy a little house. But then, with the pawnbroking business in mind, they find a little old cobbler's shop for sale. It is small, dingy, covered in dust and the little white-haired cobbler, extremely elderly, wants £13,000 for it. They sell their first house for £12,000 and Dave goes round to the cobbler's shop with £10,000 in cash and throws it on the table, and tells him if he wants to sell the shop, this is what he can have for it. 'These days, you can't buy a thing without getting survey-ors' reports and all sorts of things, but I didn't know 'owt about that sort of stuff, I was sort of flying by the seat of my

pants. He'd never seen £10,000 before in his life and he snatched it off the table and said, "It's a deal." So we were away.'

Friends from a building firm help them put up shelves and panelling, and they scrub the place clean. They install alarms and grilles on the windows and Dave goes out and buys a couple of safes (if there is one thing Dave knows about, it's safes!).

And so the pawnbroker's business gets under way. And Dave loves it.

'When we first opened the shop I still had a lot of friends who were villains and I used to say to them that once you realize how easy it is to make money legally, you wonder why you ever did anything wrong in the first place.

'I think that when I was fifteen and sixteen and making money on the horses, the money I could earn in work was a pittance by comparison and it didn't inspire me to work. It wasn't until I got to actually work for myself and earned a few quid that I realized you could get pleasure out of using your brains to earn money. For two years I ran it largely by myself because Mandy was still working at the other place – and I got quite excited about it. I could put my energy into something positive. As soon as I started earning money going straight, it was a great feeling.'

After a few years they decide to specialize a bit and to concentrate on gold and diamonds, and they move the shop to a busier shopping street and call it Uncles.

But it's not long before Mandy takes over the running of it.

Because Dave has got into poker.

3 / The poker player

Going broke is both a rite of passage and badge of honour;
a reminder that they live life on the edge.

Michael Craig, *The Professor, the Banker, and the Suicide King*

It's the mid-eighties, and Dave, now over thirty, can at last
look the world in the eye as a man of property and an honest
trader. He no longer has to watch his back for informers or
look over his shoulder for the police . . . and he's happily
married to Mandy.

But one thing hasn't changed. He's still a gambler.

He's still backing horses, and increasingly now is playing
cards.

While only sixteen, he had met a much older man, Jack
Gardner, who introduced him to Hull's basement casino, the
Fifty-One Club. Dave took up brag, a form of poker played
with three cards, and learned how to count the cards as they
were dealt, and began to make some serious money, albeit
much of it donated to the bookmakers the following day.

Over the years he's moved on to the more conventional
forms of poker, and, now that he's abandoned crime, he's
playing almost every night. Wherever poker is played in Hull,
Dave seems to be there. He organizes his own games in the

back of the shop, with Mandy catering for the players. He dominates others' home games, developing his own brutal style of raising and reraising and forcing lesser players out of the game. But his aggression and his winning – his bullying others out of their money – makes him increasingly unpopular. After a while, people stop telling Dave where the latest game will be. Not that this deters him; he always finds out, and turns up anyway. Then, one evening, he's the first to arrive, and while he waits for the others, he notices that the host/game organizer is constantly leaving the room to answer the phone. After about the sixth call, he admits to Dave that the others have seen his car outside the house and refused to come in. They've moved the game elsewhere.

Dave has to accept that his poker-playing days in Hull are over. One night towards the end of 1990 he walks into the Dragonara Casino in Leeds. There, at the bar, he meets a twenty-six-year-old called Gary Whitaker, a well-built, good-looking lad who manages two cafes in Wakefield, part of a group owned by his mother.

Gary recalls that 'This particular evening, there's this guy at the bar. I've never seen him before, but he has a kind of arrogance about him . . . looks around as if he owns the place. We make eye contact and I say hello, and he asks if I play poker. So we chat a bit, and it's Dave. Then we start playing the game, and there's a man there, known to everybody but Dave as being the main man in the Leeds Mafia and not someone you want to annoy. Anyway, Dave's taking him on, telling him to hurry up, calling him "Pedro the Bandit". This goes on for about a quarter of an hour. Because of Dave's dialect – he talks so fast you can't understand him – the man is smiling at him, but I don't like the way it's looking, so when there's a break I tell Dave that I know the man opposite

him and what he does you don't want to know. So my advice is don't call him "Pedro the Bandit".

'So we play poker and Dave gets knocked out of the final table, and I end up winning it. We go into the bar afterwards and have a few drinks, and I'm pointing out a few faces – Leeds Mafia – then I mention that I also play in Stockport and Dave suggests we meet there.'

So begins a relationship that lasts over a decade.

Dave and Gary start to go to the casinos together, almost every night – to Bradford on Mondays, Derby on Tuesdays, Stockport on Wednesdays, back to Derby on Thursdays, Leeds on Fridays and back to Stockport on Sundays. Saturday is reserved for backing horses. Dave is barred from William Hill's betting shops, partly because of his aggressive attitude, and partly because he's winning too much, so Gary places the bets for him.

'You're talking about anywhere between £200 and £1,000 on a race. He'd come up to Leeds on a Friday night and give me a grand, or even more, and say that in the morning he wants me to place a bet on a particular horse. I'd set off in the morning about ten and put £200 there, £200 there, probably into six or eight bookmakers.

'Of course, he doesn't win all the time, no one does, but because when he does win he often gets good odds he sometimes wins a hell of a lot. I remember one week he walks in with four grand and puts it on a horse and it wins at 5–2 and he now has £14,000. He has what was the *Sporting Life* then – now it's the *Racing Post* – and he spots a horse and says, "I really fancy that one," so he puts £10,000 on it and wins at 2–1, so he's played his money up to £24,000. I'm saying, "Come on, let's go now." He says, "No, no, there's this Frankie Dettori mount at 5–2. We have to back it," and

he puts £20,000 on it to win £50,000, and it bolts in, doesn't it? The bookmakers can't believe it; they think there has to be a catch. It takes two weeks before they'll give him the money . . . They take the till away, they interview the counter staff, they're looking for clues and stuff like that. Eventually, they decide it's a true bet, and they pay him out, but they bar him. He won £70,000 that day.

'It's just like Del Boy. He'll say, "Next year, kid, we'll be millionaires."

'You can't stop him. He comes to my wedding, and even then he slips off to the bookies and wins about £14,000.'

By now they have a deal: they will travel to the poker games in Gary's car and Gary will drive, and Dave will pay the petrol, accommodation and any other costs. Birmingham is added to the circuit – they now become regulars in the Rainbow Casino and in Stephen Au Yeung's spieler, and finally Dave finds himself in the city's biggest cash game, at Barry's spieler.

As Gary describes it, 'This is a big game. An action game. On a Friday night you need £1,000 to sit down, and players who are household names today like David Colclough, John Shipley and Lucy Rokach are there.'

There is a bit of a mystery about whether Dave wins or loses at Barry's. Dave claims he's a winner, and Gary backs him up. 'We're pulling ten grand a week out of this game over the weekends. Regular.' Gary is adamant about this, and there's no reason why he should lie. He never goes out of his way to paint Dave as either hero or villain. He tells it as he recalls it. But the fact remains that some of the main players at Barry's say Dave is a loser in the game.

The truth probably lies somewhere in between. Most players best recall the games they win, while their opponents best

recall the ones they lose. Dave and Gary remember the days they left with a bag of money; the others remember the days when money was left on the table.

It's actually surprising that Dave or Gary can remember any particular game because they're now on a crazy roller-coaster ride around the north, the Midlands and London, from game to game, day after day. Dave plays for the high stakes, Gary in smaller games. Gary often has 10 per cent of Dave's action. They must be winning overall because Gary is eventually able to tell his mother he's making more out of his share of Dave's poker winnings than he can hope to make running her cafes.

If there isn't a casino to play in, there's a spieler some-where . . . There are spielers in houses and hotel rooms and backs of cafes all over the north, in a tiny room in a keep-fit gym in Nottingham . . . anywhere where more than two people can gather round a makeshift table . . . and Dave and Gary know them all.

It isn't without its dangerous moments. Gary describes being 'asked to one game, but we're planning to go racing the next day, so we turn it down. Anyway, just as well, because a bunch of men with shotguns burst in and take about 7,000 quid off the table. That was in Leeds.'

Eventually they turn up in London. Dave doesn't make the best of starts. At that time the big game at the Vic is London lowball, a game he takes a dislike to and never masters. 'Also, lowball is a massively lucky game – a real gamble. And I just didn't get the cards when I needed them. A lot of people wouldn't even play this game.' But he also learns that the 'difference between bad players in the north and bad players in London is that the bad players in London have more money. You can't get them off a hand. This makes

bluffing more difficult, and bluffing is an essential part of my game.'

Even at his preferred games, the aggressive, bluffing, high-risk strategy that works so well with weaker players in the provinces doesn't stand up in the more sophisticated London game.

As Gary says, 'Dave used to win a lot up north because they would bet £50 and he'd raise it to £500, putting the pressure on them and forcing them to abandon even hands that were good, but if you're in a top London card room and you're putting pressure on a man with the best hand, you can't remove him, can you? In the small games up north, he could dominate, clean them out, but when you're playing with people who have a lot of money, who've read all the books and know a lot more than you do, you have to play differently.'

The experienced and sophisticated players Dave's now meeting at the Vic can't understand a word he's saying, and they're unimpressed by his bravado and the gangster-style image he's been deliberately cultivating in the provinces. Unprovoked by his taunts, and working out that the odds on him bluffing justifies calls, they begin to cast him as the fish in the game.

But, once more, his will to win, or, more accurately, his intense dislike of losing, drives him on. He's determined to beat London and he spends hours replaying hands with Gary on their car journeys, and begins to develop a more balanced game that makes him less predictable and thus more danger-ous. The Vic crowd are underestimating him. They don't understand that he's worked his way up from the roughest and toughest of beginnings, in life and in poker, by observing and adapting. Dave may be uneducated, but he's not a fool

. . . he learns, albeit the hard way, and now he adds experi-
ence and a growing knowledge of the practicalities of the
game to his extraordinary instinct for it.

Even today, if they remember him losing more than
winning, it is partly because of the scale of the game he was
playing. As always in his life – from that battle outside the
pub at nineteen until today – when he succeeds he does so
magnificently and when he loses he does so spectacularly.

Even when he was a kid, backing the horses, Dave had little
interest in small bets, and now he's on the poker circuit he
begins to play for big money. He wins and loses sums in a
night that many people would take years to earn. In this he
reflects a characteristic of most professional poker players –
what Tony Holden in *Big Deal* describes as 'a serene indiffer-
ence to the worldly attributes of money'. I've seen some of
Britain's best-known poker players stony-broke. But what's
worrying them is not how they'll pay the mortgage or the rent,
or even how and where they'll next eat; most take for granted
that somehow they'll do that . . . because they always have.
No, their dilemma is far more acute – it's how to get the money
to get back in the game. In Dave's case, a complete lack of fear
when it comes to putting his money on the line may partly
reflect his earlier life. Winning on the horses ('So this one lost,
so what? . . . There's a cast-iron certainty in the 3.30 at Don-
caster tomorrow'), cracking the occasional safe ('So I've spent
what I took from the tobacconist, so what? . . . There's always
the off-licence down the road') . . . It's easy come, easy go.

He's now playing more and more in London, and experienc-
ing some spectacular ups and downs. He once loses a £60,000
pot to Donnacha O'Dea at the Vic when the latter gets a last-

card ace, one of only two cards in the pack that can save him from Dave's full house, only for Dave to win nearly all of it back in a cash game with others at the Metropole in the early hours of the following morning, and in a heads-up with another player later that day.

But he still has time to smash-and-grab his way round the lower-stakes spielers of the north, best illustrated by one twenty-four-hour stretch when he plays in no less than five towns, beginning in Sheffield where he wins a few thousand. He and Gary start off home but, as Gary recalls:

'In the car he's ringing all over the place – "Where's there a game? Where's there a game?" I says, "Come on, Dave, let's go"; he says, "No, no, let's just go to Nottingham for a few hours."

'Now we're in Nottingham where there's this Chinese triad game – five-card stud. We get there and it's full of Chinese, and obviously we've been told before that these are not people to be messed with. We go into the kitchen, and they're all round the kitchen table. There's a big bucket under the table, about two foot six high and about two feet wide. I think, what the hell's in that bucket? I look down and all I can see is fifties, tenners, twenties and casino chips. The dealer is the owner of the house and he takes pounds every hand – that's the session money. And he drops it in the bucket. It's amazing.

'Dave puts down a couple of grand. The Chinese guy's wife comes over and asks if we want some food. I thought, great – Chinese duck, barbecued spare ribs, dim sum, the lot. Anyway, she comes back with two bacon and egg sandwiches. I've never forgotten that.

'He wins about £14,000 there. But he looks utterly exhausted. "OK," he says, "we'll go home now."

'Instead, we end up in Leeds and he says, "Is there a game round here?" We start to phone round and find out there's a private game in Bradford. So we go to Bradford. We've now been playing for twenty-odd hours, but he sits down and proceeds to annihilate them all. One by one, they're skint. He wins about £8,000 because there wasn't much money on the table. And there's this scrap-man called Norman and he says, "Dave, do you wanna have a game? Just you and me in my house?" So we go to Wakefield to his house and Dave takes three grand off him in twenty minutes.'

So they eventually get home from a journey that has included Sheffield, Nottingham, Leeds, Bradford and Wakefield and wins them around £35,000.

Dave still finds time to win and lose money on the horses. Gary remembers, 'One day we're driving down to London for a tournament and it's misty and I'm tired and hungry so when we see a cafe I stop and suggest we have a cup of tea and a sandwich. I go in and order two cups of tea and two chicken sandwiches and when I come out there's no one in the car and I look in the boot and the money's gone, too. I look around and see a Ladbrokes betting shop. Somehow I've found the only one on the road from Hull to London and of course he's in there and he's down £7,000. I say to him, "For God's sake, £7,000 for a cuppa and a sandwich – that must be the most expensive cup of tea in history." '

But, as always, it's 'So what?' Dave wins the tournament – £11,000 – then goes on to win about £45,000 in a week in cash games.

♥ ♦ ♠ ♣

This crazy life, driving the length and breadth of the country, playing in the top card rooms one moment, and with shady

characters in back rooms in the Midlands or the north of England the next, winning and losing what were in the context unbelievable sums of money, sleeping in the car on journeys from one game to another, snatching food on the run and pausing to take just enough time to lose some money at the bookmakers, goes on for nearly ten years. Somehow Dave manages to drag himself home to Mandy at the end of many evenings, but poker has been taking over his life. And over these years he's been developing a more formidable game, built on the same sheer nerve and bullying and bluffing at the table that he began with, but mixing it up more, playing tighter, reducing the gamble, increasing the skill . . . a better class game fit for higher class company.

To anyone watching what's happening it's becoming inevitable that Dave will move from the behind-the-scenes card rooms to front stage, and now he does. He begins to win consistently and to enter the bigger tournaments. He first starts to appear on the national 'score card' in 1993 and 1994 with a series of high places in London festivals, including second place in a seven-card stud event in June 1993, and second place in a £300 pot-limit Omaha event in July 1995. His first recorded tournament win at this level comes at a £100 pot-limit Hold'em in the European Championships at the Vic in June 1996, this being followed a week later by third place in a £1,500 no-limit Hold'em main event at the same tournament. In two weeks at the Vic he picks up £100,000 in tournament and cash games.

Gary begins to notice a difference. 'He's getting this inner belief. You can see him growing in stature. He's playing a real professional game. And he's started dressing better, building an image, looking like a winner.'

It's then that someone says to Dave, 'I think you should

go to Las Vegas – your game is well-suited to the way they play there.'

So, in January 1997 Dave says to Gary, 'How would you like to come to Vegas?'

4 / From Dave to Devilfish

The good news is that in every deck of 52 cards there are 2,598,960 possible five-card poker hands. The bad news is that you are going to be dealt only one of them. The best news, however, is that you don't have to hold the best hand to win. The one dimension unique to poker . . . is the element of bluff. By betting as if you are holding the best hand, by representing strength, you can frighten every other player out of the pot and take their money without even having to show your cards.

Anthony Holden, *Big Deal*

Dave and Gary arrive in Las Vegas in January 1997. Dave takes £10,000 with him. He's decided he doesn't want to risk any more; this is basically a reconnaissance trip for the World Series in April.

They stay in the Four Queens Hotel in Glitter Gulch, downtown Las Vegas.

Dave is unusually disciplined for this point in his career, playing in relatively small-money tournaments and safeguarding his money in cash games. His form is uneven, winning one day and losing another, but he's doing no real damage.

Then he enters the main Four Queens tournament of the

week and, after a highly professional performance, finds himself on the final table with Men 'the Master' Nguyen.

Men is a forty-three-year-old Vietnamese. He came to the US without a cent, unable to speak the language, and has become a legend in poker circles in southern California. His nickname – 'the Master' – is based on victories in over seventy-five major events and prize money believed to be over $5,000,000 in nineteen years, including no less than four gold bracelet victories in the World Series in 1996. Men operates at the centre of a number of Vietnamese poker professionals and has a financial interest in many of these players, and probably has made as much money from their overall winnings as he has himself. This is Dave's most formidable opponent to date.

Dave ends up in a head-to-head with Men, with the piles of chips moving backwards and forwards from one to the other. The crowd gets involved, with Men's Vietnamese supporters baying for Dave's blood. Gary Whitaker responds: 'Go on, the Devilfish!' he cries out. In the end, it's Dave who prevails, and the next day the Four Queens press release headlines its report, 'Devilfish Devours the Master.'

Dave has won $90,000, but the main outcome of this success will prove much more valuable: the nickname Devilfish now registers with the poker world and the media, and will contribute to him becoming one of the world's best-known players.

(There are conflicting stories about where the nickname Devilfish originated. In fact, it began with Stephen Au Yeung, who ran the Broad Street spieler in Birmingham and loved to give all his players a name. 'You're "the Devilfish",' he said to Dave, claiming this was a rare Asian fish that could poison

you if not properly handled. Actually, the fish books describe the devilfish as a big, shark-like fish, one that frequently terrorized early whalers around the coast of North America. Well, who cares – both versions are appropriate!)

Strangely, today Dave dismisses this victory over Men Nguyen as being of no significance, other than to establish his nickname, but it was a big win, and it's hard to believe that it didn't add to his already considerable self-confidence. Undoubtedly, when he returns for the World Series a few weeks later he's in a mood to win.

But this he doesn't do – not immediately. Initially his campaign goes disastrously wrong.

He comes with $200,000 and within three days he loses the lot, in cash games and tournaments. He raises $3,000 for another tournament, but this is lost too. He manages to raise another $7,000, but this also goes. No matter what Dave does, it doesn't work out. He gets four cards to straights and flushes – but never the fifth. If he gets two kings, someone gets two aces. It's one of those disastrous runs every poker player knows and no one can do much about.

At these events, there's always someone looking to buy into the action, and Dave now has a stroke of luck: a Texan bail bond dealer offers to lend him $60,000. But the losing streak continues and he loses even this – in another three days. He borrows from some other players and acquaintances over from the UK, and loses that, too.

As Gary says, 'All his bridges are burned. He says, "Look, I don't know what to say to you. If we can't raise any more money we'll have to go home." Anyway, somehow we managed to raise another few thousand. He enters a $2,000 World Series gold bracelet tournament with a first prize of $180,000.

It's pot limit. I've never seen him so determined. He tightens up his game, puts his head down and fights his way to the final table. There he gets into a heads-up.

'Dave has ace-4 of hearts in the pocket; the other guy has 7-7. The flop comes down 3, 5 and 7, two of them hearts, so Dave has 4 for a flush and the other guy has trips. He checks, and Dave bets the pot. The other guy then reraises all-in, and Dave gets up to his feet and says, "All-in, son." They turn their cards over. Dave needs a 2 or a 6 for a straight or any heart for a flush. The dealer – it's a woman – taps the table and turns over a king of clubs. No use. I'm now standing right behind him, desperate. I'm clutching a horseshoe I've been holding all day for luck. She taps the table another time, and flips over a 2. He's won with the straight. I jump over the rail on to him . . . waving the horseshoe.

'It's fantastic. It's like he's back from death row.

'Only now he has a gold bracelet.

'And I say to Dave, "All those guys at the Vic and places who didn't reckon you, what can they say now?"'

Dave admits to having been excited, although he says he was confident when he went all-in. 'The press release the next day talked about a miracle 2, but I had actually had two shots at three 2s, three 6s and nine hearts, so I was actually favourite to win the hand. But it was a good moment and I remember going out of the card room to have my picture taken and bumping into friends, a husband and wife who were on holiday from Hull and who had no idea what was going on. They asked me what I was doing there and I said, "Playing poker". It's amazing – the odds of bumping into good friends from Hull in the Horseshoe Casino at a moment like that.'

♥ ♦ ♠ ♣

It's hard to describe to non-poker players what a gold bracelet means; suffice to say, it's what every player dreams of, the ultimate symbol of success in the game, poker's equivalent of an Olympic gold medal.

Now the losing run is well and truly over, because the success doesn't end there. Dave is now on fire. He launches an assault on Las Vegas, not waiting for good cards, bluffing and terrifying all in his path and winning $10,000 and $20,000 a day, sometimes much more, in cash games. And he does that for nearly two weeks.

Gary remembers that 'at the end of this we go for his bracelet fitting, and while we're out Dave spends $4,000 on suits. We're walking back into the casino with all these purchases – I mean eight carrier bags and boxes – and they're dealing some cards out at a table near the foyer and there's nobody sat in seat three. Dave says, "Do you mind dealing me in? How much is it?" and the bloke says, "It's a $5,000 table," and Dave puts five grand down. He picks up the cards and it's aces, double-suited, and he goes all in and quadruples his money to twenty grand. So I say, "Come on, let's leave" but he ignores me and the next minute he's all-in for a second time and in two hands he wins $83,000.'

Two hands, two minutes, $83,000.

'Do you know what we come back with from that trip? We have $742,000 cash in two duty-free carrier bags.

'When we stop off in New York, I say, "For God's sake, let's stop and buy a proper bag," so we go straight into this little boutique and ask for a bag. The lad in the shop says, "No problem" and then we open up the duty-free bags and tip the $742,000 dollars into the new bag, zip it up, tip him $200 and walk out. We were in and out within a couple of minutes. And this kid looks like he's in shock; it's obvious

he daren't say a word because he thinks we've done a bank job.'

In that 1997 World Series, Dave not only wins the $2,000 Hold'em pot-limit event, but also comes thirteenth in the $1,500 Omaha pot-limit event, and seventeenth in the $5,000 limit Hold'em event. He is now established as someone who can compete in the toughest arena in the world.

There is perhaps no better way of illustrating the distance that Dave has come than to describe the scene at the Leeds casino where he and Gary met when they come back from Las Vegas. They walk in, and there are about fifty or sixty players at the tables. There is a momentary hush, then one player stands up and begins to clap. And then suddenly they're all clapping and cheering. They know where the Devilfish has come from, because they're still there – but what he's now shown them is just how far it's possible to go.

♥ ♦ ♠ ♣

Back in England, the Devilfish now confirms his class with some solid performances, including second place in the 1997 European Championship and also the £1,500 no-limit Hold'em event, and with a second and fourth in that year's Christmas Cracker tournament in London.

In May 1998 he goes back to Las Vegas where, on an otherwise disastrous trip in cash games, he nearly wins another gold bracelet, coming second in a $3,000 Hold'em pot-limit event.

He goes on to win a pot-limit Omaha tournament in Paris, and then in the summer of 1999 comes the success that finally establishes him not only as the leading British poker player of his generation, but as a national celebrity. It's on

the programme that's become a television phenomenon, *Late Night Poker*.

By the time of the final on 21 August it's attracting well over a million viewers in the early hours of the morning. In it the Devilfish, who has already won his heat and is well established as a favourite with viewers, gives an electrifying performance. In dark suit and open-neck white shirt, he looks like a star and plays like one.

There are ten players on the final table including such top flight performers as Joe 'the Elegance' Beevers of the Hendon Mob, 'Gentleman' Liam Flood and Surinder Sunar. They're competing for £60,000 in prize money, with £40,000 for first place. Dave gets off to a flying start, beating Surinder's straight with a flush to win the first hand, and then puts a lesser player right out of the final on the third hand with a full house.

At this stage the cards are running his way, as Joe Beevers finds to his cost, losing a hand to Dave's four 10s.

Dave is now sitting behind a huge pile of chips and is never to lose the lead.

He sees off Liam Flood when the latter goes all-in with ace-7 to Dave's ace-king and the community cards don't improve either hand.

There are three left, and now there are two hands with Dave Welch from north London that capture the imagination of the television audience.

In the first, Welch has a king-queen of clubs, the Devil-fish ace-9 unsuited. Welch bets £3,000 pre-flop and Devilfish raises him £20,000. It's a critical moment. If Welch can win this hand he can take a commanding lead. Welch takes ages to decide how to play it, while the camera lingers on

Devilfish's face. He's looking over his glasses, almost frighteningly impassive . . . an image that's hard to forget. The pressure proves too much for Welch. He folds.

And then comes an even more absorbing hand.

The camera shows Welch has two jacks in the pocket, a powerful hand with only three players left at the table. He raises the blind £3,000. We can't see Devilfish's hand, but he merely calls. There's now £6,500 in the pot including the blinds.

Now comes the flop – 5-ace-10.

Devilfish checks. Welch considers. Does the Devilfish have an ace in the pocket? If he does, would he not have reraised before the flop? He bets carefully – another £4,000. The Devilfish calls. Now, for the first time, the camera shows his pocket cards. He has two aces to accompany the third in the flop . . . three aces to two jacks.

As commentator Nic Szeremeta exclaims: 'He's got him strangled.'

But for the Devilfish this is not about winning the hand, it's about persuading Welch to fall for an all-in bet. He wants him out of the game.

He checks on the turn. So far there's not been the slightest hint that he has such a powerful hand. Despite this, and despite his own hidden pair of jacks, Welch is suspicious. He checks, too.

Devilfish now decides Welch is committed. On the river – it's no help to either player – he says to Welch, 'I'm going to put you all-in,' challenging Welch to bet all his remaining chips.

Commentator Nic Szeremeta says, 'I've never seen a hand played so well.'

His fellow commentator Jesse May adds, 'I'm staggered.

Ninety-nine out of a hundred players with £40,000 at stake and two aces would put all their chips in before the flop and not leave the chance for anyone to get lucky later on.'

This is where Devilfish's reputation for aggression and bluffing helps. Welch has to think that if he's played it this cautiously so far, he doesn't have an ace. He is surely bluffing. It has to be beyond his imagination that, in fact, the Devilfish has two.

Welch calls. And for him it's all over.

And indeed, the final is all over, for the closing hands are an anticlimax as the Devilfish coolly allows scrap-metal merchant and part-time poker player, Peter 'the Bandit' Evans from Birmingham, to hang himself.

He picks up the £40,000 and throws £1,000 of it to the dealer, and later buys a crate of champagne for the other players and the television crew. This has been about more than the money – ever-sensitive to criticism, he knows this is an emphatic response to those in British poker who still hark back to earlier days and question his skill. And he knows that for the first time a British professional poker player is known beyond the spielers and casinos of London, the north and the Midlands; he has become a star to over a million people, a number that will be multiplied many times over by the programme's manifold repeats.

And so, as the century comes to the end, Dave has incontrovertibly 'made it' – from the Fifty-One Club in Hull to the Vic in London to Binion's Horseshoe in Las Vegas to the television screen.

He's more than a top poker player; he's become a star. Devilfish, superstar!

5 / Devilfish – superstar

His victories bring him neither reputation for wisdom, nor credit for courage. He wins his battles by making no mistakes. Making no mistakes . . . means conquering an enemy that is already defeated.

Sun-Tzu, *The Art of War*

Tunica in Mississippi is a long way from Hull, in more ways than one. To get there Devilfish has to travel by car to Heathrow, fly to Washington DC or New York, and from there take another flight to Memphis. There he has to hire a car or take a taxi to make the last thirty-five-mile journey, along a road lined with huge billboards advertising casinos, a garage that deals with car wrecks ('We meet by accident') and a church that's up for sale. Tunica itself was a tiny isolated farming community with only twenty hotel rooms in 1992; it now boasts over 10,000, all linked to huge casinos sprinkled around a county that previously had so little infrastructure that it didn't even have a chief of police.

This has happened because it's the law in Mississippi (home of the riverboat gambler) that casinos are only allowed on the waterfront, so someone had the bright idea of creating a brand-new canal from the river to empty cotton fields and then building casinos around it. Now huge casino-

cum-resorts called the Horseshoe, Gold Strike, Bally's, the Grand, Fitzgerald's, Harrah's and Sam's Town dominate the Tunica skyline, attracting gamblers not only from Memphis and this part of Tennessee but from Arkansas and Alabama. All have poker rooms and a flourishing poker clientele.

Jack Binion, having lost control of the Golden Horseshoe in Las Vegas, established the Horseshoe Casino in Tunica, and each January, with the neighbouring Gold Strike Casino, it jointly hosts the opening WPT event of the year, the World Poker Open. In 2003 it's one of the largest tournaments in the world, requiring both casinos to accommodate more than 160 players, all of whom put up $10,000 for the main event. Devilfish is one of them.

He had come to Tunica the previous year and picked up $123,772 by winning a pot-limit Omaha tournament after a final table battle that lasted six hours and ended with a monumental heads-up with American player Ron Rose, so Devilfish likes Tunica, and now, in 2003, he begins quietly in the run-up to the big one, finishing fifteenth to win $2,614 in the opening event.

But it's the main event that matters. Not only is the first prize $589,990 plus a $25,000 entry fee into the WPT championship event at the end of the season, but this is one of the World Poker Tour televised tournaments. A final table performance will further build his profile all over the world. But for the Devilfish it begins disconcertingly: the organizers have forgotten to put his name in the draw. There's a delay while they open a new table and move a few players around.

The event lasts four days and he leads almost from the beginning.

By the time it comes to the final table, he's full of confidence, justified by a huge chip lead.

He's confronted with five others:

— Jeremy 'the Kid' Tinsley, twenty-five years old, from Texas. Tinsley learned to play poker from his father when he was six, and went to Las Vegas when he was twenty-one with a bankroll of $3,000 to see if he could make it as a professional. Within a year he had built it up to $100,000 in cash and was playing $40–$80 limit on a daily basis. He now regularly plays in local cash games in the Houston and Beaumont areas of Texas.

— Buddy Williams, sixty, the crowd's favourite, confined to a wheelchair after an accident when he was a child. He made a lot of money as an estate agent, and is set to achieve his best result ever. (He finished twelfth in the main event at Tunica in 2001.)

— Johnny Donaldson, also sixty, a building contractor from Arkansas, on his first final table. He won his seat in a super satellite at a cost of $220.

— Tommy Grimes, a veteran poker player, a gambler for most of his fifty-seven years. Born in Jackson, Mississippi, he had a stint in the army and then became a road gambler, before moving to Texas where he now plays mainly in home games in the Houston area.

— Finally, the astonishing Phil Ivey, sometimes called the 'Tiger Woods' of poker – a brilliant young player, aggressive, a television poker superstar. Only twenty-six, the previous year he had won three gold bracelets in one World Series of Poker festival, equalling the record.

Ivey is clearly the main threat, although Dave knows that at this point the American is relatively inexperienced at no-limit Hold'em events. 'He even said that. I think I got Phil when he was feeling his way into the no-limit game. He's a lot harder to beat now. He's a lot tougher now.'

The two had met several times before. At the WSOP in 2000, Ivey beat both Devilfish and Dave Colclough on the final table of a pot-limit Omaha tournament, but Devilfish came second, ahead of Ivey, in a no-limit Hold'em tournament.

This is a powerful line-up he faces, but Devilfish knows how to play from the front. 'Once you're on the final table you find two or three people who aren't ambitious enough to win; they're just trying to climb up, get a little bit of extra money, they're not actually planning to win it. You try to play at these guys because they don't want to put all their chips in unless they've got the stone-cold nuts. You try to dodge the super-aggressive types who are out to win same as you.

'Once I get chips in a tournament I try and stay away from the big pots . . . I just want to try and win little pots, medium-size pots, bully the weaker players, bully the low stacks. I don't want to stick all the money in and go out in one big bang. I just try to chip away so that it's harder for them to get the chips off me; I'm not going to be reraising with ace-queen, ace-jack, ace-10 . . . I'm going to try and see flops with 8-7 or 10-9, whatever, and try and catch a big flop and take the money that way.'

Well, that's the strategy . . . In reality Devilfish's lead is such that he can to some extent break his own rules.

It's Tinsley, not Ivey, who opens the assault on the leader,

consolidating his position in second place by confronting Devilfish twice in the first three hands.

In the first hand, the Devilfish, in the small blind, raises with queen-6, and Tinsley, in the big blind, calls with queen-jack off-suit. Tinsley then flops two jacks to give him trips. The board ultimately comes down jack-jack-5-ace-queen and Tinsley, having slow-played his hand beautifully, ends up with a full house on the river and 100,000 of the Devilfish's chips.

In the second hand, after the Devilfish has bet on the flop and Tinsley has called, the hand is checked on the turn and the river, and Tinsley uncovers pocket 7s to the Devilfish's pocket 6s.

But a couple of hands later Tinsley's pile of chips collapses around him. The only amateur at the table, Donaldson, makes what appears to be an amateur move, going all-in over the top of Tinsley's raise with an ace-10 of spades. Tinsley then makes a reckless call himself. To his chagrin, his hand doesn't improve whereas Donaldson picks up a 10 on the flop to win with a pair. Tinsley is never to recover. A few hands later he goes all-in with an 8-9 off-suit and is called by Williams. The latter has become extremely popular with the crowd around the table, and there's a roar when his ace-queen off-suit is joined by a second ace on the flop, and a third one on the turn. Tinsley is out, with $69,000.

In the meantime, the Devilfish is giving Ivey a real lesson. With the blinds at $3,000 and $6,000, he has a 2–1 chip lead over Ivey, and increases it when he raises with jack-8 of spades and bets out on the rag flop to persuade Ivey to lay down king-queen off-suit.

A few hands later he bets an up-and-down straight draw

on the flop with a 5-4 of spades to get Ivey to throw away the ace-8 of hearts.

The veteran Tommy Grimes raises Devilfish 36,000 from the small blind with king-5 of hearts. He must be expecting the Devilfish to come over the top of this raise with *anything*, because he calls his all-in with all of his remaining 137,000. But the Devilfish has a real hand this time, pocket 7s, and Grimes is out. Says one commentator, 'It was a strange sequence, but one that Ulliott has seen repeatedly in his illustrious career. Tight players pay off bluffers all the time.'

Devilfish then sees off Williams. The latter goes all-in over a Devilfish raise with a king-queen off-suit versus a king-7, but the Devilfish, with a huge chip lead and the chance to eliminate someone else for 41,000, goes all the way and picks up another 7.

Meanwhile, it's proving not to be Phil Ivey's night. He falls into third place when consecutive ace-king and ace-ace hands both lose.

However, it's Donaldson who goes out in third place. He's performed brilliantly for an amateur but now he fails to press an ace-3 of spades pre-flop and allows both Ivey and the Devilfish to slip in, each with a queen-rag. A queen flops, Donaldson's ace-3 suited is in huge trouble, but he doesn't know it and goes all-in for his last 102,000. Devilfish turns over a queen-8 for a winning pair and it's heads-up – Devilfish v Ivey.

But it's completely one-sided, with the Devilfish having a huge lead in chips, and it takes only three hands to finish it off. The Devilfish has 6-5 in the pocket, and the flop produces 3-8-7. The turn produces the 4 for a Devilfish straight. But

Ivey, of course, does not know this. He's got a king-8, i.e. top pair on the board. He goes all-in and it's all over.

After six hours of total dominance, despite only having two playable starting hands, a pair of 10s and a pair of 7s, the Devilfish has won the $589,990 first prize – easily his biggest payday – and a World Poker Tour title to add to his WSOP one, cementing his standing in the US as Europe's most fearsome player.

But it's the way he won that draws most comment.

The World Poker Tour commentator Mike Sexton was transfixed by it: 'I truly believe that the win he had in Tunica in the World Poker Open was the best, most one-sided win, most dominating performance that I have ever seen on the tour. It was truly dominating, and I say that because he was in chip lead position, a dominating position, almost from start to finish, in total control of the table, and you could see that all the other players towards the end had decided "Well, we'll never catch up with Devilfish, but there's a lot of money for second place and we'll settle for that." He picked up on this, so what he was doing was raising every pot on the way, with everyone throwing their hands away, and he would win the blinds and the antes and finally they all became short stacked and he'd raise it, and somebody would go all-in, with the ace-king or some other biggish hand, and he'd often call him with a smallish hand because it would just be a few more chips and there was always the chance he would come out on top.'

Sexton says, 'It was sad for me because when the television show was edited, the viewers couldn't really get an understanding of how he was dominating it. Don't be in any doubt, there were some top players in there, but it was absolutely a one-man show and the Devilfish was leading the charge and dominating the event.

'We are now in our fourth season, and, believe me, it's still the most dominating performance we've seen on the World Poker Tour.'

The brilliant young French-Canadian player Isabelle Mercier was also there. She later writes in *Poker Europa*: 'There were 200 spectators and supporters. The atmosphere was electric. Every person in the room felt like part of history . . . with four players remaining he was clearly favourite to win . . . he never gave away one single chip to his opponents. He didn't hesitate to lay down cards he had raised with in the first place. He did no gambling and he took no risks, even though he had an amazing stack of chips in front of him. On the contrary, he was the one who took the chips, little by little, from the others, stealing pots every chance he had.'

She concludes, 'After the prize-giving ceremony, the champagne and the pictures, you could see the Devilfish signing autographs and giving interviews. Even the players in the low-limit games were talking about him . . . how good he looked in his suit, how well he played. They were actually talking as though they knew him personally. That's pretty much what celebrity is all about.'

The final result is:

1. Dave 'Devilfish' Ulliott $589,990 plus $25,000 entry fee
2. Phil Ivey $291,031
3. Johnny Donaldson $145,065

Devilfish has become a consummate poker professional, feared on both sides of the Atlantic. Now a major figure on the US poker scene, he comes back three months later to come second in a pot-limit WPT tournament at the Bellagio in Las Vegas, make a final table at the WSOP (pot-limit

Hold'em) and finish high up in tournaments in a later tournament at Las Vegas and another at Palm Beach. He also wins over €60,000 by coming third in the Master Classics of Poker in Amsterdam.

He begins 2004 by winning a pot-limit Omaha tournament in Walsall, and getting a third and a fourth at the same festival, then wins a no-limit Hold'em tournament at the British Open in London, picking up £90,000. He goes to Barcelona that year, comes third in the no-limit Hold'em event at the world heads-up championships and goes on to win the Omaha event, chalking up nearly €50,000.

As he comes into 2005 he can look back at a remarkable decade at the top of a profession in which it's exceptionally difficult to perform consistently, such is the influence of luck, and the increasingly competitive nature of the game. He has already won around $3 million, but like the other big poker stars, his income is increasingly coming from outside the card room. He has signed a contract to be one of the personalities to front the poker site UltimateBet.com (along with Phil Hellmuth and Annie Duke). For this he gets 1 per cent of the company (likely to be worth $1–3 million when the company floats) and nearly $500,000 a year to spend as he wishes, mainly on travelling to and entering poker events all over the world. Yet he obviously believed he could do better, because at the end of 2005 he was planning to end the contract to open his own site, DevilfishPoker.com. There will also be a DevilfishPokerstore.com, selling his endorsed products – poker chips, etc. He's signed a deal with BlahDVD.com, and says we can expect to see him in the cinema soon in a film called *Poker Face*.

His family now lives in a spacious house in an affluent village near Hull, full of big houses with names like 'The Hawthornes', where there's a school, a striking church with a high steeple, a newspaper shop, a pharmacy, a hair and beauty salon and a small sub-post office. There's a village hall and a playing field, the base for the local football club, and that's about it. About 300 yards from the centre of the village, near the small railway station, is the family's sprawling home, conspicuous for much of the year by the three sparkling vehicles in the space at the front of the house – a BMW, a convertible Lexus and a H2 Hummer given to him by Blah ('It's a mean thing, jet-black with spinners on the biggest wheels possible, and everything you can imagine inside – a DVD player and a camera in the mirror for reversing'). The house is minimally but tastefully furnished. There's an unruly but not unattractive garden out the back, a barbecue area, a fish pond, and then at the end of the garden, a skateboarding area.

All of this raises the question: where has Mandy been all this time? (And, for that matter, what happened to Gary?)

The answer is that Mandy has been having children, four in all: Steven, now nineteen, Christopher, now eighteen, Michael, now fourteen, and Matthew, who's eight. And she's been running the business. This has done well and finances the running of the family on its own, with Dave using his poker winnings to buy the house and do it up . . . and to pay for the cars, guitars, etc. – the trappings of success.

Mandy admits it hasn't been easy: 'At the beginning he used to play a lot in this part of the country so he wasn't away that much. Now he's away a lot, but that's the thing he does, playing poker for a living. What with having the kids and running the shop, I didn't really notice for a while. But he's away a lot more now.'

By mid-2005 Dave and Mandy are living more or less separate lives, with Dave living at least two-to-one as international celebrity and playboy, on the one hand and, on the other, as husband and father who occasionally reappears in Hull to hammer out songs on his music centre and party with his friends (still assorted hard cases, villains or former villains, generally folk you wouldn't want to meet on a dark night; he still feels more comfortable with them, even if he's out of the 'business'). As for Mandy, she may have been as accepting a wife as Dave could hope for, but at the time of writing, both were admitting that patience was being tested to the limit.

As perhaps it was bound to be. Since they married Dave has moved from local villain (reformed) to, at least in the context of his background, fame and fortune. And he's never there, because the places where he makes his money – London, Las Vegas, Los Angeles, Paris, Barcelona, etc. – are far away, not just geographically but in terms of lifestyle and temptations. Yet, even as they are increasingly apart, there is clearly still a strong bond between them. When each says that if they end up apart, even divorce, they'll remain close, it's entirely believable.

As for Gary, it all goes wrong for him for a while. Travelling with Dave for nearly a decade destroys his marriage and he becomes more than three stone overweight and ill. 'Dave has this incredible energy and stamina, but my body was rebelling – at the hours, the stress (because I felt it for both of us . . . he never worried). I got really down . . . thought if I went on I was going to die.'

So after ten years the partnership breaks up. Gary gets a job on the commercial side of the local newspaper, and when last seen was in good spirits and looking well, having given up smoking to please an attractive girlfriend he hopes to

marry. As time has gone by and Dave has moved on, Gary has adjusted to life without him, but those years with Dave remain the high point of his life.

Ask him about his relationship with Dave. Was it like father-son? Do you miss him?

He will find it hard to reply. Look closely and you'll see tears in his eyes.

Meanwhile, the Internet-television boom is well under way. The game needs personalities and stars, and who better than the Devilfish? He has the charisma and the looks, and he plays a brand of poker that creates action and excites television viewers. He begins to become a celebrity beyond the world of poker; he's appearing on the front pages of magazines, he's handing out the cup to the winner of the 2000 Guineas at Newmarket, he's building up his business interests. He's now flying first class, staying in the best hotels, developing a taste for the more expensive restaurants and quality wine.

But what he still doesn't like is losing. He hates losing: 'I get so wound up when I'm knocked out of a tournament it's scary.' Yet back in the card rooms, Devilfish is finding 2005 a tough year, apart from two early wins in tournaments at Deauville and Paris and a highly respectable performance at the World Series. The cards are not falling right, and he's finding it increasingly difficult to motivate himself, except for the big events. 'The bigger the occasion, the better I play. Definitely. I need television cameras and I need a lot of money.'

There's another problem: his fame means that when he does play in televised tournaments, he's heavily featured, and, because they can now see his pocket cards, opponents are getting the chance to see exactly how he plays. They see

how and when he bluffs. And this helps them to judge better when to call him.

And, finally, there's the sheriff-gunfighter syndrome. We've seen it in countless westerns – the experienced sheriff with the reputation for a quick draw, and the young, hot-headed gunslinger who comes to town and wants to prove himself by putting the sheriff down, preferably as publicly as possible.

There was a time when the Devilfish was that gunslinger. Now he's the sheriff.

It's all got a lot tougher.

So, for Devilfish, is the party over?

That's not likely.

As he's climbed the poker ladder, Dave has picked up much more than money and prestige. He's picked up experience. This is not like tennis or football or most sports where you're likely to be over the hill at thirty. Experience, added to an exceptional feel for the game, can keep you at the top for years. Ask Doyle Brunson, now seventy-five and still able to win a WSOP gold bracelet in 2005.

What lies ahead for Dave 'Devilfish' Ulliott depends on how he uses that experience, and what he's learned . . . about poker, but also about life, because it's one thing to become a star, another thing to behave like one and to succeed as one. The fact is, he's having to take decisions and make judgements he's never had to make before, often in areas where he has no experience, and where lack of education or broader life experience can't be helpful – business decisions, decisions about how he promotes himself, decisions about how he handles himself in public and in private.

All who respect his more positive qualities – the courage and the determination and the skill, the ability to learn from

error and adversity, all those things that have created real rags-to-riches achievement – will hope for his sake, but also for poker's sake, that he makes the right decisions, at the table and beyond it.

Because Devilfish, superstar is the most challenging hand he's been called upon to play.

BOOK TWO

'All-in' with 'the Usual Suspects' . . . life on the professional poker circuit

6 / *From whence they came . . .*

> There are few things that are so unpardonably neglected
> in our country as poker . . . Why, I have known clergymen,
> good men, kind-hearted, liberal, sincere, and all that, who
> did not know the meaning of a 'flush'. It is enough to
> make one ashamed of one's species.
>
> Mark Twain

In the sixties I'm working in a sixth-floor office on the Strand.
Opposite is the Adelphi Theatre and close by a shop that sells
second-hand bits and pieces, lost property, or stuff that fell
off the back of a lorry. Looking out of my dust-covered
window I see from time to time a variety of rather shady-
looking characters disappearing into a doorway next to this
shop, never to reappear (well, of course they must do, but not
until day has turned to night and I'm long gone).

Were I to become curious and wander over there I would
climb a steep fight of stairs and, on the first floor, pass a
seedy-looking (and, I'm told, 'evil-smelling') cafe. On the
second floor I'd push open a door and find about thirty men
playing chess. Not just any men – some of the best chess
players in England. This is En Passant, run by a huge, muscu-
lar Eastern European (some say Russian, some say Hungarian)
called Boris Watson. I'd walk down the narrow room past

these absorbed competitors, and up a few more steps; at the top I'd discover an attic room devoted to poker. It's run by another huge man, albeit overweight rather than muscular, a former policeman called Ted Isles. Both Boris and Ted are top chess players, but they've decided that card games will be a nice little earner and have founded what becomes for a time London's premier poker venue, a probably illegal, round-the-clock game that attracts a mixed clientele, from journalists and lawyers from the nearby Law Courts and Fleet Street to what the late David Spanier describes as 'low-life players, hustlers and hangers-on'.

The celebrated American journalist Tom Wolfe goes there at one point and describes it as 'gloriously seedy. There is some kind of wall-to-wall carpet, only it doesn't look like a carpet but like the felt padding you put under a carpet, and it's all chewed up and mouse-grey with bits of cigarettes and lint and paper and God knows what all else caught in the chewed up surface. There is haze from the smoke, and at the end of the room there are six men seated round a table playing poker, under a big lamp with a fringe on it. They are all in their 30s and 40s, it looks like, a couple in very sharp sort of East End flash suits, like sharkskin, a couple in plain off-the-rack suits, one in kind of truck-driver clothes, and one guy looking rather Bohemian in some kind of trick zip-up shirt of corduroy.'

If you play in the game, it's not at all unlikely you'll have a lawyer to your left and a criminal to your right. Stewart Reuben recalls playing with a man called Viv who made a living from enticing homosexuals to hotel rooms, beating them up and robbing them. 'He used to play with blood-stained banknotes . . . fortunately they were nearly always dry by the time he joined the game.'

Ray Joseph (who for years made a living by combining poker with selling badges in Leicester Square, but now spends his time in front of a computer, sports-betting) graduated from the LSE and stumbled upon En Passant: 'I remember vividly my first night there. There was Jake the Waiter, and Chris the Photographer, and Vile Oats and Big Bad John and Accordion John, and Maurice the Lawyer and Brian the Burglar, and I played all night and I loved it. As I walked home and the dawn was coming up, I could see my whole life before me – what else would I ever want to do but play poker at En Passant?'

Of course, there are other places you can play poker, in private homes, in the back rooms of gentlemen's bridge clubs, in spielers of one kind or another, but En Passant is the first generally recognized, open-to-all-comers London 'home' for the game and gradually it attracts some of the most experienced and skilful players. It's been described as the 'academy' of British poker; from it emerged the first players to make a living out of the game.

Ray Joseph is a big admirer of Boris Watson: 'He was an enormous man. I would say he weighed twenty stone; but not fat, kind of muscular. He commanded enormous respect with both the police and the gangsters. Everyone respected Boris. I'm not saying everyone liked him but everyone respected him. And, of course, he was a fantastic punter. He used to smoke one cigar a day for his health, an enormous cigar, and that would last him the day. And he would drink water from a half-gallon pitcher. He was always immaculately turned out, well manicured and hair done nicely. He was a bit like Minnesota Fats in *The Hustler* except he was the reverse in that his poker was a non-disciplined mess. However, he was a brilliant man to have in charge of the game

because it meant we were, as far as you could be in those days, trouble-free.'

Ted Isles was to be a dominant force in the London poker scene for some years. When En Passant eventually closes he transfers the game to his Covent garden flat, and then becomes an outstandingly effective host at the Vic and in other casino poker rooms. At En Passant he introduces player-friendly concepts like 'going-home money' for those who have lost the lot, and at casinos he proves a genial and imaginative promoter of the game. Unfortunately he had, while a policeman, become involved with an under-age girl and ended up in prison; when the gaming authorities later unearth this fact they take away his card room manager's licence, so he graduates (some would say, sinks) to running spielers including the Mazurka in Piccadilly, until he fades away and dies.

A third key figure at En Passant is Colin Kennedy, born outside Belfast and a former Cambridge student. Colin helps run the poker. Colin is one of a small number of chess players who move on to poker and will quietly make a living in cash games for more than forty years. Stewart Reuben is another who has lived comfortably from poker earnings over that time.

One player at En Passant is a journalist called Nic Szeremeta. Nic also plays in an 'informal' poker club near a greyhound track at this time. It caters to the bookmakers and their clientele when the racing ends. He's sitting there one night feeling good because he's holding three 10s, only to see two more 10s turn up in another player's hand ('I said I wasn't feeling well and left'). Nic plays at En Passant for about three years and will go on to become an outstanding and,

inevitably (poker being what it is), under-appreciated servant of the European game, and to run, as he does today, the invaluable poker magazine, *Poker Europa*.

Eventually there's a fire at En Passant and the building is declared unsafe. From then, right up to the present day, the real 'home' of London poker – in fact, British poker – has been, and is, the Vic.

When its poker room opens it's known as the Victoria Sporting Club, but it later becomes the Grosvenor Victoria (it's in the Edgware Road a short walk from Marble Arch). During the sixties it has a big card room on its top floor where the main game is seven-card stud, and it now becomes a legal and popular centre of poker, although, it should be stressed, the poker community is still a small one.

Over the years the Vic is challenged by and sees off a number of rivals.

There's the *Lyndhurst* in St John's Wood; it opens in the late sixties and has a chequered life, at one point getting raided by the police and being closed down because of illegal bookmaking activities.

There's the *Sportsman* in Tottenham Court Road. It opens a card room in the mid seventies but closes it a few years later, subsequently moving near to the Vic and reopening its card room towards the end of 2005.

There's the *Barracuda* in Baker Street. It has a card room in the late eighties and also for a time in the mid-nineties.

There's the *Gala* in Russell Square; it opens a card room in its basement (known to its habitués as the Dungeon) in the late nineties. It's closed now.

These places tend to open or close according to the casino managements' whims, or because at times there's not a big

enough poker community to sustain them, or because other casino games prove more lucrative. (This, of course, was before the poker boom.)

More recently the Vic has found itself facing stiffer competition: as well as the Sportman's reopened card room, *Palm Beach* has added poker to its casino activities. And then there's the *Gutshot Club*, a popular poker club in Clerkenwell, currently challenging the gambling laws (its 2006 court case was expected to become a cause célèbre in British gambling history). It's become hugely popular, especially with the young. Finally, there's the *Western*, created by a consortium of players in the Vic's big game, who became disillusioned with the Vic's management and decided to open their own place; it, too, is yet to prove it can outwit the gaming authorities and the police.

If there's a common thread running through most of these venues it's in the person of a cheerful, poker enthusiast called Roy Houghton. Roy is a dealer at the Vic in the early days and becomes its card room manager for a while, before being poached by the Barracuda and going on to advise or manage a number of other places. He eventually runs the Dungeon and then helps set up the Gutshot and has an outstanding reputation for poker room management, for integrity and for helping and encouraging younger players learning the game.

'From time to time the Vic regulars rebel and try these other casinos,' he says. 'For a while there's a big game at the Barracuda . . . probably the biggest game in the world at the time. It had a £10,000 sit-down, a fortune in those days. They play five-card strip deck – that's five-card stud with the 2s to the 6s taken out. The main difference is that a flush beats a full house because you've only got eight suited cards in the deck. There's a pot there once that got over £120,000.

That's in 1988, with Max Thomas the bookmaker . . . he's one of three players who all hit a good hand in the one pot and none of them believed the others had one.'

But, despite this rival activity, the Vic holds its own, its players always returning and its clientele growing. In the eighties it has to overcome a serious problem. Cheating. Stewart Reuben claims it became endemic, reaching 'epic proportions', with collusion between some dealers and some players, and card-marking.

Roy Houghton confirms this, recalling one incident: 'One of our experienced players, Derek Webb, came up to me and said, "There's something wrong with this game." Well, I have to be honest, I never took a lot of notice. A couple of days later he came up again and said, "Roy, there's definitely something going on," so the second time I couldn't ignore it. So I went to the security room where we had the cameras and put the camera on the game. I watched the game for a while and then I suddenly realized what was going on. There were two or three Greeks playing at the table and every so often they would touch the cards in a particular way. I said to security, "They're marking the cards." We went and took them out of the game. Sure enough, they had pads of wool in their ears which had white spirit on. They would dab the spirit in the cards and if you caught it under the light you could see where the card was marked. And the beauty of this particular marking is, two or three hours later, if someone asked you to check that pack there wouldn't be anything wrong with it at all because it would have evaporated. The guys were arrested and charged.'

Then in the early eighties the Vic card room is temporarily closed, its owners misguidedly believing it isn't profitable, and when it reopens after eighteen months the cheating

seems to have stopped. Just why it never recurs, it's difficult to say, but there have been no serious allegations since.

In the eighties the Vic hosts what becomes known as 'the big game'. Frequent players are Donnacha O'Dea and Tom Gibson who come over from Ireland especially for it, a Swede called Chris Bjorin, Stewart Reuben, Mansour Matloubi, who won the WSOP main event in 1990, and a character called Bruce Atkinson (who I last saw at the WSOP in Las Vegas dressed as Elvis Presley, of whom he has become a well-known, if bizarre, impersonator, and who is believed to have won the biggest sum ever in one game at the Vic, £99,000).

For some time the game is London lowball, a kind of seven-card stud in reverse in that you have to create a really bad hand – the nuts being 6, 4, 3, 2, ace. It has a big luck factor and leads to some wild betting. The game lasts for some years and is later joined by show business agent Peter Charlesworth, the Midlanders Surinder Sunar and David Moseley, an Iranian called Ali Sarkeshik, the up-and-coming cash game player Ben Roberts, and Eric Dalby. According to Peter Charlesworth, Dalby was one of the big winners at London lowball, on one night winning £63,000. Peter was himself one of the better players of this game, and is remembered for winning two other big pots of £20,000 and £26,000. As we've already noted, the Devilfish also came to try his hand at London lowball, but with little success. But probably the biggest loser in the game is a man known as Spanish Roy, believed to be down about £1 million.

The big game at the Vic becomes very big. Ray Joseph says, 'I would say, pound for pound and allowing for inflation, it's probably the biggest public game there's ever been in England. We're talking about six figures, regularly won or

lost.' (In fact, it has a competitor in the game played in the late nineties at a Birmingham spieler called Barry's.)

Speaking of spielers, away from the Vic and the other casino card rooms, these are the other homes for the game. *Spiel* is a German word meaning to 'play a game'. My dictionary, however, defines *spieler* as 'gambler, card sharp and swindler'. Mix all this up, and in Britain spieler comes to stand for an illegal poker club where you'll definitely meet gamblers and card sharps, but as for the swindlers . . . well, maybe, maybe not.

Usually spielers are in a basement. There will be a table and chairs, some wallpaper if you're lucky. There'll be cards and chips, possibly some food and drink, often a professional dealer, who has to be tipped, and, of course, the man or men running the place, making a table charge or raking the hands. The game will run all night, sometimes all day and night, sometimes for days. If all goes well, it will be peaceful and reasonably honest. If not . . . Well, Derek Baxter describes one experience: 'I went into one, and you used to meet all sorts of people – doctors, lawyers, policemen, they all used to use these places – and I'd never been in there before, but I'd heard there was a poker game so I sat in the game and it was about £5 to sit at the table. And I'd been playing for a few hours and won £25–£30 and all of a sudden some guy pulls a gun out and fires a shot into the ceiling. He says, "Nobody leaves the room until I get my money back." So I think, I'm getting out of here. I asked if he minded if I went to the toilet and he said fine, but to leave my money on the table. So I left the money on the table and just walked out and never went back there.'

Professional player John Gale remembers 'one place in

Camden Town, run by some men I thought were nice guys. It was a seven-card stud game and they were useless, they were absolutely hopeless, and I could have sat there all day for a year and taken them for a fortune. I was about £16,000 up and decided to leave and I was told in the clearest possible terms that I could leave but the money stayed there. Then I noticed some guns and knives and thought, Well, I'm not going to argue, but that was my last experience of that sort of place.'

Most of those who play in spielers go in with their eyes open and most can handle themselves. In fact, if you're going to be cheated or conned it can just as well happen in a 'set-up' game in a private house. One of the most notorious took place in north London. It involved David Moseley, a heavy-smoking, highly experienced player, well known both in the Midlands and London (albeit under more than one name, but we'll come to that later). Moseley is drawn into what he's promised will be a big game by someone he's entitled to trust, someone he's played with in the Midlands and London. Whether this man is fully aware of what Moseley's getting into, no one knows, but the winner in this game is a heavy-weight villain, and by the end of the night Moseley has lost a lot of money, some say £50,000, a substantial sum in those days, but others say as much as £250,000. It's assumed by everyone in poker that he's been cheated. Moseley then goes 'on tilt' and proceeds to lose a small fortune in a matter of weeks, wiping out a bankroll carefully built up over years of play. (He disappears to Ireland, plays in small games there and eventually comes back to London and the Vic, but is never the same man. He now lives in Spain.) What is chilling about this story is that even today no one will say out loud the name of the big winner in the game; I've been told the

story countless times (the above facts are beyond dispute, although whether Moseley was cheated can never be proven), but in each case the storyteller falls silent when it comes to the winner's name. The fears may be exaggerated but no one is taking any chances. Even gamblers have their limits.

Throughout most of the seventies, eighties and nineties, spielers thrive in London. A lot of them are ethnic. In North London there are the Greek and Cypriot spielers, in the South Kensington/Gloucester Road area the Polish ones. There are spielers in the East End and one in an Italian cafe in Brixton that runs for thirty years. There are also Jewish spielers in north London. There's one run by a couple of professional wrestlers in Earls Court and there's Black Alan's in Bayswater. And one, just round the corner from the Vic, called Costas, caters (I'm told it still does today) for those who want to play beyond the casinos' 4 a.m. closing time. Willie Tann used to deal there. In the West End there is a big but sleazy spieler called the Mazurka.

Some of the best-known names in British poker are at one time or another involved in the running of spielers; for instance, Bambos in Sussex Gardens (at a time when the Vic was temporarily closed) and Joe Beevers and Ram Vaswani in Hendon.

Colin Kennedy, who played in a lot of them, reckons there were about 100 spielers in London in the mid-sixties. 'When the theatres and bars shut, out come the tables and the poker begins.'

Nor are they only in London. In Birmingham a Chinese player called Stephen Au Yeung (the man who gave Devilfish his nickname) runs a spieler above a disco in Broad Street for nearly ten years. It opens up when the Rainbow Casino in the Hagley Road closes at 4 a.m. and Stephen takes 2.5 per

cent of the game, providing dealers, food, tea and coffee to some of the best-known names in British poker, including Derek Webb, Devilfish, Mickey 'the Worm' Wernick and Surinder Sunar. Later this spieler is replaced by Barry's, and this place in Bearwood, run by veteran poker player Derek Baxter, becomes the base for one of the biggest games in the country. Games would often last for a weekend, or even longer.

The London poker community, being typical of Londoners generally, tends to think the capital city is the capital of all things, including poker, but there are many in the Midlands who beg to differ. Many of the big winners in British poker – David Colclough, John Shipley, Mickey Wernick, Lucy Rokach, Derek Baxter, Derek Webb, David Mosley, Surinder Sunar, Paul Maxfield and others – come from the Midlands. Most of them cut their teeth at the Rainbow Casino in Birmingham or in other small Midlands card rooms. The Rainbow no longer has a poker room, but in its day they were all there. The Midlands was also well ahead of London when it came to tournament poker.

The other major centre of poker is Ireland, notably Dublin, its key personality figure being a flamboyant and abrasive bookmaker called Terry Rogers, a familiar figure in his dark pinstriped suit at race meetings in Ireland and England for decades. Says veteran Dublin poker player Frank Callaghan: 'When you got to know him he was a likeable man but it was hard to get to know him because he was always roaring and shouting and if you didn't know him you would be offended. If you think of the most abrasive man you could possibly meet you think of Terry Rogers.' Roy Houghton also says, 'When you first met him, you couldn't stand him, but the longer you knew him the more you came to love him. He was all right, was Terry.' One of his many idiosyncrasies is a

concern that he's about to be cheated. He even wears a jacket at the races with notes pinned all over it saying, 'This jacket has been stolen from Terry Rogers.'

In fact, Rogers is an extraordinarily generous man and raises a lot of money for charity. His friends are close friends. And he likes poker, although is reputedly not the best of players. He opens a place called the Eccentrics Club above his betting shop, and it's there that most of the well-known Irish poker stars – Donnacha O'Dea, Liam Flood, Tom Gibson, Padraig Parkinson and others – develop the skills that make them a big force in the international game.

Terry Rogers's biggest contribution to poker in Ireland and England is to import the game of Texas Hold'em, which is to become the best-known and most popular form of poker and will contribute to the poker boom. Rogers takes whole teams of Irish players to Las Vegas for the World Series and it's there that he sees the potential of Hold'em. He promotes poker tournaments and founds the Irish Open. It's not possible to exaggerate his influence on the game this side of the Atlantic, and perhaps his crowning moment was to see three Irishmen make the final table in the main event at the 1999 World Series, with a wealthy racehorse owner and carpet-manufacturer called Noel Furlong actually winning it and earning $1 million. By all accounts, Furlong is a wildly aggressive player, the opposite of his personality. He's in fact quite shy.

Another major figure in Irish Poker is Donnacha O'Dea's father, the actor Denis O'Dea, who is a central figure in a high-stakes game that takes place at the Gresham Hotel in Dublin.

There's a tendency in London to underestimate the standard of Irish poker. In fact, more players from Ireland have made the final table in the World Series main event than

from any country except the United States, and the Irish record in the World Series is generally better than England's.

♥ ♦ ♠ ♣

Throughout the 1990s the poker community in England and Northern Ireland remains relatively small. Most of the better players know each other and encounter each other across the table from time to time. Then comes *Late Night Poker*, followed by the other television programmes, and a whole generation of late-night television viewers decide they want to play this game too. But where? This is where the Internet comes in. Online poker rooms emerge and attract huge numbers of players.

Now the playing field changes. Up to now the relatively small number of professionals in British poker have either made money by playing each other, or by emptying the pockets of the fish who end up in their cash games. (The players who make a living out of poker call the obvious losers 'fish'; they say if you look round the table and can't identify the fish, it's you!) The playing field is the poker table in the card room. But now it becomes possible for people to sit in front of their computer and play others from all over the world via the Internet. And we're not talking about a few people. This is an explosion. In 2003 alone the industry grows six-fold. When Party Gaming, owners of the Party Poker site, announce in June 2005 that they're going to list on the London Stock Exchange, they claim their profits have gone from $30 million in 2002 to $601 million in 2004. Their 2005 results show a 95 per cent increase in revenue. By then they're hosting 70,000 simultaneous players.

At the beginning online poker is dominated by the American sites – PokerStars, UltimateBet.com, Paradise Poker, etc. –

but quickly the big British bookmakers, such as Ladbrokes, William Hill and Betfair, get into the action.

Ladbrokes says that by mid-2005, some 250,000 players have registered with them from 107 countries (USA excluded). Every day, over 30,000 people play poker online with Ladbrokes, up to 10,000 playing each other at one time. Its players increased 167 per cent between the first half of 2004 and the first half of 2005, and 60 per cent are under thirty years old. The average age of a Ladbrokes poker player is thirty-two. Peak time on the site is 10 p.m. to 12 a.m. GMT when Ladbrokes will deal upwards of 12,000 raked hands (games) per hour to over 8,000 simultaneous players. Overall, 700,000 hands (including tournament hands) will be dealt in a day – that's over eight hands every second, twenty-four hours a day. There will always be at least 500 people playing, even at the slowest time of the day, which is 9 a.m. GMT. Hand speed is now averaging forty-five seconds per hand. This is approximately three times as quick as the hand speed in a live poker card room and explains why online players learn so quickly.

William Hill comes on to the market more cautiously but by mid-2005 has 50,000 players on its books and one of the classier sites. By then Betfair has 60,000.

All three have online tournaments and send growing numbers of their winners to the World Series and other big international events.

The game also grows quickly in Continental Europe, beginning with the Concord Club in Vienna, and then a big Amsterdam tournament. The tournament scene spreads to Helsinki, Paris, Barcelona, Moscow and . . . Well, it goes on and on. If there is one place where it's become overwhelmingly popular, it's Sweden; indeed, when I went to Stockholm

recently I was surprised to find anyone on the streets, having assumed they were all at their computers playing poker.

Worldwide there are now many millions of players, confronting each other in cyberspace, across oceans and international boundaries, twenty-four hours a day, and, as the online sites compete with each for players, the clientele benefits from a wide variety of incentives and, above all, the opportunities to play in satellites for the big live events.

An untold number of young players are now making a living at poker, or at least supplementing their income. Some play for long periods. When I was playing cash games on the Internet (rather than the tournaments I play today), I often clocked off at midnight and returned to the site at 9 a.m. the following morning to find two or three of the players still in the same game.

Who are they? Many are, as Ladbrokes testify, in their late twenties or thirties. Before this craze they would have been in the professions, maybe working in the City, or in some form of finance. Now they have a lifestyle unique to the poker generation. Typical is twenty-seven-year-old Phil Shaw, who, having earned an English degree at Oxford, worked with Nic Szeremeta on *Poker Europa* for a couple of years. Phil describes himself as a semi-professional player. By this he means that as well as singing and playing the guitar in a band, and writing, and watching television and following sport and generally doing what twenty-seven-year-olds do, he earns over $100,000 a year playing no-limit Hold'em on three or four sites at the same time for twenty to thirty hours a week. Phil has about $40,000 sitting in accounts with Pokerstars, Party Poker, Paradise Poker, UltimateBet and Full Tilt, preferring the American sites because he says there are more Americans playing and they're not as good as the players you can contest

pots with on the UK sites. He coordinates the funds via an online payment service. But the point is this: Phil has no doubt whatsoever that he will hit his $100,000 target every year doing what he likes doing. This gives him enormous freedom in other aspects of his life. After all, if you start the year with $100,000 guaranteed from your hobby, you can be choosy about what you do with the rest of your time.

Whether Phil is typical is another matter. He appears to have it in proper perspective. Also, he's a winner. They can't all be; if Phil is going to win $100,000 a year, someone has to be losing $100,000 a year.

In addition to the Phil Shaws of this world, and the big Internet professionals like Paul 'Action Jack' Jackson who we'll meet later in this book, many of the established card room professionals, people like World Series final table players John Shipley and Julian Gardner, are increasingly preferring to stay at home, kick off their shoes and make prodigious sums of money on the Internet, rather than fighting their way round an increasingly competitive tournament circuit or playing in cash games night after night in the Vic and other places.

Apart from the promotion of the game on television and the opportunities provided by the Internet, the biggest influence on the game has been the arrival of tournament poker. There are probably fewer than a dozen nights in the year when you cannot go somewhere in England and play in a major tournament; the smaller ones create the opportunity to meet other players and contribute to the building up of a healthy poker community and the bigger ones can make you seriously rich. There are now major festivals of poker all over Europe.

♥ ♦ ♠ ♣

Now, while all this has been happening, what's been going on at the Vic? Well, in a way it hasn't changed that much. It's still a noisy and colourful place where you can go any evening and play poker. You can still see Colin Kennedy and Stewart Reuben and the rest . . . players you would have seen in En Passant over forty years ago. But some things have changed: the games are now exclusively Texas Hold'em and Omaha and the stakes are not as high as for the 'big game' of the past; the waiting time before you can get on a table has grown as the place becomes packed by mid-evening; and more of the players at these tables are making a living at the game than you would think. This is where the Vic can be a trap: everyone looks the same, but everyone most definitely is not.

Imagine you turn up at the Vic and in all innocence sit down at the £100 buy-in Hold'em table. That elderly man in seat one is, to borrow a House of Commons term, the 'father of the house'. This is Michael Arnold. Michael has been playing at the Vic longer than anyone can remember. He loves the game and, even in his seventies, remains a student of it. He wanders in every evening and slumps into his favourite spot, next to the dealer, places an impressive stack of £100 chips in front of him and, shortly after play begins, falls asleep. But don't be fooled. He can follow the game while fast asleep. It's uncanny. When the dealer nudges him, he wakes, glances at his cards and either throws them in, or barks, 'Pot', thus matching all the money in the middle, and forcing everybody else to do the same or fold. I can't begin to recall the number of times I've inwardly groaned, having limped in with a speculative drawing hand, desperately hoping to see a cheap flop, only to hear that word 'Pot' and know the hand has become a hopeless case.

Michael is famous for his dislike of playing with an empty chair at the table. 'One seat *here!*' he shouts at the floor manager. Many of the older Vic hands have learned to mimic his tone of voice, and thus the cry 'One seat *here!*' from any and every table has become a familiar one to all who play there.

Beware of Michael. He may look old. He may be asleep, or appear to be asleep, some of the time. He may not be a full-time pro. But he takes a considerable sum of money out of the Vic – most nights.

To Michael's left, in seat two, is a man half his age. This is Neil 'Bad Beat' Channing. Neil plays regularly at this table; it gives him a fair-sized chunk of his living. And if you're not careful, you'll be that living, because Neil may be chatty, good-humoured, friendly, but he's also sizing you up, looking for signs of inexperience, waiting to pounce on the one mistake you make. He plays it cool but he's thinking, watching all the time, and constantly doing little things, making little raises, that look ill-considered but are all part of a plot, with you as its intended victim.

Listen to Neil talking about the Vic:

'It's an unusual casino because you get a lot of passing trade. I mean, I play in the £100 Hold'em game and there's people that you see in that game that you've never seen before. And they tend to be the source of the wages of the professionals and on any given night there will be at least two full-time pros earning about £60,000 a year in that game. It's easily the toughest to win in, yes, absolutely. But the interesting thing about the Vic is, if you play in provincial casinos the average standard of player is far, far worse than it is in the Vic, but to make a living in those games is harder, because often the games are based around tournaments. They

start about eight o'clock and people don't get knocked out much before half ten. And the cash game starts around eleven when a few people who have been knocked out want to play. This doesn't give you enough time to make a decent living. Whereas if you come to London and play the Victoria you know there's always going to be a game. You can come in at four o'clock and there will be a game and you stay until four in the morning and people have got money. You get some Arabs and Chinese and they don't care; they've got so much money it doesn't matter to them. That naturally attracts the pros. If you're a professional poker player and you need to pay the mortgage, you need to play in a game where you can win enough to sustain a lifestyle. You need the game to be regular and there to be enough money in it and enough bad players. The good players are attracted by the bad players so there's a combination of some really bad, really rich players and some of the best players in the world.'

Notice the reference to 'passing trade' and the earning of 'wages'. Neil may be fun but he's not there for fun.

Let's assume you're next to Neil in seat three . . . The attractive thirty year old in seat four, the one who slips out for a ciggie every few minutes and is clearly a close friend of Neil's, is the Vic's sweetheart, Vicky Coren. She's a journalist, poker commentator, runs a game of her own at home, has been playing with the grown-ups at the Vic since she was a kid, convincing them she was over eighteen, and is to be underestimated at your peril. Vicky is a romantic about poker – if she had her way we'd all be back in smoke-filled rooms, a glass of whisky in hand, leaving our guns at the door. But Vicky is a semi-pro, a winning cash game player and she makes a profit and it could easily be from you.

Next to Vicky in seat five is a neatly dressed, courteous

man you vaguely recognize. That's because he's appeared on *Late Night Poker*. He's one of the most experienced professionals in the business. This is Bambos and you shouldn't really be playing with him.

Nor the guy in seat six. This is Stuart Nash. He's nearly always there. Recognize the name? Can't remember where you saw it? Look at your latest copy of *Poker Europa* – he's currently right up there, in the top six in the European rankings. You shouldn't be playing with him, either.

Seat seven is a big, cheerful, funny guy called Dave Binstock, great to play with. I like to think of Dave as the Vic's shop steward. He's always taking up an issue with the management; if it isn't the air conditioning it's some other problem. Dave is a financial advisor and he's been playing most nights for twenty-five years or so and more than holds his own.

Seat eight – the white-haired guy? That's Fred Carle. Big winner at the game, shrewd as they come. And a lovely man – as Dave says, he 'takes the wins and the beats with the same grace'. If you have to lose to someone, better Fred than many others. Just as well, because you *will* lose to him.

Seat nine – if you're unlucky it could be the legendary Willie Tann. In which case, leave now, because with him, Bambos and Stuart at the table you're in serious trouble.

But it could also be one of forty or more players who make their living at the game. Then again, it could just possibly be a no-hoper who has stumbled into this trap. This could be the fish (assuming, of course, that it's not you). If so, notice how welcome he's made. Notice how, if he wins a hand, everyone warmly congratulates him. 'Nice hand.' 'Well played.' Notice the unstated conspiracy to keep him there until the flesh is taken from his bones.

Now the point is this: when you walk into the Vic you probably don't know any of these players. It just looks like a game of poker. It's relaxed, it's friendly, and, if it soon becomes clear you're out of your depth, it becomes extremely friendly. These guys want you to enjoy losing. They want you back. But be in no doubt: you're playing in a tough school. One of the toughest in the world.

Nor does it get any easier at the lower-stakes tables. That bunch of elderly guys you often see dealing their own hands may look a piece of cake but they've been playing in the Vic since before you were born. They may be there because they haven't got anywhere else to go, but that doesn't mean they haven't learned how to avoid defeat. They have no intention of giving you their money. As Vicky Coren says, 'Some of those old men who look like they have no other home are quietly making £100,000 a year. It's just that they don't make a big song and dance about it. They don't play tournaments, they don't get sponsorship, they don't go on TV, but they're quietly making a helluva lot of money.'

It is no coincidence that three of Britain's biggest successes at the 2005 World Series of Poker, Jeff Duvall, John Gale and Willie Tann, have all been playing at the Vic for years.

None of this is to turn you away from Vic. It's fun. And it's well run. Go there and play. But within your limits and choose your table with care, because it's testing. If you're going to make it in world poker, you've got to make it at the Vic – in the words of the song, 'If you can make it there, you can make it anywhere.'

So the Vic goes on, both a home for many would-be or seasoned professionals and a centre of British poker, but increasingly supported, even challenged, by a national infrastructure as the casino chains, like Grosvenor (owners of

the Vic) and Stanley, cotton on to the poker explosion and provide facilities and promote events all over the country. There's a mini circuit, including Luton, Walsall, Brighton and many other towns, providing endless opportunities to play competitively at buy-ins everyone can afford. Even the higher buy-in major tournaments, including the EPT ones, now have a choice of major venues throughout Europe.

As for the players in these top-level tournaments, for day to day performance and consistent earning on the tournament circuit, we can still look to the old-school players, the guys who were around throughout the nineties in the Midlands, in Dublin and at the Vic. They're still doing the business. Look at the European rankings at the end of 2005 and they're nearly all there.

But that does not mean they're actually *winning* the tournaments. Like those commercially minded middle-rank American golfers on the PGA tour, they're consistently earning a living, they're there on the money list, but the events are increasingly being actually won by players who appear to have come from nowhere. In fact, they've come from cyberspace. It's partly a question of numbers: the odds on winning have lengthened because there are so many players. It's partly a question of style: some of the younger players are ultra-aggressive; they don't have families, they don't know or care about the value of money, they are fearless – and that makes them dangerous. And it's partly because they've gained in a short time the playing experience the old school have accumulated over twenty or more years. Also, they've had access to a huge number of newly published 'How to' books by the top players, and all sorts of other educational aids.

The fact is, the tournament scene is now too competitive to guarantee you'll meet the mortgage; if you want to make a

living day to day, it has to be in the cash games. Fortunately for the old-school players, on the whole the younger generation are playing the tournaments live but remaining on the Internet for cash games. The young Swedes may invade Barcelona or London in packs for the tournaments, but they stay at home to play cash. So those from the old school who can't or don't want to play on the Internet (and, of course, many do) are still able to either make a living or support a tournament career from the live card room cash games in places like the Vic. But this may all change.

What is stunning is not that the poker world has moved on, but that it's moved on at such speed. Little may have changed in poker from the early sixties to the late nineties, but in the first five years of this twenty-first century it's changed beyond recognition. Even the promoters are having difficulty keeping up with it. Go to any major tournament in Europe and you'll find them struggling to cope with unexpectedly big fields, their card rooms overflowing, their resources severely taxed.

The position is not helped by gambling laws in Britain that are totally out of touch with the growth in popularity of the game. It's crazy that the authorities cannot check the explosion of poker on the Internet, where it's at least arguable that there are real problems of addiction, etc., while poker clubs, where the game could continue to be properly regulated and run, and where tournament poker could take place without harm to anyone, remain illegal. The prosecution of the Gutshot Club may be technically justified but it is a petty and unnecessary attack on a respectable, well-run place that is hugely in demand. All over the country there's a need for American-style poker clubs to cater to those who would like to play in live tournaments. This should be recognized, either

by a change in the law, or by not enforcing one that is clearly now irrelevant and even damaging.

This, then, is the history and background to the world of British professional poker I am about to enter, spending time with the pros as they play the European circuit and plan their annual assault on Las Vegas and the World Series. When it comes to the circuit, with all its costs in buy-ins, travel, accommodation, subsistence, etc., the British contingent of regulars is still a manageable number. Gradually, as I travel from London to Barcelona to Paris to Las Vegas and to other playing fields, I come to recognize their faces, get to know them, hear their extraordinary stories. I call the ones I see most frequently 'the Usual Suspects'. Come with me and meet them. Because, as they say, it's time to shuffle up and deal.

7 / Looking for Barry's . . . a journey to the Midlands

I'm left sitting alone at the table. Big Loser. I want to keep playing and they all quit me. I guess that's the only end for this nightmare. I feel like I'm dead in the chair.

Jesse May, *Shut Up and Deal*

Given the glamour of the international circuit, the Midlands may seem a strange place to start, but a surprising number of the Usual Suspects live in the Midlands, and I'm wondering why. Also, I've become intrigued by the legendary spieler called Barry's. I've heard many stories about it and I want to know what really happened there.

So I drive up the crowded and ugly M1 and make my way across Birmingham city centre, past Edgbaston cricket ground and on to the leafy district of Moseley. This is where Dave 'El Blondie' Colclough lives, under Great Sensations, a lap-dancing club he once part-owned until it caused him more trouble than it was worth.

I'm met at the door by a young woman in white (and tight) T-shirt and shorts, who turns out to be Dave's twenty-five-year-old wife Rhowena. She takes me to a huge L-shaped lounge with an equally huge television set. On the way I'm shown the fully equipped gymnasium, the sauna and a study

with computers and a full-size poker table. In addition to their own high-ceilinged en suite bedroom, there's a separate wing with two more suites. This does not come cheap; clearly Dave's a winner.

'El Blondie' is tall, slim, ascetic-looking, friendly, laid-back. Barny Boatman has described him to me as 'one of the most talented tournament players in the world . . . highly intelligent . . . a good thinker on the game . . . and honest.' I also know that he once threw away the chance of a World Series gold bracelet. How could he have done that?

♥ ♦ ♠ ♣

DAVE'S STORY

'I didn't know any better. Actually, that was the most eventful day I've ever experienced at poker, and, because of the gold bracelet, the one I most regret.'

Dave 'El Blondie' Colclough is thinking back to 2003 and Las Vegas.

'I'm in Vegas to play cash games, really. But I couldn't find a game on this particular day so I decide to play a gold bracelet tournament about three minutes before the start of it.

'I arrive at the final table in about fifth or sixth place and I decide I'm going to play aggressive because at that time most people played too tight. And it works, but it just happens that I end up picking on Phil Hellmuth.' (Hellmuth is a prolific WSOP gold bracelet winner and the game's self-titled 'super brat' . . . a poker equivalent of John McEnroe in his younger days.)

'It isn't out of choice, and I don't get there with a strategy to pick on him, but he raises and I repeatedly look down

and find what I call a marginal hand, like a pair of 8s, and I move in all over the top of him because I think that he's super tight and he won't want to get knocked out. I do this three times on Phil and he doesn't like that and he starts having a go at me. Eventually we play a six-hander where I trap him in a pot where I have a pair of 9s and, because he's got the needle with me, he calls a small raise before the flop. Anyway, he flops one pair and then he turns it into two pairs, but I make a set of 9s on the river. So I knock him out and he loses his rag and accuses me of being super-lucky and he screams and stamps his feet and runs round in a circle and it's like one of the most embarrassing things I've ever seen at a poker table.

'Anyway, my aggressive style is working and I'm chip leader from the point I knock Phil out, and all the way now I have complete control of the table. When we get three-handed I've probably got 55–60 per cent of the chips and the other two guys have got 40 per cent between the two of them, and then they stop playing and say, 'Let's make a deal.' Because they see me as the winner they offer me half way between first and second prize. I think it is a good deal . . . that they've made a bad deal for themselves because we're still three-handed and I can still finish third. I think the money is too good to say no, so I say yes, and we chop up the money there and then. We do it at the table and the tournament director is there and says we can't include the bracelet in the deal. So we play on for the bracelet, but at the time I have no idea the esteem the bracelet is held in, so, as soon as the money is out of the equation, I relax. They, on the other hand, are now no longer uptight. When I'm raising and reraising, they don't care any more, so they're calling the bets. All the pressure is off; I let my advantage slip and then

go altogether, and I end up not winning and missing out on the bracelet.'

Did he now wish he had refused the deal and fought to the end?

'Well, the deal made sense, but I do wish I had fought on to win the bracelet because I think my chance of a gold bracelet now may have gone. It's become a lot more competitive since then and a lot more difficult to win.'

Dave, who is now forty-one, was born in Carmarthen in South Wales and has lived in the Midlands and Wales ever since. He started playing cards when he was a kid. 'My dad had two brothers and all three families had two children and every Saturday we would go over to my grandma and grandad's in Stoke-on-Trent and somehow we'd get twelve or fourteen people into a two-up-two-down terrace house. God knows how we did it . . . it really was tiny. It was always the same routine: Saturday lunch with meat and potato pie and in the afternoon the men would play various card games for pennies, such as Crazy Eights and Slipper Ace. They first allowed me to play when I was seven or eight. That's when it all started. Then, years later, after college and after I began working in IT, I found myself at the Rubicon Casino in Northampton. I walked into the poker room and there were at least eighty people in there. I was amazed how much fun you could have for ten quid. That really got me into poker.'

It's time to cut to the chase: 'So you played at Barry's?'

'I was one of the mainstays in Barry's circle, yes. I was there every weekend for about three or four years, from the day it opened until the day it more or less closed . . . around 1997 to 2000. By then I was playing quite a lot of poker but only cash poker and I had become a bit of an Omaha specialist, but especially six-card Omaha.

'Because I played it more aggressively than the others, I think they initially thought I was the fish in the game, but if I wasn't the biggest winner, I was the second biggest winner at Barry's over the years.'

'Was Barry's legal?'

'Technically, no, and it did get raided. Barry didn't take a rake from the game, he took an hourly charge. Now obviously that was a table charge but Barry would say it was a service charge for teas and coffees – that's the legal argument.

'People like Paul Maxfield and Lucy Rokach came occasionally, and Devilfish, but the stalwart regulars were people like myself, John Shipley, and Derek Baxter, who helped run the game. And Mickey Wernick (Mickey 'the Worm'). And also a local builder and developer who was probably the biggest loser in the game – you could say the game was built around him.

'We used to start the game up at two o'clock on Saturday afternoon and stop Monday morning; in fact, sometimes we'd start Friday night and the game would run all day and all night till Monday. There was a television set so we could keep an eye on the football or the racing and there was a pool table and a backgammon table and plenty of food. On Saturday we would have a big fry-up and sometimes on Sunday a proper Sunday roast – pork or lamb.'

'Was it a hard, unrelenting sort of game – or was it fun?'

'Well, I enjoyed it – but I won. Nowadays I don't play cash games as much, partly because of Barry's. I saw a lot of people get hurt in that game and I think now I've changed. I really enjoyed playing there and John Shipley did, but there were several people like 'the Builder' who lost an awful lot of money. He must have lost at least £1 million in the game over the years – probably more.

'I must have made £300K–£400K out of the game and I think John Shipley won more than that. Probably the most consistent winners were Barry and Derek Baxter, because they organized the game between them and must have earned a fortune in house fees.

'They were huge games and there were two or three times when they got completely out of hand. The game might start Friday night and everyone would sit down with £200–£500 in front of them. Anyone who lost £500 would buy in for another £500 and you weren't allowed to take money off the table unless you left. So come Sunday night we've got all this accumulation of £500 buy-ins and typically on a Sunday night people would be sitting with £10K to £20K in front of them. And on a couple of occasions it got really silly. I can remember somebody was sat there with £75K in front of him and he lost £68K of it and left only winning £7K. But games like that were rare – a typical Sunday night there would be £100K in total on the table.'

Since 2000 Dave has won close to 100 tournaments, with winnings around $1.5 million. In 2003 he was voted European Player of the Year, having broken the record for the number of final tables reached in ranking tournaments. He also reached two final tables in the World Series in Las Vegas that year. In 2004 he won the £100,000 first prize in the main event – no limit Hold'em – at the European Championships. He's now a regular player in the big television tournaments. So, what's the key?

'There's two different ways to win. You can sit there and play very, very tight and only put your money in when you've an 80 per cent chance, but I play a lot of 55–45 pots where tighter players would take no risks. The way I look at it, if I play in more pots then I'm reducing the ups and downs

of the game, becoming less dependent on any one pot. I'll put my chips in on anything better then 50–50 but there's a lot of people who will only go on 75–25.

'I always try to give some thought to what I'm playing and who I'm playing and the best way to win. The difference between winning and losing is probably as simple as that. I mean, tonight I'm playing in a one-table tournament and I've got a very deliberate strategy.'

Dave was due to play in a televised Poker Den game that night.

'Now, the problem with the game tonight is it has a very fast structure so I know if I just sit there and play tight it could turn into a crap shoot with just a few key hands after an hour or so. So my strategy to avoid that is to loosen the game up early. So I'm going to try to play one or two aggressive hands in the first ten minutes or so just to try and loosen the whole table up. Hopefully I'll win those few hands but if I don't at least I'll get the rest of them playing a bit looser. If the play is a bit looser then hopefully we'll lose one or two players early and that means it won't turn into a crap shoot because there's more chips between less players as the blinds go up.'

Poker, he says, is all about putting people under pressure. 'There's more than one way to win a pot. First of all, you can have the best hand. The second way is to make the other person pass if you've got the worst hand. So by playing aggressively you constantly put pressure on and cause them to make mistakes. The problem with someone who sits tight and only plays one hand an hour is that they're obviously not bluffing. But the problem when you're playing with someone a lot more aggressive like myself is that you never

have a clue whether I've got it or not; I'm constantly trying to put you under pressure and force you to make a decision.'

Now 'El Blondie' has to drive to London for that night's televised game. I head out of Birmingham in search of Solihull. And John Shipley. I drive down a narrow grassy lane to find him standing outside a mysterious-looking L-shaped house, protected by trees and on the bank of a canal. This is where he lives with his seventeen-year-old son John Jay.

JOHN'S STORY

John Shipley wakes up in his Las Vegas hotel on the final Saturday of the 2002 World Series of Poker believing he's just a few hours from having the world at his feet. He's about to conquer Everest . . . win an Olympic gold medal . . . the British Open . . . the Wimbledon Singles final. Or poker's equivalent. Because he's entering the last day of the $10,000 buy-in 'main event' of the World Series on the final table – and with a huge lead, having amassed over two million chips, roughly the same as all the other final table players combined. He can almost feel the coveted gold bracelet around his wrist.

He's not exactly refreshed, because they've played into the early hours, but he's slept reasonably well. And he's not exactly relaxed . . . well, who would be? But nor is he excessively nervous; he knows he only has to play sensibly – avoid any unnecessary confrontations, let the others eliminate each other – and the world title and the gold bracelet and the $2 million are his.

But when he gets to the card room in Binion's Horseshoe it all begins to fall apart. It's not one big thing that gets to

him . . . it's lots of little things. First, he's been told the start will be twelve noon, but turns up to find it's actually one o'clock. He would have given a lot for that extra hour's sleep. He's then pitched into a series of television interviews that don't go particularly well (John is a shy man and not used to this exposure), and then finds himself standing around for nearly forty-five minutes with the others before being called into the arena and introduced to the crowd.

Despite being irritated by all this, he tries to keep his cool. But the organizers have one more surprise up their sleeve: they announce that the dealer for the final table will be the oldest dealer in Las Vegas. They no doubt mean well. It's a kindly gesture, as well as good PR. Everyone applauds. But it doesn't work out. The old man is past it. He can't even count the chips.

After a couple of hands John Shipley, a normally self-effacing man, the last player to make a fuss, especially in public, has to insist that the dealer be replaced.

By the time this is sorted out, his nerves are frayed, and from then on his final – what was to be the big day of his life – becomes a nightmare.

'I've played really well for four days, had a sort of game plan, stuck to it and it's all gone well. I got extremely lucky in one hand with Phil Ivey, I think it's on day two, where he was 50–1 to win the hand. I get four aces – the odds on that are just amazing – so I get as lucky as anyone can get and I'm still there. I haven't squandered it, I'm playing really well. On the fourth day, I've got moved to this seat and there's two players who are being very aggressive so I want to stop them. There's been a hand, they've raised, I've reraised, they've passed. Somebody has come and spoken to one of these guys – this shouldn't happen, but it happened – and I've heard the

conversation, and the guy that's playing has been told he's not betting big enough. So the very next hand he puts a big raise in before the flop. Now I'm pretty sure he's just raising to pick up what's there, so I reraise. As it happens, I have a pair of 8s. Now we are two of the chip leaders, and because I've reraised him, all of a sudden this is a huge, huge pot. There's 450,000 in the pot before the flop. But he still calls me; as it happens his hand is jack-9 so he shouldn't call, but his head's gone or whatever and he's called. I guess you'd say I shouldn't be raising but I raise him and the flop comes down jack-high, but it comes down three clubs. I've got the flush draw, tricky, but because there's so much money in the middle, I feel compelled to continue with the hand and I end up hitting the flush and winning the hand. I go from one of the chip leaders to doubling up and in a very strong position. I end up knocking out a couple of the other players and go to the final day with 2 million chips.

'Then I have all this hassle on the last day, with the delays and the TV people and whatever, ending up with the dealer. He is an old man. They've dug him up just for the TV. So we're dealing the first hand and he can't count the chips. He's hopeless. We're playing for this huge amount of money, first place is $2 million, and they give us a dealer who can't deal. I ask for a change – I don't want to play with this dealer. Now, I'm the sort of person who never complains and just gets on with it. I've never had a penalty at the table, no one's ever heard me use bad language. But I am getting annoyed because the tournament's been run so well all the way through and now all of a sudden at the final table, because the TV cameras have come in, the players don't seem to matter. I guess with a bit of nerves or whatever I get annoyed. I get wound up, which isn't like me, but this time it happens.

'So the game goes on but I'm not playing well. I also haven't had any cards at the final table. It just isn't going right for me at all. The people with the small stacks keep doubling up so the game goes on for several hours.

'Now, everyone believes the key hand is the one that comes later – with ace-jack – but that isn't the key hand, the key hand happens well before that. The very first hand that is played, Robert Varkonyi has a pair of 9s and raises. Julian Gardner, who is also on the final table, has a pair of aces and reraises. Varkonyi, he calls and goes down from having a healthy stack to having, I think, 250,000, if not less, so he's crippled. My big mistake is the first hand I double him up. I never have to get involved in this hand. I make a number of mistakes at this point, getting involved and doubling players up where I don't need to. This is where the real damage is done. This, not the ace-jack decision, is what blows it for me.'

By now John's supporters are getting worried. They can see he's not the same player he's been on the opening four days and now, to their horror, they see him make another mistake, one that has become legendary in British poker circles – what has become known as the 'ace-jack disaster'.

Varkonyi opens the betting on a hand with 60,000 chips and John reraises with a further 90,000. Varkonyi responds by going all-in with 750,000. John has ace-jack in the pocket, just not a good enough hand to play with so much at stake. But he thinks, and then – to the dismay of his supporters – he calls. Varkonyi turns over a pair of jacks. No ace follows to pair John's pocket one and Varkonyi picks up 2 million. In a matter of seconds John goes from being leader to one of the lowest stacks.

It is a call he didn't need to make, a mistake that, when

you consider what was at stake – $2 million, the title of World Series champion – was of monumental proportions.

His British supporters in the crowd are stunned. Paul Maxfield, who is one of them, says, 'It's heartbreaking. He's done so well for all these days, hours and hours and hours of poker, and we all think we're there to see him win and then you can see that it's all going wrong and there isn't a thing you can do. I just sit there feeling sick inside.'

Julian Gardner, sitting close to John at the final table, is 'gutted. Apart from being a friend of mine, we've actually swapped a percentage with each other. So obviously I'm rooting for him. I'm not going to win it and I would love him to win it. Actually, I don't share the opinion of a lot of others, many of whom were not even there. I don't think he does fall apart . . . it's just one big hand and one mistake. If he'd lost a few pots but won the big pot and gone on to win the tournament then everyone would have said, "Well, he was just trying to run over the table and after a few hiccups he got going." So it wasn't like I'm sitting there for two hours watching a guy crumble. To be honest, I think he held himself together well and then he just crashed in a second. He made one bad decision. I just think it was a bad decision, and you can understand why it happened because, like most players, when it starts to go wrong, which it was – instead of gathering chips, he was losing chips – you get frustrated and it can lead you to make a bad decision and that's all he did. One bad decision. I'm shocked, but I've seen far worse decisions made at poker tournaments.'

John, too, still argues it isn't as black and white as his critics – and there are many of them – make out.

'The real mistake was the very first hand when I let him

double up. The ace-jack was a mistake, but not huge. The huge mistake was the very first one. I had got rattled, I had let it all get to me, and I wasn't on my game.

'But I do play properly after. I have played badly but I do regroup and I do give myself a chance. The hand I ultimately get knocked out on I have a pair of 7s against his ace-10. He raises, I reraise. He could pass the ace-10 but he plays it. By then he's big chips, I'm small chips. I think there's still 700,000 in the pot so if I win with a pair of 7s against the ace-10 I'm back with 700,000 and I'm in the game. Instead he gets an ace and I'm out in seventh place.'

Robert Varkonyi is sympathetic to John. 'I remember one of those early hands. I had a very small stack where I had queen-king and I flopped a pair and he had 6-7 suited. I checked, he put me all in and I called, and to be fair to John, the television commentator said it was a good move by him to try and knock me out of the pot. So I don't believe John should be criticizing himself for that, although in retrospect it may seem a mistake. The hand he's most criticized for, the ace-jack hand, was not unreasonable if he was reading me as being very aggressive. And it did look like I was positional betting. But when you get two big stacks you want to avoid confrontation, so when the first big stack goes all in the other one usually has to lay it down unless they have aces or kings. It's just not necessary to risk your stack . . . you really don't want to take a coin flip in this situation when you have lots of chips. For this reason I was horrified when he called me; I thought he must have aces, kings or queens. I think the real mistake, and it's an error that all of us make, is that he misread and he probably speculated on me having a smaller holding. He probably misread me as being over-aggressive. But don't forget, even then he still had a 30 per cent chance

of winning the hand and I could easily have been knocked out there and then.'

John doesn't recover and is soon out, completely devastated. In addition to his $120,000 for seventh place, he has a 5 per cent deal with Julian Gardner who comes second and wins $1,100,000. So John ends up with over $170,000 in all. But it's no consolation.

'Everyone's interviewing the winner so I've ended up just drifting off. I'm completely shell-shocked. I go to the Bellagio to sort out the money with Julian and they're all having a party with champagne. Obviously I'm not celebrating; I'm the guy who blew it. I'm basically climbing the walls. I go back to my room and sleep for an hour and then I wake up and I begin to pace up and down the room. I can't stop myself. I've woken up going, "No . . . no . . . no . . . no . . . no." I can't stop myself. "No . . . no . . . no . . . no . . ." I keep going over every single hand from beginning to end. I can't stop myself. On the plane I see a friend of mine, travelling back with his wife. I can see the look on his face – it's saying, "You blew it there." I'm dying. I'm absolutely dying. I'm on the plane and can't stop myself. I'm going through every single hand. I get home, the same thing . . . a couple of hours sleep, then pacing up and down, going over it in my head. The next day slightly less, the next day slightly less, still doing it. A week later I'm still doing it but gradually getting less and less. I don't know exactly how long it is after I get back, but Dave Colclough phones me up. A few of them are involved in a bar, they're going down to the bar: "Come down and have a drink." Now I'm going over every single hand with them. They're bored to death, all getting drunk, but I can't stop myself.

'There comes a point when it does stop but it really is

something you wouldn't want your worst enemy to go through.'

It wasn't helped by the fact that many in British poker who have never got near a final table at the World Series took it upon themselves to criticize his play. As Barny Boatman says, 'You would think it was their money . . . and most of the criticism was unfair. I watched him through the days when he built up that chip lead and he had to do some incredible things to get those chips. On the day of the final, the biggest day in his life, nothing went right for him, he lost the even shots whenever he raised Robert Varkonyi, then everything that could go wrong went wrong. He made one decision that, in the cold light of day, possibly wasn't a great decision but it was an entirely understandable decision that I might have also made. Varkonyi had come over the top of him quite a few times. If you ignored all that went before, it was far too risky a call to make, but if you'd watched all that went before it was really understandable that he decided to make a stand with this hand, and it was the hand that lost him the World Series, basically. One of the reasons I felt for him so strongly was because something similar happened to me in the World Series in 2000, where I was going really well and was well placed and made one bad decision in one very big pot and that's all anybody ever talked about or remembered. I got a lot of criticism . . . and you don't need it.'

Still, it's a moment John will live with all of his life.

I decide John has probably had more than enough of it for today. So I change the subject to greyhound racing – because there was a time when John was the most famous greyhound punter in the UK, feared by bookies from one end of the country to another.

'I'm born into gambling, in 1960, because my father's a

bookmaker. He shows me how to tic-tac and while I'm at college I work at nights at the greyhounds. That leads me into backing dogs and I do that for a living for about twelve years. I think the biggest bet I had was £20,000 on one greyhound. This was 1990. At the time this was a very big bet. There was an article about it in the *Racing Post*. That one *does* win – at 2–1.

'I have ups and downs. I sometimes get it wrong and go broke. My biggest win is not on the dogs. When I get to about twenty-five I decide I want to buy property. I decide to have a big bet to earn the money and buy a house. I watch the football and decide there is a really big difference between the first and second division. I follow the season and decide to back one of the teams that goes down to the second division . . . back them to win that division the year after they go down. Because of the difference between the two divisions, this has to be a good bet. I'm watching the season very closely and Norwich lose their last five games, so Norwich go down. I decide to back Norwich. So I've got this £5,000 that I want to have on. The odds are 9–1 that they'll win the second division. I can't get all my money on at this price but I'm reasonably happy. The season starts, Norwich are playing really well but keep drawing and Portsmouth are winning so the price drifts to 16–1. So the money I didn't get on at first, I get on at 16–1 so I've now got a really good bet going that Norwich win the league. They win the next ten games. At Christmas they're 6–4 favourites and they carry on and win very easily, and I win £55,000. In the late eighties, £55,000 was a lot of money. I buy this house just before the price boom for £92,000. I put £42,000 down and get a mortgage for £50,000 and I've owned it almost twenty years.

'I'm now finding it really hard to get a bookmaker to take

a bet from me and about this time I go into the Rainbow Casino in Birmingham and begin to play poker. This is about 1991. I'm hooked on it straight away. In dog racing there are ten or twelve races a night so you have twelve options to bet. When you're playing poker there are hundreds. It's every hand.

'Because I have a background in gambling, I know how to gamble; I understand about risking money and not being worried about it. But I do get hooked on it and I don't know the fundamentals so I lose for the first twelve months. I'm making lots of mistakes, sitting in games, winning in games but ending up losing at the end of the night. I'm hitting the front because I'm capable of gambling but then losing it all because there will be one or two big hands where I get caught. I don't understand the dynamics of the game, but eventually I have a better understanding of what I'm doing. I haven't had a losing year since then.

'I try to approach it like a bookmaker – in other words, only put the big money in when you have the odds in your favour and allow other people who are more naive, for want of a better word, to be chasing after you. So you become the bookmaker and in real terms the other players are the punters trying to beat you. That's how you make money playing poker.

'Originally I started in the Rainbow, but there were some private games in Birmingham, and I got to know them and play them. Then there was Barry's; that was built around one individual who invariably lost.'

Ah ha, my chance to talk about Barry's.

'I had a set rule. I would always leave at four o'clock in the morning. Then I would come back at eight the following

evening and I'd come in fresh and they would have been playing all that time.

'The most I won in a weekend was £50,000, but it was a lot of money in those days.

'Barry's gave credit and that meant the game got a lot bigger. When you're playing, a game ends up being built around somebody who's going to lose. Everybody wants to know where the money's going to come from. And this builder was the big loser at Barry's. But he loved to play and had the cash to do it. When you lose week after week after week you've got to know what you're doing, even if you're losing, haven't you? And he did lose a great deal of money. When you have a player who generates the game like he does, he also attracts other players in . . . even other losers want to come in and play and try and get some of the money. Invariably they may be the same sort of character but to a lesser degree. You'll end up having winning players, marginal players who can win and can lose, other players who won't win as much . . . there's a kind of structure. The winning players won't win all the time. The house wants losing players to win. It's not going to happen over a long period but they do want players to win occasionally.

'Unfortunately, what can happen when you go to a private place is that if the guy who is going to lose overall is winning on a particular night, and if he doesn't get up and leave, as he should do, the other players at the table will say, "Come on, let's go on a bit longer" and invariably he loses.'

I want to end the chat on a high note. 'After Las Vegas you did come back to the big time and you did show every-one you could do it?'

'I was playing mainly on the Internet at home so I could

be with my son but decided to enter the televised main event at the Vic in 2004; it was a £3,000 buy-in, and I won it. That was £200,000. Obviously that's good money but . . . sure . . . it was also good just to win and to show that Vegas was just one of those things.'

There's a silence. He's thinking back . . . then he smiles. 'Yes, it did mean a lot.'

I decide it's time to go.

I head north now, my target Stoke-on-Trent and Lucy Rokach.

♥ ♦ ♠ ♣

LUCY'S STORY

As she leaves the end-of-terrace home in the university quarter of Stoke-on-Trent where she's lived for over twenty years, this small, grey-haired, bespectacled fifty-seven-year-old woman could be mistaken for an old-style school mistress (actually, that's not so surprising; she once was one). No passer-by would imagine that such a reassuringly conventional-looking figure is known and feared in card rooms all over Europe as one of the most aggressive players on the professional poker circuit – a fireball who does not believe in losing without bloodshed.

This is a woman who is capable of spending her days peacefully in a tastefully decorated home (shared with her partner and fellow poker professional, Tom Gibson), cooking like an angel and pottering happily in the garden, and then going out at night and playing with a howitzer of a poker game and mowing down anyone in her path. Her refusal to allow anyone to push her around means she experiences life on the edge . . . either big wins or spectacular defeats. Since

she took up poker in her late thirties, she's been broke several times, has been forced to work as a waitress for £2 an hour to pay the bills, once lost £40,000 in Barry's spieler in one night while stubbornly refusing to listen to pleas from others to give up, but has also beaten all of Europe's top poker players in one tournament after another, and in 2003 was honoured for Lifetime Achievement at the European poker awards.

So who is Lucy Rokach? She was born in Cairo in 1948. At the time of the Suez crisis in 1956 the family was given a matter of hours to leave so they came to Britain with only the clothes on their backs. Her father found work in Stoke and Lucy's lived there ever since. She went to Manchester University, became a school teacher, then got into a relation-ship with a garage owner and ended up working with him, selling cars. He gambled a bit in casinos and Lucy went with him. Eventually the relationship broke up and rather than sit around feeling sorry for herself, Lucy decided to go down to the local casino. It was a decision that was to change her life.

'One day I'm in the Stoke casino and I see these people in an alcove playing cards. I know one of the punters there and I ask him what they're doing and he tells me they're playing poker. So I ask him to teach me and he shows me the rankings of the hands and I think, well, this is easy. So I proceed to lose all my money – every cent – and go into debt. I'm playing with people who've played for twenty years. A minnow in a pond infested with piranhas.

'At that time they're holding competitions in Wolver-hampton, at the Rubicon Casino. A few of the players go down from Stoke and I tag along. Again, as soon as I sit down at a cash game table the whole table fills up because I just don't know what I'm doing. I'll be in the middle of an Omaha hand and I'll say, "Is this the one where you can use one card

or two cards?" Dear me! I lose about £40,000 in twelve months. Something like that. I have to remortgage my house, I borrow off my brother. But I'm not a quitter. I can get very stubborn, and now I've found something that's totally engrossing and a challenge, I never actually think that I'm not doing any good and had better stop.

'It's a mad sort of year but at the end of it when I'm really short of cash I find myself with £298 and the Rubicon Wolverhampton is holding a major tournament and the entry is £100 with re-buys. This is a lot of money then. I'm dithering over whether I should enter it and then the card room manager tells me there's a prize for the last woman standing, so I think, Oh I can get that easy, as there are only about four or five other women playing in Wolverhampton and I don't rate them. So I think, that's easy then, easy money for me. I don't have to win the whole tournament, I'm going to make £100 anyway. So I enter and there are only six women playing but what I don't know is they've come from Ireland and from London and they're top players . . . tough players. I don't know that, do I? So I enter and I'm sitting there. Fifteen minutes later I've got ace-king and I've walked into aces. Now I'm stuffed. If I re-buy, I definitely can't play in my local cash game, and if I don't re-buy I can't win the last woman standing and get my money back, so very reluctantly I buy in. My back's to the wall now. If I lose, I'm flat broke. I play like I haven't played before. I play like a tiger and I survive to the next day. It's the biggest tournament they've held in England and it's the first two-day tournament. So I'm sitting there passing, passing, passing, my chips going down, going down, going down. The next thing, a tap on the shoulder, the card room manager comes up to me and says,

"You're the last woman standing and you've made the last sixteen in the main event." Sixteen prizes. Sixteenth got £200 and last woman standing got £200 so now I'm in profit. It's like the albatross round my neck is gone. So now I can let rip with these chips. I just go on the offensive and end up on the final table and end up winning the whole thing. I do a deal, even though I have the most chips, because I like the other two who are left; also, I'm so skint I want to secure £3,000– £4,000 rather than go for £6,000 or something and end up with a lot less. That's the only time I've ever asked for a deal in my life. If people ask me for a deal I will consider it, but I don't ask. So that allowed me to pay some bills and things like that. I won £4,500. Magic. That was my first tournament win.

'After that, I read David Sklansky's book for beginners. I realized how little I knew about the game. Don't ask me how I won that tournament. It was like fog lifting when I read that book.

'From then on, it was ups and downs. Lots of downs, a few ups.'

This, of course, is an understatement. Lucy went on to become one of Europe's top players – not just a top woman player, a top player, full stop. In 1996 she got a third place finish in a pot-limit Hold'em tournament at the World Series ($45,000) and after a series of good results over the next few years, including two big wins in Paris and Dublin in 1991, she began 2003 in top form, winning a pot-limit Omaha tournament ($51,000) in Melbourne, Australia, in January and a pot-limit Hold'em tournament at the European Champion-ships ($44,500) in Paris in February, and then coming second in a no-limit Hold'em event at the British Open ($37,000) in

London in March. She also went on to win the Irish Winter no-limit Hold'em tournament and pick up another $73,000. It was a good year in what has been a remarkable career

I ask about her style of play.

'Aggressive. If I'm going to go over the cliff, you're coming with me. If you want to mess in my pot then you learn that all your chips are on the line. Not a few – all of them. I'm not saying that's necessarily the best way to play but it has definite advantages. I will make calls that a lot of other players won't make and a lot of the time I'm going to lose, but a lot of the time it's going to be the crucial hand to allow me to win the tournament. But I'm not afraid of getting knocked out.'

'Where does this aggression come from?'

'I think what really helps me is that I've got an instinct for what's going on. My father was a bully, a violent bully, and when you live with someone like that it's like living on eggshells. That definitely has honed my antennae so that I'm highly sensitive to people around me, how they're feeling or how they're thinking. So I will pick up vibes you may not. And inevitably, with that home background, I don't like bullies. Don't try and bully me at a poker table. I'm not saying I always make good calls. If you ask other players who are there, they'll all say I'm mad. They wouldn't do it. But I don't care what they think. I want everyone to know that if they mess with me they'll need a good hand.'

She doesn't play many cash games as a result of a catastrophe at Barry's. About eight years ago she went there with Tom Gibson and hit a spectacular losing streak. 'I lost £40,000 that night. Tom was sitting next to me, pleading with me to leave and I wouldn't, and even Derek Baxter, who was running the game, was telling me to stop.'

Tom and Derek both recall it with shaking heads. Derek says, 'Tom and I took her aside and said, "Look, it's just not your night, for God's sake stop," but she wouldn't listen.'

Tom says, 'Lucy will admit she can be stubborn. Of course, I wasn't going to create a scene in front of others; if I'd had my way I would have put her in handcuffs and dragged her away but you just don't do that kind of thing. And she's her own person anyway . . . but of course it was very distressing for me to watch.'

As for Lucy, she does admit she was stubborn: 'Just plain stubborn. Afterwards, I was choked. I just couldn't believe what I'd done. It was just horrendous. And, of course, I went completely broke.'

So she decided to give up on cash games and concentrate on tournaments, winning a couple of small ones a few weeks later and then going on from there, culminating in recognition by her fellow professionals at the European awards.

Although as recently as 2004 she won the £50,000 first prize in a European no-limit Hold'em tournament at the Vic, and has not lost her enthusiasm for the game, she's not as driven as she was, playing less in big buy-in events. But she remains a player who can never be taken for granted. She's also become a top television commentator and writes for poker magazines. And she's probably got more friends in the game than any other player.

Some time after our chat I have to be back in the Midlands, and Lucy and her partner Tom kindly ask me to stay the night and have dinner with them.

It's easy to see what attracted Lucy to Tom Gibson. He's fun. And he doesn't just gamble on poker.

'Donnacha O'Dea and I were having breakfast one day in Shepherds Market and beside us sat two American ladies, one

was about twenty-four stone and the other about ten stone so between them they ordered two coffees and one cake which they're going to share. So I said to Donnacha, "Pick one to have the last piece of cake. For a fiver, you can take your pick." So he said, "I'll take the fat one" and I'm stuck with the skinny one and we sit there watching them eat this cake and they're going at it with gusto and the slices are getting smaller and they come to the last piece. The suspense was killing us and we were getting impatient because we'd finished our meal twenty minutes earlier and we had to wait for a result. And the result was a tie because neither of them would eat the last piece.'

Lucy, who's been listening, says, 'There's another time, we go to this pizza place and this family come in and I'm sitting here and they're sitting there, man, wife, one child and grandmother, and the grandmother is smaller than me and she's ordered a pizza and the pizza is huge. So Tom says to me, "I bet you she has more than half of that pizza" and I say, "No way," so we have a bet and I'm sitting there watching and she's getting close to the halfway stage and I can't believe she's managing to put it away. Next thing she's eaten two thirds of the pizza and finally she finishes. So I lean over and say, "You've cost me £1" and she asks why, and I tell her. And she says, "Well, I had to eat more than half because they'd taken me out to dinner and I couldn't not eat it." And the thing is, he knew that would happen.'

Tom looks smug. 'I surmised that would be the case, yes.'

Which is why, of course, he's a good poker player. He can 'surmise' what the others are going to do and why.

You won't find many entries for Tom in the tournament records. He's basically a cash game player, and he's made a living at it for well over twenty years.

He was at one time a tax inspector in Ireland, with a talent for bridge. That led to poker, and he was one of a number of top Irish players who began at Terry Rogers's Eccentrics Club and who soon found himself making more at poker every week than he got paid at his everyday work. So he turned professional and began travelling regularly to London with Donnacha O'Dea.

'We would play three days a week, Wednesday, Thursday and Friday. There used to be a pot-limit Hold'em game in the Barracuda on a Wednesday and Friday and we played at the Victoria on the Thursday. Then after a few years the game changed and Omaha became stronger, and then one year they introduced London lowball and that took off and mushroomed out of all proportion to what it should have. It became enormous. It was really one of the biggest games in the world at the time and there was a pool of about twenty to thirty players and every day it ran there would be two full games and there would be waiting lists. It would be a £1,000 buy-in allegedly and the antes were £25. I remember there was a guy from Australia who would sit down in the game with £40K. There was one time a side pot got to £70K. This is when money was money, and of course a lot of people got hurt . . . but that's normal in high-stakes gambling.'

Tom and Lucy met at the poker table playing pot-limit Omaha. 'She called my bet for £75 and I had a nut flush and she had a jack flush. She's been complaining ever since. She claims I owe her this money.

'We tend not to play in the same tournaments. We did originally with the bigger tournaments and it did happen occasionally that we were at the same table. It was invariably compromising our game because I might make a move or Lucy might make a move, which you have to do in a tourna-

ment, and I'd have to be careful not to do it unnecessarily when she had a blind or whatever . . . so all the time this would work to our opponents' advantage, not ours. So we decided that we wouldn't play in the same games together.

'And we don't talk a lot about poker at home. I find a lot of poker talk boring. We may try to analyse a few situations but she plays more tournaments and I play more cash games so we're not necessarily comparing like for like. Still, it's always good to have a sympathetic ear to bend, because most poker players are intolerant of listening to bad beat stories . . . it can be good to have someone to give you at least half a decent hearing.'

Inevitably over dinner I press them more on Barry's. Tom says that 'one dangerous feature of the game was they had a very liberal policy about giving out credit. It was virtually unrestricted. It was a private game so there were no controls, whereas you'd never get that kind of credit at a casino and you'd have to have properly established funds. At Barry's there were no controls and men like the builder you've heard of could go on losing all weekend without protection.'

'What was the place like?'

'Well, there was a heavily padlocked metal door with a video camera above it. When you were buzzed in you got halfway up the stairs and you came to a second metal door. Once you got past that there were two rooms and a small kitchen. In the second room there was a pool table and a backgammon table. These games were played for high stakes – you could have games of pool for £2,000–£3,000 a time. There were also one or two people hanging around, waiting to get into the poker game. Basically, Barry provided the premises and Derek recruited and handled the people. At

the end of the night we would all be paid our winnings by cheque.'

Lucy was there the night it was raided by the police. 'There were about twelve of them and they all towered over me. But by the time they got past the second metal door we had pocketed all the chips. Anyway, we all got off in the end because of the defence that the table charge was in fact only for catering, etc.'

'What was the table charge?'

'Ten pounds an hour.'

I whistle. If you added up nine players paying £10 an hour for a minimum forty-eight hours over a weekend, that was over £4,300. Multiply that by, say, fifty weeks in a year and that was over £215,000 a year. A profitable business, this spieler. Not, of course, that this was a table charge. Oh no. This was for catering . . . egg and chips, that kind of thing. Making them probably the most expensive egg and chips in the world.

♥ ♦ ♠ ♣

Alas, the following day I have to move on from Lucy and Tom's cosy home. Because Lucy and Tom are not the only famous players living in Stoke. I have a date at a Thai restaurant nearby – with Paul Maxfield.

♥ ♦ ♠ ♣

PAUL'S STORY

It's April 2005 and Paul Maxfield has been having a bad time. Five years after ending a marriage so strained that he suffered a nervous breakdown, he's still engaged in a dispute over the

financial settlement. The business he's built up from his early twenties is facing bankruptcy. The market for its engineering services has collapsed.

Problems at home; problems at work; Paul is a robust character but, just the same, it's all proving a bit too much.

Then he's persuaded to escape for a couple of weeks to Las Vegas, where only the previous year he made two final tables at the World Series, winning nearly $60,000 (he also won two big European tournaments that year, winning another $170,000). This time serious poker is not part of the plan – just a few cash games, plenty of golf and sunshine. This is a holiday.

But the World Poker Tour has come to the Bellagio and he decides to pay $1,000 to play in a one-table satellite for the main event, the televised $25,000 entry Five-Star World Poker Classic.

He enters the satellite for the fun; if he wins, he won't play in the main event, he'll cash in and use the money to pay for the holiday. He doesn't even alter his flight plans in case he qualifies.

But he *does* win the satellite and he *does* qualify, and then he changes his mind: instead of cashing in, he's persuaded to stay and have a go at the big one. A few tough card-playing days later he's crushed everyone in his path and finds himself on the final table, and by the end of the day he's in one of the most exciting heads-up battles ever with the young Los Angeles player Tuan Lee. It lasts 180 hands.

As it nears its end, Paul is behind. Playing in a red shirt and dark jacket, wearing sun shades to avoid the glare of the television lights, but also because 'you can't stop your eyes dilating if you're on a good hand', he's under more pressure

than he's ever experienced and well behind in chips. Then he gets king-3 of spades to Tuan's 8-5 of clubs, and the flop comes queen-king-queen, with the queen and king both ciubs. Paul, with two kings, goes all-in and gets up and walks off into the shadows, unable to watch. The first card is an irrelevant 5 of spades. Tuan is now also on his feet, looking to his family in the crowd for encouragement. Finally the river card comes. It is not a club, but it is a king to give Paul trips. He can tell from the crowd reaction he's won the hand, and swings round, grinning with relief. He now has 16,500,000 chips to Tuan's 6,200,000.

But it's not all over. There's another all-in encounter leaving Tuan needing a 7 on the river for a straight to beat Paul's two pairs. Once more they're on their feet, unable to look. Sadly for Paul, it's a 7.

Both have now been one card away from winning, and once more the balance has changed, Tuan with 14,900,000 chips and Paul with 7,700,000.

Then to the final hand. Paul gets king-5 and goes all-in. But Tuan has a better hand – king-jack of diamonds. He calls. Paul, walking away from the table out of the glare of the television lights, grimaces as a roar from the American crowd greets a jack on the flop (jack-10-3) to strengthen Tuan's lead in the hand. The turn card is a queen. Paul's only hope is a 9 so that he can split the pot with a straight. It doesn't come. Tuan has won.

But Paul has won a staggering $1.7 million in a tournament he never planned to play – more than any British player has ever won in one event to this point – and responds to defeat with good-humoured sportsmanship that does the image of British poker proud.

No wonder I find a happy man waiting for me in the Thai restaurant when he comes to Stoke this day, some ten weeks later.

'It was unbelievable – emotional, physical, psychological warfare,' he says. 'By the end I was just glad it was over. The stress was phenomenal. I couldn't have taken any more. Obviously, immediately afterwards I was disappointed because it was the biggest moment in my life and I felt for most of the day I had outplayed him. But now I'm not, because I look back and there were 500 good players in that field and the final table had Phil Ivey, Rob Hollink and Hasan Habib, so it was a real result.'

'What did you do afterwards?'

'I went for a Chinese meal and then I slept for about twenty hours. Including the satellite, it had been seven days, twelve hours a day.'

'So what's the secret?'

'It's to understand you can't win the tournament on the first day. You've got to avoid mistakes. You don't want to be gambling with ace-king and stuff like that. You just want to try to accumulate chips and keep in the game. I was never the chip leader and never particularly high on chips. It's all about timing and I picked a time when I was down to the last two tables before I began to take some chances and make some moves. The aim is the final table. It's like golf; you rarely see Tiger Woods shoot sixty-six on the first day, he's just there or thereabouts and makes the cut. All the good scoring comes at the end.'

Paul is not a conventional professional poker player in that he's mixed it with business in the past and even now plays only the big tournaments. But he did have his obsessed days.

'I started going to various casinos in the Midlands. I once

played for five days in a spieler. We would have breaks and sleep on the floor.

'There were no books then, you learned by losing. I just loved playing, the excitement and the atmosphere. Eventually, I was winning regularly. I bought my first house with poker money, put the deposit down at twenty-three, and I set up my business with poker money. I went to night school and studied engineering and started up a business at twenty-four. I ended up doing both, playing poker and running the business, and sometimes I would go straight from the poker, change in the office and begin work. This went on for years.'

'Did you play at Barry's?'

'I used to go there when the Rainbow closed for the night. I was there the night it was raided. Lucy was there, too. I was sitting there playing backgammon, for quite a lot of money, because I couldn't get a poker game, I was waiting for a seat. The next thing, there was a crashing at the door and the police burst in. There was a toilet right next to where I was playing backgammon so I darted in and shut the door. I thought, 'Oh no, I don't want my name in the paper associated with an illegal gambling game.' I could hear what was going on and I thought, I've got to bluff my way out of this somehow. I looked through the door and could see Lucy standing there, arguing and pointing her finger at one of the police officers. I slipped out and started pointing my finger at them, saying this wasn't right, there was nothing illegal about it, we weren't paying for any sessions and I thought it was absolutely disgraceful. They said, "Have we got your name?" and I said, "Yes, it's down there" and I walked straight out. So I never got put in the papers or had to go through all that the others had to do. They got off on a technicality. It's illegal to charge for playing poker but they said they only charged

for food and tea. Barry got off and the game just carried on the following week.'

I ask him about two others, David Moseley and someone else he has heard of, Chris Randall. He laughs. 'They're the same man. He was a blackjack card-counter and had to change his name because he was banned from the casinos. He was a real gambler. He would gamble on crazy things. I remember one time in Las Vegas we had been playing backgammon for about two days and nights in his room. By the end there were coffee cups and plates everywhere, scattered all over the place. Lucy comes up to the room; she says, "I've been trying to find you two, where have you been?" I say, "We've been playing backgammon." I'm winning about five grand off him. It's the first time I've had it over him. I win again, I'm winning ten grand. Dave Moseley's thrown the dice away in frustration and we can't find them. He says, "This is no good, I've got no chance of getting my money back." So I say, "Well, I'm going on the balcony to have a cigarette." I don't want him to find the dice anyway, because I've won all this money. He searches for them and gives up. Lucy's sitting there, laughing. He comes on to the balcony and says, "I'll bet you double or quits I can jump from this balcony to the next balcony." Well, this is on the eighteenth floor. Anyway, I look at him and think, he won't make that. I say, "All right I'll bet you." Lucy says, "You're not serious, are you?" and I say, "If he wants to bet the $20,000." Then I think, he's got some angle here, because he's always got an angle, so I think, If he doesn't make it he's going to die so I'm not going to get paid. I say to him, "Hang on a minute, you've got an angle. If you fall eighteen floors I won't get paid. You've got to count the money out and put it on the table before you jump, otherwise I'm not going to get paid."

So Dave looks at me and says, "you've got a point there." He counts $20,000 out and puts it on the table. Lucy's now saying, "This is not right, he's going to die. I'm going to phone security." So he says, to calm Lucy, "I'll make it . . . I'll show you." He goes into the bathroom and gets two towels. He's put one down on the floor there and estimated the distance and put the other one down. Now he's jumped and he missed the first time, jumped and missed the second time, but the last jump just makes it so he says, "There you are, I've got it now." Lucy says to me, "If he jumps I'm going to phone security and you'll be responsible." She goes on and on and eventually he doesn't jump. I said, "Lucy, you've just done me out of $20,000. I was a favourite there and I was getting even money and you've destroyed my bet." '

I can still hear him laughing as he disappears into the night.

'You ask Lucy,' he calls back. 'It's true.'

I do. And it is.

♥ ♦ ♠ ♣

So it's time for me to go home. My Midlands journey is over.

Well, almost. I have one last thing to do.

As night falls I drive past the Hawthornes, home of West Bromwich Albion, past Winston Green and the prison there, and into Bearwood.

At the centre of this tough, west Birmingham district I find Three Shire Oaks Road and there it is, opposite an Indian restaurant and an undertaker's, the battered white door, the padlocks, the video camera. This is it. This is Barry's.

It's dark now and there's no light upstairs where the famous spieler once was. It looks abandoned, although I'm told that a small game still takes place there from time to

time. As I look at the darkened window I imagine the scene up there . . . Hunched over the table are some who will become famous poker players: Colclough, Shipley, Rokach, Maxfield, Wernick, Derek Webb, the Devilfish, their eyes focused on the cards and piles of chips. In the background there's the chain-smoking, ever-watchful Derek Baxter and the comparatively anonymous Barry Hawkins (I've finally discovered his last name), and all of it heading towards an inevitable climax on Sunday night – with the Builder leaving behind a small fortune.

I know the Builder's name, but he's retired now, and apparently not well. There seems little point in revealing it. After all, this book is about professional poker players and the Builder played for fun. And this – that he played for fun – is worth stressing, because it would be easy to accuse the professionals of cynicism and greed, so ruthlessly did they exploit his love of a game that he seemed destined always to lose. Except, he himself would probably reject that charge. He *did* play for fun, it was apparently his one relaxation, and he probably *could* afford it. He could have spent £1 million on a yacht, or a luxury villa in Spain. But he didn't. He spent it on his hobby – playing poker. And losing at poker. At least two of the players tell me that the Builder was urged from time to time to restrain his betting or take a break, but instead he would defiantly force the stakes up.

Poker has its dark side. The exploitation and manipulation of players who are out of their class is part of it. But the Builder was not a fool; he was an intelligent, resourceful man who ran a business that made a lot of money; if he played at Barry's every weekend for three years, it's because he loved it. This was his thing. This was where he liked to be.

Every night in poker rooms all over the world there are

thousands of players who usually lose, and who in many cases expect to. There have to be. That's how it all works. And few of them care, because the game's the thing and they're playing within their limits. I occasionally play in a local home game. Sometimes I win, sometimes I lose, but always it's within my limits. In that respect, the only difference between me and the Builder is the limit – *how much* we can afford to lose. I can lose £100 on a bad night; the Builder lost many thousands almost every night he played, well over a million over three years or so, maybe more. But it was what he could afford.

I have not met the Builder but I'm prepared to wager that the Builder has no regrets.

It's to be hoped not.

Because his opponents have none at all.

8 / Heads-up in Barcelona . . . and the battle of the bad beats

Poker is a combination of luck and skill. People think that mastering the skill part is hard, but they're wrong. The trick to poker is mastering the luck.

Jesse May, *Shut Up and Deal*

The Casino Barcelona, on the ground floor of the fabulous Hotel Arts, is one of the best places in all of Europe to play poker. It's right on the seafront beside Port Olympic with its scores of bars, cafes and fish restaurants, and a short walk from the H10 Marina Hotel where most of the players stay. As it sensibly doesn't open until late afternoon, and competitive play doesn't begin until about six, this is one of the few places where the pros actually get outdoors, to sunbathe by the pool or have a late al fresco lunch or stroll on the beach.

It's June and several of the Usual Suspects have come to compete in the 128-player field for the World Heads-up title. Heads-up is just two players confronting each other across a small table, head-to-head, each committed to knocking the other out. It's no-holds-barred, unrelenting pressure, no respite. The winner has to survive seven of these bruising bouts.

The tournament director, Jon Shoreman, a regular on *Late Night Poker*, says it's a very macho side of the sport in that it's 'player to player and whoever's the best wins'.

'The difference with heads-up is you're being forced to play every hand. In a regular ring game, tournament or cash, you can afford to sit back and hide. You can wait and you can pick on weak players at the table and choose when to confront them. You can build up your chip stack. You can change gears and slow down and you can afford to step back from the game. In heads-up, you can't. You're putting a blind in on every single hand and you have to play, and if you don't play then a good opponent is going to wipe the floor with you.

'Also, every game differs from the last one, and, unless you really know your opponent, it's very difficult to go in with a strategy. You have to adjust to what the other player is doing. It's like a cross between chess and boxing in that you constantly have to think and adjust and it's tense all the time.'

The games vary extraordinarily. Some stretch the nerves for hand after hand. But Dave Colclough was knocked out on the first hand of a match last year. He was playing Rob Hollink, a well-known Dutch player, and by the turn card on the first hand both of their 10,000 chip stakes were in the middle.

Paul 'Action Jack' Jackson describes this as 'the purest form of poker . . . a slow aligned structure that caps at a low level with a decent starting stack, enabling proper poker to be played on a very personal level, one on one.

'This,' he says, 'should mean that the best player on the day will generally win the game, not like a ring table with plenty of opportunities for uncontrolled out-draws or freak hands, or the short-handed TV games with rapidly increasing blinds lending themselves to TV action rather than poker.

'Obviously, freak hands can arise and some players are

hyper-aggressive and happy to get the lot in on a draw, but, generally speaking, whoever plays the best poker in each game ought to be victorious.'

El Blondie provides an insight into how professionals approach the event, recording in his diary on day one: 'I have a strategy . . . you just don't get enough quality hands dealt to you in a heads-up match, so you have to win pots by stealing, or playing all your draws very aggressively. My policy in Barcelona is to raise as often as possible on my button, as opponents don't like to play out of position. Follow this up with the occasional steal from the big blind, and hopefully there will be just enough edge to swing things in my favour. Obviously, the better opponents will spot this strategy after a short time. So, I will then switch to a more defensive strategy. Hopefully by then, I'm sitting on a good chip lead.'

The Devilfish is less subtle. He combines the usual hint of menace with a show of boredom, implying that this particular opponent is merely a time-wasting obstacle to his preordained passage to the next round. In this mood, he easily disposes of an Austrian, and then a Spaniard, moving comfortably into the third round where he's faced with a British player, Stephen Pearce. By now, Devilfish's opening gambit with opponents is to recommend they book themselves on the next flight out. And it looks as if Pearce will have to, especially to Devilfish who, with an ace-7 in the pocket, benefits from an 8-7-7 flop, giving him three of a kind. He moves all-in, only to discover to his chagrin that Pearce has pocket 8s. Out goes Devilfish.

El Blondie stays in all the way to the semi-final when he, too, comes head-to-head with an unknown called Peter Gunnarson, from Sweden. 'Having researched my opponent, the

information I received was that he was generally "too tight". The truth was that he was very good at disguising his game. He called and raised all my early bets. By the time I realized that the classification was totally wrong, I had lost half of my stack. I should have spotted it earlier. Peter loved to check and call, always giving me the opportunity to bluff. The perfect strategy to foil my strategy. I spotted it too late and had to toil with a short stack for over an hour. The fact is, he out-thought and outplayed me.'

So, strike one for the Unknowns v the Usual Suspects. Before winning this by outplaying an impressive list of top European names, Peter Gunnarson had won less than £2,000 in European tournaments!

Later I chat over coffee at the H10 Marina with Jon Shoreman, one of the driving forces behind heads-up. Interesting guy, Jon. Bald, fortyish, intelligent face, he's someone who's mixed poker with business – including poker business – and has clearly made a lot of money, enough for a town house in Knightsbridge and a classy-looking BMW.

He can name every game he's played in since he started playing at the Rainbow Casino in Birmingham while he was still at Warwick University studying IT. 'What I did from day one was to say to myself, I'm giving myself six months and £100 to play in these tournaments and I'll keep accurate records, and if after six months I'm winning I can continue and if after six months I'm losing, that's it.

'In either the second or third tournament I played in, a £10 tournament in the Rainbow in Birmingham, I placed third and that won a couple of hundred pounds. That took my poker account into the black and ever since then it's never been in the red.

'And I've got records of every single game I've ever played

in from the point I first went into a casino. I've had down-swings and big downswings but I've never dipped below that starting point.'

This is unusual. The best players in the world have gone into the red from time to time. Yet it doesn't cross my mind to disbelieve Jon. The guy is obviously as straight as they come (if you ignore the fact that he's a magician, a member of the Magic Circle, and can probably make your stack of chips disappear without even playing his cards).

He went on to play professionally between bouts of working as an IT consultant, linking up for some time with Dave Colclough. This led him to launch a poker Internet website, primarily for European poker. 'Over the last year I'm probably 60 per cent on the website, 30 per cent on organizing the heads-up and 10 per cent playing.'

Jon's a cool character. Simon 'Aces' Trumper is not. Jon needs to be persuaded to talk; Simon can't be stopped. But Simon is a character on the European circuit who simply can't be ignored, so I persuade him to have lunch on the seafront.

Simon, a talented, largely no-limit Hold'em player who, like the Devilfish, has won a *Late Night Poker* series, has an image that suffers from the endless repeats of *Late Night Poker*, because his appearance changes so dramatically from one series to another. One night you find him on channel A with a black ponytail, looking like an ageing hippy, and the following night you find him on channel B with shaved head, looking like a serial killer. It's disconcerting.

♥ ♦ ♠ ♣

SIMON'S STORY

Simon 'Aces' Trumper is a communicator. He's already written 250,000 words of no-holds-barred diary on the Internet and there's no sign of him stopping. And he's a talker, invariably about himself and his game. And it gets amazingly detailed. As one fellow pro puts it, 'He doesn't edit. He doesn't distinguish between the internal dialogue we all have with ourselves and what we actually say to others. You get the lot.'

But, as he says, this is what makes Simon so disarming. He's incredibly honest about what's going on in his life. He's had his ups and downs and he's taken his knocks and he shares what's happening. Simon wrote a much admired article for *Poker Europa*, describing in graphic detail two years that culminated in him going broke. Most professional poker players go broke at some point, some do often. Few will talk about it. Simon does.

It soon becomes clear to me that Simon feels compelled to communicate because he's an enthusiast about whatever he's doing. For instance, having been expelled from school for playing dice in the middle of an exam, and refused by the army because he was suffering from asthma, and having done all sorts of bits-and-pieces jobs, he ends up working for a chain of wine merchants. He's a relief manager. This has him travelling around the country, running shops for just a couple of weeks. The full-timers inevitably come back from holiday to find their whole shop completely reorganized. Simon, ever the enthusiast, believes in doing things properly.

He gets into the drainage business. This man even gets enthusiastic about cleaning drains. He ends up setting up his own company and making a lot of money. (This is an edited

version; I learn more from Simon about drains in an hour than anyone could ever learn or want to learn in a lifetime.)

He starts playing poker in 1995 and finds he has a knack for it. Only two years later he gets four top-four places, including one win, in the European Championships. His *Late Night Poker* series win is in 2000 and he follows that in 2001 by winning $65,000 with first place in the European WSOP trial in Vienna. In the same year he wins another major tournament in Vienna and one in Paris. While he may not strike fear into the hearts of the top pros, this man can win. Now forty-two, he's proving himself to be a thinker about the game; he's emerging as one of the better television commentators.

But apart from his poker he's best known for his extraordinary running commentary on his career, notably on his website, where all is revealed on a regular basis.

Take his entry for September 2005:

'There's no other way to put this so I'll be blunt, August was crap!

'I played three events in one week at the beginning, all around £5000 entry and didn't place once, then i went to Luton, made one final in Omaha and finally to LA where . . . the best I could do was 37th of 258 in the $1500 No Limit . . . I did win a super satellite for $5000 so it wasn't a total disaster but my confidence which was high after the WSOP has taken a battering . . .

'I did well in Barcelona in May cashing three times out of six events, hopefully i can get things moving again there.

'It is about time i made one of those televised finals, i have had enough chances, i am not achieving the goals i set myself at the beginning of the year and it's not good enough.

No other poker player so openly shares his thoughts with the world, except perhaps Phil Hellmuth, America's poker 'super brat'. And sometimes Roy 'the Boy' Brindley

This brings us to the famous *Poker Europa* article. I ask Simon to rerun the story. (Needless to say, he takes little urging.)

'OK, but what you have to understand is that being an international tournament player costs a fortune. I'm really lucky; I'm sponsored now, thanks to Eric Semel of UKbetting who asked me to write for his site and now pays my expenses and buy-ins. But otherwise, think what it would cost – this year alone I'm going to Australia, Paris, Deauville, Walsall, Vienna, Monte Carlo, London, Dublin, Las Vegas, Barcelona, Las Vegas again, London again, Luton, Los Angeles, Barcelona, London again, Baden, and back to Dublin. So my problems – any player's problems – must be seen in the context of the cost of actually playing.

'The two years I'm describing, 2001–2003, began at Reading in March where I played in a £50 pot-limit Hold'em and split first prize. The following day I went to Luton to play a similar event. I worked out if I made the top three I could afford to go to Vienna for the European WSOP trial so that was my goal. I eventually split that one too, with Steve Vladar.

'I went to Vienna and came home with the trophy and about £30,000, and that's when it all really started.

'I was full of confidence now and I began travelling to other events, including Paris and Vegas, with no result, then back to Vienna in June where I won my second £1,000 no-limit event. I then went to Paris for a second spot in the £1,000 Grand Prix no-limit, and then went back there and won another £500 no-limit in Paris. I then came second in the fourth series of *Late Night Poker*.

'So I had won about £140,000 and was in great shape.

'Or was I?

'After I paid all my expenses, including cash game losses – you should have seen the gleam in the cash game players' eyes when I sat down – I was actually ahead only £20,000.

'Because I was away all the time, my business suffered and turnover dropped but I was still able to take a minimum wage and a small dividend. However, I would have been better off concentrating on the company and just targeting selected poker events in this country to cut the costs.

'Did I do it? No. First stop, Melbourne, Australia, and the Aussie Million. No good.

'Then I had a few results, split the £750 no-limit at Luton for £20,000 and won the £250 Euro pot-limit Omaha in Vienna, came fourth in the $3,000 no-limit at the WSOP, and made both the no-limit finals at the European Championships at the Vic and five more finals at Luton and Paris for a total of £120,000, without the smaller placings.

'By mid-September 2002 I was now £30,000 up and I had gained tremendous experience at the highest level all over Europe and America, and was making finals virtually every month and was completely self-financed from winnings.

'It's become clear to me by then that my best game is no-limit; you can't argue with eighteen finals in eighteen months with a buy-in between €500 and €5,000.'

'So what could possibly go wrong?'

'Well, here is what: I was spending a minimum of £10,000 a month in flights, hotels, food, taxis and tournament entries so even £30,000 only gave me a three-month cushion, but as I had only missed out on a result in two months of the last eighteen, for me it was unthinkable that what was about to happen could.

'From mid-September to mid-December I went to Vienna, Baden, the Vic, Dublin, Amsterdam, Paris, Walsall and Helsinki, playing probably thirty events and only cashing in twice, for a total of €5,000.

'I then played in the Poker Million and came second in my heat, losing another £6,500. I ended the year £10,000 down.

'Of course, my business suffered and I had now to stop taking a wage. Something had to change. At this time, some players had come up to me saying I had changed my style and was clearly under pressure. Well, the reason I had such a drought was a few unforced errors of my own followed by seventeen lost even-money shots at crucial stages of events including ace-king against 5-5, three tables out, for a big pot, and queen-queen against ace-king in another event. Such beats are everyday occurrences in no-limit, but seventeen in a row hurts.

'However, I realized people were right. Although I had taken a lot of beats, I knew I was not accumulating as many chips as I normally did, so when I lost these pots I was being knocked out when previously I would have had enough to make a recovery.

'I decided to take a month off in January, apart from a heads-up in Australia. I was convinced this bad run couldn't last and, as I was "only" £15,000 down, was prepared to continue hitting my credit cards until the wins started again. After all, one decent result and this minor hiccup would soon be a memory. So after Paris, I went to Vienna, back to Paris, then Luton, and after scraping three finals but winning only €5,000, by the middle of April I was £35,000 down.

'The thing is, I figured I was playing well and that it was only the poker gods conspiring to challenge my sanity with beats like the Omaha in Vienna. This was a key event. I had

won it the year before and with eight players left I fancied my chances. The chip leader raised and I looked down at ace-ace-king-jack double-suited and moved all-in. I was called by ace-queen-queen-4 and naturally the queen was the first card on the flop. I was out and he went on to win the tournament. This was a real blow. It's at times like these when you have to decide: do I stop now and take a break, or what?

'So I booked a flight to Vegas and the World Series.

'A little voice in my head said, "OK, you're £35,000 down, but you won £42,000 there last year, so go for it – this is your last chance to get out of trouble."

'I arrived five weeks before the main event with £5,000, intending to play one event, the $2,000 no-limit, and use the rest for super satellites (in these preliminary events, players compete to win $10,000 seats in the main event).

'I had pumped myself full of self-belief that I could turn things round, and I sat down to play the $2,000, very confident. But now I know what happens when you're under pressure: you play without feel and with fear.

'And this is what happened: I had built up a good stack and a player two off the button made the standard raise. He had only been in two other pots with ace-king and king-king so, looking to find queen-queen in the big blind, I chose to call rather than raise as both times he had been raised before he moved all-in.

'The flop was 8-9-jack and I made my second mistake and moved all-in. He shrugged his shoulders, sighed, checked his cards and then called, flipping over queen-10, and I was out.

'Not a good start.

'The super satellites were very quiet at the beginning due to a $200 no-limit event being held every night, but I decided I had no option but to play even if there was no main event

seat up for grabs, just cash. My first try was uneventful, then suddenly, for the first time in eight months, I hit form.

'It was a Friday, five days before I was booked to leave – three weeks before the big one. It was the afternoon super satellites – two tables and not enough players to generate the money for a main event seat. Down to three, I'm chip leader, and offered a proportional deal. I take $2,300. That evening there's only enough for one table and, down to three again, I'm chip leader, and take $1,700. The following night there's one $10,000 seat, and with three left I'm chip leader but can't afford to offer the others a deal. Then one of the players offers me $3,500 and the other guy $3,000 and takes the seat. Now I am $6,825 up, and I enter the Sunday evening super satellite. This time there's a seat and $2,000. I get heads-up, but we can't agree a deal so we play on. He raises and I move in with pocket 3s. He quickly calls, showing queen-queen. Here comes the flop for the seat in the big one and it's 6-6-3. Lucky me. I'm in the main event.

'But all is not well. What I should've done is fly home and then back again two weeks later. Instead, I decide to stay and try and win some more supers which will earn me $10,000 a time.

'The rest is a blur. Basically I play another seventeen supers, make three more finals, but miss the seats. Also, due to some help from some great players who know my predica-ment, I'm put in the $5,000 and $3,000 no-limit Hold'em events, but to no avail.

'The weekend before the main event I tell myself I'm going to rest, ready for Monday. But by now I've done my tank and I'm borrowing money. The last four super satellites always give the most seats, so on Saturday afternoon my good intentions to take a break go out of the window and I sit

down with 301 other players. After the re-buys have finished, it's announced that we're playing for fifteen seats. With sixty players left, I'm chip leader and dreaming of winning the $10,000, paying back my friend and being in great form for the big one. Sadly, I finish a gut-wrenching seventeenth. This was one of my darkest hours. You can't believe how much it would've meant to win at this time.

'I tried to get over it on the Sunday but after five weeks in Vegas and the roller-coaster taking a steep drop, I'm never in shape to play my A game, so for the first time in four attempts, I fail to make the second day of the main $10,000 event.

'Yet again it's queen-queen and my big blind that cost me most of my chips. Under the gun, I raise. The flop is 5-6-7 and this guy milks my calls all the way to the river before flipping over 8-9 for a straight. For the first time in two years I completely lose my focus and walk away from the table in a daze a few hands later.

'To be honest, I almost feel a sense of relief. I know I'm at the end of the road.

'I've gone from £30,000 up to £50,000 down in eight months and I finally come to my senses. I fly home from Vegas and know I have to make a lot of changes before I can play again.

'I would like to be able to say that I get up the next day full of enthusiasm and start working again and sorting my life out. But it's not that simple. When you've lived this almost surreal existence, travelling all over the world, experiencing the wonderful highs for eighteen months before finally hitting your personal wall and with it the despair of failure and financial difficulty, it takes time to recover. I'm depressed for three months with no energy and it isn't until one day in August I wake up and think, That's it. I'm sick of

feeling sorry for myself. If I'd listened to my friends this could've been prevented but the way I figured it, with my record it was only a matter of time before I won another decent-sized win. Well, I have learned the hard way.'

Ironically, it was this story, told more briefly in *Poker Europa*, that helped Simon back on his feet, catching the attention of Eric Semel and leading to the sponsorship that enabled him to come back on to the circuit fighting.

Even so, as I talk to him, he's moved from his house to a flat, exchanged his gold Rolex for a steel one and got more than £50,000 on his credit cards.

Not that he cares about any of this. As he says, one big win could change all that, and anyway, he's determined to make it in poker, either as player or commentator, or ideally both, and I find myself hoping he does. Despite the period of depression, he's proved his resilience. And his enthusiasm is infectious.

Later I'm thinking about the difference between the cool Jon Shoreman, with his private records and his achievement of never going into the red, and Simon Trumper, with his public outpourings and his roller-coaster ride from triumph to disaster.

They are both likeable characters. But Jon, I conclude, is a schemer; Simon a dreamer. Jon's a realist, Simon's an idealist. Jon will probably never know the highs that Simon will, those special moments of great exhilaration, but nor will he know the lows, the days of depression.

Jon will stay in the black; Simon's bank account will know all the colours of the rainbow.

Will they both achieve all they want to? Jon is even money. The odds on Simon are longer. But then Jon will play it safe; Simon will take the risks.

Who said all gamblers are the same?

♥ ♦ ♠ ♣

I thought I had heard from Simon the bad beat story to beat 'em all, but that was before I met Roy 'the Boy' Brindley. He came second in last year's world heads-up and won €40,000.

So that was good news, then?

I had to be kidding. The money was irrelevant; he had wanted to be world champion, and still becomes distraught at the memory of it.

'I was so broke at the time that I had to walk all the way back to my hotel every night. I couldn't afford a taxi. So I guess I should have been pleased, but winning the money didn't matter. I was close to being a world champion and I really believed I was going to do it. When I came second all I felt was that I had lost, and I was broken. I was devastated. I walked back to the hotel in a daze carrying €40,000 and it didn't mean a thing. I got to my room and cried my eyes out, then I took the bag with the €40,000, opened the window, and I was just about to throw it into the night when I was disturbed by the phone ringing or someone knocking – I forget what it was – so I didn't. But I was that close. Because I didn't want the money. I wanted the title. You have to understand that in my life I hadn't been anyone, done anything. It wasn't that long since I was actually living on the streets. And now I was that close to being world champion. *That close.*'

My God. Between them, Simon and Roy's stories could get a man seriously depressed.

But I had to know more about this man from Dublin.

♥ ♦ ♠ ♣

ROY'S STORY

My trip to Barcelona is turning into the battle of the bad beats . . . a contest to find who can tell me the most depressing story.

Roy 'the Boy' is now keeping me spellbound with a story of sixteen hours of Internet poker mayhem.

'It's a Saturday afternoon and I'm still trying to recover from a bad beat that I had in a Dublin card club the night before. It doesn't normally bother me, but when the guy gets a 50–1 shot (two running cards), and with the rent and phone bill both due . . .

'Anyway, I crank up the computer and collect the emails. There's one from the Hendon Mob, advertising a $10,000 free roll tonight at 8 p.m., and one from poker-in-europe.com, advertising a £15,000 giveaway.

'In between the 3.25 at Newbury and the 4.15 at Doncaster I download both lots of software and deposit £25 into each.

'At 5 p.m. I'm in a 90-runner tournament in Victor Chandler's collaboration with poker-in-europe.com. This offers the first three finishers a place in the semi-finals of some event, which is worth some part of $25,000.

'Don't knock it until you've tried it, I decide, sitting back with a tin of Foster's and a chicken korma. Well, bugger me, by 6.30 I have 125,000 of the 180,000 chips in play and there are still twelve players all sitting on futile stacks that barely cover the next round of antes.

'A bit later, the four tins of Foster's have gone and so have ten other players but I manage to get beaten heads-up. But I'm still one of the three in the semi-final of some super competition that might give me a trophy and I love trophies.

'So I start on a box of six Millers before taking my chances in the Hendon Mob's freebie comp that offers a weekend in Dublin along with a meal in the Merrion Casino – irresistible. Ten thousand dollars added, apparently. I get knocked out of that but after finishing the six Millers I check "cashier" and see that I have in excess of $100 in my account – don't know how that happened but it was there. So I think, Let's play in one of these Mob "heads-up" things.

'I beat Joe Beevers and both the Boatmans in turn. This calls for some more refreshment and I have a John Jameson.

'Now the cashier says I have $577. After starting with around $40, this has not been a bad night and I can replace those beers, Baileys and vodka bottles with it.

'But now what? I know. Let's go play with that bit of "change" I still have on Victor Chandler's site.

'I play a $50 in a $1–$2 cash game. I end up getting four of a kind called and now I'm up to $250-plus. This calls for another drink.

'To cut a long story short, I get to $2,200 as quickly as my bottle of JJ goes down. I'm going to take this and run because I have just paid for a flight to Vegas and a month in a hotel.

'Then I'm on another lively table and they're real mugs too. I can't stop winning and soon I have another $2,000, another, another and another . . . In two hours I'm at $10,000 plus.

'I can see a Porsche 911 in my driveway. I'm out of here . . . But no, no, I have aces and a guy has just raised $3,000 into me. Where is this bloke from? How big is his palace? But I've won a fortune in one night, I'm drunk and happy and I don't want to call. But I do. Flop comes ace-9-3, all different suits; guy immediately goes all-in. I don't believe this, I've won the lottery. The next card is a king and the final card a 9.

'Twenty-two thousand dollars slide their way across the screen to me!

'I phone up my girlfriend in England, who simply goes crazy when I tell her that a year's take-home pay will be in her account next week. We're going on holiday to the most exotic place in existence and that Porsche will have a turbocharger attached to it.

'The cashier section of the site seems to be a little unhelpful when I try to take out the money. In fact, it won't let me.

'Then the phone rings, and it's my beloved – it didn't take her long to find a holiday brochure. A ring, too, probably! Um, why is she crying? "I've just had a Mr Victor Chandler on the phone. He says he's very sorry but you can't draw $20,000 from your account because *you've spent the last five hours on a practice table with play money!*" '

You have to laugh.

Well, actually, Roy isn't, but I am.

Turns out that despite living in Dublin and writing regularly about Irish poker and playing under the Irish flag, Roy is not Irish at all. He was born in Southampton, in 1969.

'I've only lived in Ireland for five years but I started playing in Ireland and served my apprenticeship in Ireland, where the standard is really high. If you look at the results in the World Series, year after year there's an Irishman at the final table. And no English guy has ever won the World Series but an Irishman has. I think there was one year when four Irishmen took part and three were at the final table. Now this is no accident; they play to a high standard in Ireland. And they play a little differently. There is a lot of no-limit Hold'em. In England, nearly all the casinos play pot-limit. If you play pot-limit Hold'em week in and week out and suddenly you're thrust in the World Series playing no-limit, this

is a bit of an extra challenge. The glory of this game is you can put all your chips in and put the gun to someone's head and pot-limit players aren't used to that.'

But back to Southampton and his younger days. 'I got interested in dog racing because my father ran greyhounds. I went to work in a kennels as a seventeen year old, near Dorking in Surrey. It was a bit of a shock to the system, six days a week cleaning up dogs' mess and brushing and walking them. Going to dog tracks three or four nights a week. But I went on to do that in a few other kennels, one in Slough and one in Essex and eventually moved up to Lincolnshire to start up my own kennels. Then I finally settled in Andover, Hampshire, and between 1991 and 1995 I lived and trained greyhounds on a farm in a little town . . . a beautiful, picturesque place with thatched cottages and English countryside like it's meant to be.

'In 1995 I packed up and went to America. I thought this would be my new shot in life . . . I'd go over there and train greyhounds, but it didn't work out and then eventually I gave up and came back and had a mass of personal problems and somehow ended up living on the streets. I had a mid-life crisis at twenty-eight. Playing cards now, I often reflect back on that time. I remember one day I found a pound coin in the street and I made that £1 feed me for five days. Remarkably, it's doable. You can buy a tin of baked beans for 9p.

He got involved in an Irish greyhound magazine and did that for a couple of years. Then he saw a famous documentary on poker featuring Noel Furlong's big World Series win, and for Roy that was it. Poker.

'I started playing cards in spring 2001. It was in the Jackpot Casino, the only card club in Dublin at the time. I remember going to a casino in Dublin and playing for the

first time and I'm quaking in my boots. And it was hard-going. There's a lot of players in Ireland who quietly make a living out of poker and shun the spotlight and shun the headlines and don't want their pictures in magazines and they don't want to be on television. They've quietly got their heads down, making a lot of money out of cards. And unlike a lot of people who have got the ego and are on TV all the time, they have got the results to back it up. A lot of the real poker players are the ones that you don't know and they're the people I respect the most.

'I started to do OK and I was really lucky because in January 2002 Liam Flood was organizing a televised tournament. It was only for Dublin players and I felt privileged to be invited because I wasn't an Irish guy and I was still relatively new; I had only been playing six months. There were people there who'd been playing for ten years. But I went and I won it. And this went out for seven weeks on Sky Sports; this was their first foray into poker as well, so although it wasn't a major tournament, and I've never claimed it was, I was very lucky to get seven weeks' TV exposure. I went on to Vienna and came second in the heads-up world championship which was televised, so in the space of three or four months I got plenty of TV coverage at a time when there wasn't the same TV coverage as there is now.

'So I managed to become high profile very quickly, and I had enough going for me to get some serious sponsorship from Ladbrokes, who I've been with for nearly four years.'

He won't divulge what he gets from Ladbrokes but says he's on a retainer and it's a more than useful income. And he says he works for it: 'I'm not just wearing a T-shirt; I do a lot of corporate hospitality and a lot at dog tracks. I don't take it for granted.'

He's now won nineteen tournaments in three years.

'Why am I a tournament winner? Well, first of all, cash games and tournaments don't mix. They're different disciplines and you can't suddenly switch. In cash games you don't want to lose any chips obviously because that's money but in tournaments you've got to be prepared to gamble your chips and put them on the line.

'The bottom line is card sense . . . a basic understanding of what's going on and why and how. Actually, it's funny where my card sense has come from. From the year zip my family played cards, seven nights a week, and 99 per cent of the time it was a game called Nomination, which was whist but you had to nominate how many tricks you were going to make. It's done on a points-scoring basis, and what it actually makes you do is count what cards have gone, so you're card-counting all the time. From the age of four I can remember my family playing this and from age nine I wanted to play and it was, "No, you can't. Come and sit and watch me play." So, after six months of watching my grandad play, I would say, "Can I play?" but it was, "No, you're not old enough," but this time Mum perks up and says, "Come and watch me play." So, six months of watching my mum play every night and I'm ten and it was, "Can I play?" and, "No, you can't" and Gran said, "Come and watch me," so over the space of about three years I've sat and watched everybody play for six months solid, so I get to the age of eleven and they relented because they needed one player to make the game up, and I took them to the cleaners. I knew every player on that table and exactly what they did . . . I just knew everyone's game. It was just a case of knowing their game. So I learned then to watch other players and it works for me to this day.'

Roy has only one problem: he's volatile. And when he's

out of kilter he's . . . well, to put it mildly, less than diplomatic. Every now and then he does a crazy thing, like attacking Devilfish's egotism on television and wondering why the sensitive man from Hull comes down on him like a ton of bricks. He's upset a few people.

Yet he's as hard on himself as he is on others. He's an open book – what you see is what you get. And I have to confess that what I've seen I've liked. He may be the wild man of Irish poker (an exceptional achievement even if you're Irish; remarkable if you're not), but beyond the bravado he comes across as a decent guy.

And there's something there. Nerve. And a raw talent. It may be a long-odds bet, but I would wager that one day, if the cards fall right, he could be a contender in the World Series main event.

9 / Young guns . . . and the Hendon Mob

The pros want the live ones to get lucky sometimes and win. They just want it to happen in someone else's game.

Michael Craig, *The Professor, the Banker, and the Suicide King*

The Usual Suspects are, on the whole, relaxed characters. They've seen it all, done it all, been up, been down, won, lost; they've known triumph, despair. They've experienced great strokes of luck and gut-wrenching bad beats and 'treated these impostors just the same'; they've spent hours under television lights before absorbed audiences at home, and many more hours alone, hanging around airports or waiting for taxis late at night in the rain. They've had money in their pockets, been flat-broke. What else can happen?

So, generally speaking, they're a laid back lot.

At least, that's what I believed until I met Carlo Citrone.

CARLO'S STORY

It's mid-afternoon, three hours before the start of the day's play in a big Vic tournament, and there isn't a dealer or floor manager in sight. Many of the players are still asleep at home

or in nearby hotels, having played until four in the morning. Only a solitary cleaner disturbs the peace of the card room, brushing the green baize, polishing the wood surrounds.

But Carlo's here, waiting at the front door when it opens. He begins to pace around the deserted place like a caged tiger. He's glad to see me because he needs someone to talk to.

What on earth is he doing here? The answer is that he's so hyped up he can't stop himself. 'Ye gods, Carlo,' I say. 'Calm down; you're a nervous wreck.'

'Well, I hope I don't look like a nervous wreck, even if I am one.'

'But why are you?'

'It's in my personality. It's a desire to succeed to such a point that I put pressure on myself, almost intolerable pressure. I've been out of the house since 9.30 this morning, and even now the tournament doesn't start for three hours.

'I've driven around, been for a walk in the park, had a coffee, literally just walked around trying to get rid of some of the pressure that I feel. I'm trying to relax but it's almost impossible.'

The difference between Carlo and the rest of the Usual Suspects is that they want to win but Carlo *has* to win. Not because he needs the money, but because he's set himself a target and Carlo was bred to beat targets by a competitive father. Carlo is a driven man.

'I gave myself a certain time frame, which was five years, to reach the pinnacle of the sport. If I don't do it in that period then I'll re-evaluate my targets and I'll re-evaluate my ambitions but until then I'll put every living breath into making sure that I do everything possible to achieve it.

'The only thing that's missing from my package is that big win. The one major win. I've won all of the medium-sized

tournaments but because the tournaments have really risen to a new level over the last eighteen months, especially with the EPT and WPT, it's necessary now to achieve the goal of winning one of these majors. It's not for financial gain, but from my perspective it's a stepping stone to major stardom within poker. I'm not talking about the accolade of being recognized, I'm talking about how you can use the fame to develop your poker career. There are so many opportunities out there. I feel that I have the ability to have the complete package, to really maximize it, but the one thing that's missing, that is absolutely necessary to be able to achieve that, is a major title.'

Can he hide his nervousness from the other players?

'I think at the table I disguise it quite well. If it was evident at the table then I would be a laughing stock because the level of stress and the level of pressure that I'm under is unbelievable. It really is.'

Wow. I'm beginning to feel the pressure for him. I try to divert him by finding out more about him.

His father is a health nut. I've seen pictures of him. Frightening. He shines with good health, ripples with muscle; eat your heart out, Arnold Schwartz-whatever. In fact, he's a world champion body-builder fifteen times. And he makes big money in 'sports nutrition'. This is where it comes from – Carlo's competitive thing. And inevitably Carlo was raised in Whitley Bay in the north-east to become a health nut too. (He still doesn't drink, keeps himself in top shape.) At seventeen he opens a small gym in North Shields. There he meets Dave Buchanan, a professional footballer playing for Sunderland, and they decide to go into the 'get fit' business together. They buy a health club in Redcar, the first of what becomes a chain of them. They distribute get fit equipment. They grow

from three people to 234 in less than two years. They make a lot of money. And then they sell it and Carlo, in his mid-thirties, needs another challenge. Because another thing about Carlo is that he can't rest. It's surprising he can sit still at a poker table. He can't sleep. He's an insomniac. And he wants to be someone. And why not? It's a respectable ambition, and he's bright, fit, good-looking and willing to work.

Then one night Carlo is with friends at a casino in Newcastle and finds poker. 'It was the answer to my prayers because I couldn't sleep and I was wandering about all night, watching videos, etc., and I thought if I could get into poker this would be the answer. I could even play it on the Internet twenty-four hours a day.'

So he persuades an American called Steven Liu, who is winning a fortune in the north-east, to teach him and begins playing in the Stanley Casino in Newcastle. 'Within a few weeks I win my first tournament in Newcastle. I sit with Steven for a year in the Stanley. He won't let me play outside until he thinks I'm ready. That takes about a year. I'm desperate to get out and play somewhere else. I'm winning tournaments regularly and doing rather well in the cash games. We had a good cash game in Newcastle. I go to winning £2,500–£3,000 a week in this cash game and after about a year we go to Walsall in Birmingham for the Midlands championship and the condition is that I play a satellite to enter the £1,000 main event and if I don't win the satellite, I'm not allowed to play. Anyway, I win a seat and play the main event and win it. This is in 2000.

'Another Newcastle guy also helps me. He says, "I'll give you two pieces of advice. Never play in a game that's not in a casino . . . never play in a backstreet game. And never play

with people at a full table who you don't know." And these are two pieces of advice that I've always stuck to.' (It strikes me that when you add this to the old adage, 'Never play cards with a man called Doc, never eat at a place called Mom's and never sleep with a woman whose troubles are worse than your own,' you know all there is to know about life . . . if you're a poker player.)

What he does do is go on to the international circuit and achieve good results. After a series of final tables throughout 2001 and 2002, including a £23,700 second place in the European Championships in 2002, he goes on to win a Hold'em event and share first place with Lucy Rokach in an Omaha event in the 2003 Australian championships and then pick up £42,000 by winning a no-limit Hold'em event at the British Open. He also makes a final table at the World Series in 2003, taking seventh place in the $5,000 no-limit Hold'em event.

'I learned a lesson in Australia about lending money. It was when I split the Omaha with Lucy. I was very short-stacked throughout the tournament and I couldn't get a hand, but I scraped through to the final and there was a big crowd and it was very exciting. I get my money and somebody taps me on the shoulder and says, "I'm just going to pay into the main event and it takes about twenty minutes to go to my room. Give me A$5,000 and I'll pay in, then I'll go and get it." So I was so excited at winning and there was a crowd there and the television and everyone was patting me on the back, so I tossed him a A$5,000 chip and I remember thinking that he'd be all right for it. Anyway, I was so excited that I completely forgot who I gave it to and to this day I've never got it back. I did the same thing in Amsterdam as well. Somebody tapped me on the shoulder when I was involved

in a hand and wanted €1,000 . . . I forgot who I gave it to and I never got it back.'

Now, if you look at Carlo's record you'll find a gap between the beginning of 2004 and spring of 2005. That's because just as Carlo's poker career is really taking off, disaster strikes.

He answers the door one day and finds Her Majesty the Queen standing there in the form of two investigators from HM Customs and Excise. They want to discuss a little matter of 2.7 million cigarettes. The smokes have been smuggled into the country in a container opened at Southampton docks and in the container is a fax that's traceable back to a hotel room in Vienna – the room Carlo stayed in while playing in a tournament there.

Teesside Crown Court is given two versions of the story:

HM Customs and Excise say Carlo booked the shipment under the name of George Hughes and committed the alleged crime together with a Durham haulier called William Howard.

Carlo, who sticks to his story to this day, claims, 'It's not me, guv'; that Hughes was a name being used by a fellow poker player who asked to borrow the fax to send a message, and that his phone calls to Howard are about gym equipment.

He's asked to produce Hughes but says he won't grass on a friend, especially as he has three kids.

The judge believes Her Majesty, and Carlo is sentenced to two years in prison (he actually serves seven and a half months).

This could have devastated a lesser man. Not Carlo. He bounces back on to the poker scene, making no attempt to cover up what's happened, and within weeks is winning the

£25,000 first prize in a no-limit Hold'em event at Luton and the £10,000 fourth prize in a big event in Blackpool. In June he's back on another final table at the World Series, coming eighth in a no-limit Hold'em event.

'I really admire the way he handled it all,' says Barny Boatman, 'a lot of players do. He didn't let it get him down and he talked about it openly and light-heartedly and showed he could send himself up. And it was impressive the way he came back and got straight into the game.'

If Carlo's relaxed about it, it's no doubt because he knows no one on the circuit gives a damn. He also knows that at least half the other players on the circuit and most of the rest of us have at one time or another smuggled cigars or booze or cigarettes into the country too, admittedly 500 or so cigarettes rather than 2.7 million, but that's merely quibbling over the details . . . a mere matter of numbers; you're either a cigarette-smuggler or you're not, and half the country are or have been.

And, anyway, most of the players like Carlo. He's an engaging character, no more so than when in the company of his girlfriend (soon-to-be wife) Samantha and their baby daughter Angelina. And he's another enthusiast. As Barny Boatman says, 'He's got a good sense of humour, he's lively and he's a generous sort of bloke; there's not a malicious bone in his body.' Their main criticism of him is that he's a slow player, takes time to make his decisions. But that, of course, reflects his desperate need to win.

Carlo says he aims to win at least £300,000 a year from poker, about £25,000 a month, mainly in cash games. Ironically, one of the losers as a result is his tutor Steven. Before he taught Carlo to play, Steven cleaned up in the north-east.

Now he finds himself sharing the winnings with his pupil.

Some of the better known pros may soon have to learn to do the same.

♥ ♦ ♠ ♣

PAUL'S STORY

'Does it strike you,' I ask Paul 'Action Jack' Jackson, 'that you're mad?'

'Of course. We all are. We're psychologically disturbed.'

'You don't mean that, do you?

'I do mean that. We must be. Like, most of us will go into a shop and see a thing we like but it costs £7 and we say, "Oh, I don't know, seems a bit much" and we won't buy it. Then an hour later we'll put £300 into a pot, hoping a diamond comes up on the last card. We'll go into a shop to buy a pair of jeans and we'll buy the cheapest we can find because we don't want to spend the money on jeans. Then we go into a casino and risk a fortune. I make a lot of money from poker but I never buy myself a thing. Now is that mad, or what?'

You don't have to be with Paul for more than a few minutes before his nickname Action Jack becomes self-explanatory. He talks at breakneck speed – 'because I like to say what I think and I think fast' – and radiates energy. Just as well, because he needs it. Not only is he playing in four Internet games simultaneously but he's also writing magazine columns, building a 'How to play' Internet site, planning forays into the bigger tournaments, maintaining a family life that involves keeping in touch with two former wives, living with his current twenty-eight-year-old girlfriend and former

casino dealer Anna, and keeping in touch with five children in three households.

Another Midlander, now a young and fit-looking forty (if you follow cricket, think Nasser Hussain; he's the spitting image), he worked as a betting shop manager, became an accountant specializing in taxation (not much help now because he doesn't pay it), and has been playing poker since he was nineteen. Now he's primarily an Internet poker player, sometimes playing as many as sixteen or seventeen hours a day.

And he makes serious money, very serious money, at it.

We meet up in Barcelona and have a drink on the seafront in the cool of the evening.

'When I first started, I put £250 into an account on Ladbrokes. In fact, I've never made another deposit into Ladbrokes.'

That means he's never lost.

'Well, I've lost tournament games and I lose on some days but I've always been ahead overall. I've never had to go back and put more in.

'I started playing in $10 games, $15 games, sometimes $5 games, I mean really small games, but I did well and eventually moved up. Over the last three years on Ladbrokes, from that initial £250, I've probably won somewhere in the region of $400,000.'

My mind reels: $400,000?

He looks surprised that I'm surprised. 'Yes. And I don't play cash games, that's the thing about it; if you're going to be impressed, that's what's particularly impressive about it. I hardly ever play cash games. People who play cash games can win that sort of money in a few weeks at the very highest level but I only play tournaments.'

Amused at my incredulity, he adds, 'That's just on Ladbrokes. I put £300 into my account on bet365 and at the moment I think there's somewhere in the region of $40,000 in it. That's the account my girlfriend uses for the credit card. She pays it off every month through bet365. At the moment there's $40,000 in there and every month for the last eighteen months she's maxed the credit card and paid it off through that account. I only put £300 in that one. The best one is Blue Square. The poker manager from Blue Square met me in Luton about six months ago. He knew who I was and introduced himself and asked if I had an account on Blue Square. I said I did have an account but there was nothing in it. He asked me what my alias was and I told him. He said, "I'll put $100 in for you so you can play," so he put $100 in and I've got it up to about $6,000 or $7,000 now and I don't play very often. I haven't even made a deposit in that one!'

For the umpteenth time I ask myself why I'm buying the drinks for these guys. How much, I wonder, has he made in the three and a half years he's been doing this.

'Probably at least half a million dollars, maybe it's more. One particular evening a few months ago I was playing two tournaments at the same time. There was a big tournament on bet365 and there was a big one on Poker Stars. Both tournaments had over 1,500 players in them and I came first in the bet365, for which I got $23K and I came second in the one on PokerStars and I got $82,000. So that's $100K.'

Now, I find it difficult to play one game at a time. How does he manage to keep on top of two, or even four? If anyone still wonders why he's called Action Jack, consider this: 'I've played seven tournaments in one night on one screen,' he says, 'where I had one tournament in each corner of the screen and three games across the middle, and when it

was my go the relevant screen popped up. Also, I was often typing and talking to people while I was actually playing on the seven tables.' (This was confirmed later when I had to ring him to check one or two facts and asked him if he was playing and whether I was interrupting him. He replied cheerfully that he was in the middle of a high-stakes game but it was OK to talk as well.)

'Basically, in the early and mid stages of a tournament I play like a robot. When it gets to the more important stages I'll normally have been knocked out or I'll have finished one of the other tournaments and I won't add any more and that enables me to spend more time and more concentration on one that's pressing, or when it really matters I'll even close down tournaments to allow myself to concentrate on the one where the big money is. But, generally speaking, it's like playing like a robot.

'There was one particular time when Ladbrokes were enabling the winner of each week's tournament leader board to play a pro – Roy "the Boy" Brindley usually – for $1,000. If Roy wins it rolls over to the next week and it's $2,000 and so on, and when we were in Barcelona last year it rolled up to $10,000 so I made every endeavour to win the leader board that week and I played around thirty-five tournaments per day every day for a week . . . so it added up to about 240-odd tournaments in a week and I won the leader board and I beat Roy heads-up to win the $10,000. You just play like a robot.'

But to play like a robot he would have to play a very tight game.

'In the very early stages I play cautiously because the antes are so small that it's very rare I need to be over-committing

myself. A lot of people are gambling and knocking themselves out. And I let them get on with it and wait for premium hands.

'There's two ways that I play on the Internet. In the early stages I'll play very tight and hope to take advantage of other people's mistakes and allow them to give me their chips. In the later stages of a tournament, as the antes get higher, it matters to win as many pots as possible, then I'll actually try to make moves to win chips. Which puts you more at risk, but I'd rather put myself at risk in the latter stages when you can win something. So I change my game halfway through.'

'You've taught yourself all this. No one has taught you?'

'No one has taught me a thing, no.'

'So, what's the strength of your game?'

'Well, its partly that I'm good with the maths. Poker is all about mathematics. If I think I've got a 60 per cent chance of winning a hand based on the information in front of me then I can make that decision easily. If I can get that right more often than not, then theoretically, in the long run, I'm going to be in front.

'When you're looking at pot odds and looking at whether or not you should call a bet, it's risk-reward, basically. A calculation of risk-reward – how much do you have to call for what's going to be the reward if your call is the right one. There are people who don't even consider pot odds, yet it's a massive part of the game, especially in no-limit poker where you can be calling for your whole stack. It's not just the calculation, it's the general mathematical feel of things in terms of the likelihood of people having certain hands and people raising in certain positions.

'But I think my main strength is analysing other people's

betting patterns. I'll get as much information as possible to assess the strength of my opponent's hand, mainly by the way they bet. I learn that in the early stages and use it later because most people play the same whether it's the earlier or later stages. I watch how each person plays. Like, when you see someone's cards turned over you can judge whether they're a good or bad player because a bad player is likely to be playing with a weaker hand than a good player.'

But it seems to me that if you're in a card room, you see people, you see faces, they register with you and therefore it's easier to keep this sort of mental picture of where they're at, but on the Internet, where you don't have someone there, isn't that more difficult?

'Well, it's more difficult for some people. I know a lot of very good live players who can't play on the Internet and I know a lot of very good Internet players who can't play live. Some people can do both. You're right, the critical difference is that on the Internet you can only judge the strength of your opponent's hand by your knowledge of that player and their betting pattern during the game. Another big difference is that on the Internet you have seconds to weigh up all the information that's there and come to a decision. When you're playing live you can sit there for two minutes thinking about it. I think the reason why a lot of good live players can't play on the Internet is that they can't make their decision accurately in that space of time.

'You must never forget that the main difference between tournaments and cash games is that in tournaments if you make one serious mistake you're gone, whereas in a cash game you can buy more chips. The value of a hand takes on a whole new meaning when you're playing for your life – in tournament terms – as opposed to just the outcome of one

hand. You have to play differently. That's why there tend to be cash or tournament specialists. On the whole, I play so much tournament poker that you could say I'm a specialist.'

Yes, you could say that.

But mad?

He seems sane enough to me. Well . . . sort of.

♥ ♦ ♠ ♣

Back in London, it's time to meet the Hendon Mob – Joe Beevers, Ram Vaswani, and Ross and Barny Boatman. Churchill House, where I find them, is not, it has to be said, very Churchillian (i.e. grand), but then the Hendon Mob are not very Hendonian. Only Joe 'the Elegance' Beevers actually lives there. What they do have in Churchill House is a small office run by a guy called Rob who manages their impressive website and does his best to coordinate their hectic lives.

I'm well looked after. The Mob have booked a posh meeting room elsewhere in the building, ordered coffee in a proper pot and lined themselves up for a series of interviews.

While they're sorting themselves out, I recall what I know about the Mob. It's not a lot – just that they're sponsored as a group by PrimaPoker.com in what is said to be the second best deal in British poker (the Devilfish has had the best); that they each take 5 per cent from each other's winnings; that they're solid players, with Ram considered the most dangerous; that they're immensely popular; and that the publicity and the goodwill they generate is considered by everyone in poker to have been a huge asset to the game.

I begin with Joe, who is thirty-eight and just back from getting married to his girlfriend Claire in Las Vegas. While they proclaim their equality, Joe is, I suspect, the driving force behind the Hendon Mob, top dog. He has that aura,

and he's definitely pushing the buttons as far as my dealings with the Mob are concerned. Joe, I know, has not won this year, his last win being in the Four Queens Poker Classic in Las Vegas in September 2004, worth $72,000. He has, however, also come a well-paid second in Dublin, picking up over $120,000, and collected even more by coming seventh in the World Poker Classic in Las Vegas only this April, a prize of nearly $190,000, so there is little cause to worry about him being able to afford the lifestyle he leads from the luxurious four-bedroom flat nearby. This man is not called 'the Elegance' without reason.

♥ ♦ ♠ ♣

JOE'S STORY

Joe says he began his working life as a blackjack player until he and his dad were banned from nearly every casino in London.

Well, that gets my attention. Where and when did this all begin?

'I left school when I was sixteen but after a few years I went back to university as a mature student and I eventually graduated with a BA honours degree in finance when I was twenty-four. But my dad was a gambler. We played blackjack at home from when I was ten and I actually went to a casino on my eighteenth birthday. My dad taught me to count and for four years from when I was eighteen we played a lot of blackjack in London casinos.

'There were four of us and we used to travel round using a system of counting cards. My father and I would be the main counters. We used to have two counts and signals that we'd use when the two counts coincided and the percentages were

very strong in our favour, and that's when we'd place our bets.

'Like in any kind of gambling, you can have the biggest edge but be unlucky, but the vast majority of times we were walking out with their money. So we got barred, either my father or me; between us we were barred from twenty-one out of twenty-three casinos. We couldn't go to the other two together.

'I began playing poker at Luton. We were there for black-jack. They had no inspectors at Luton. They had no pit bosses watching the tables and the dealers weren't particularly well trained. We had one dealer at Luton who used to deal blackjack for us and couldn't add up. We used to find out when he was on shift and go and play his table when he was on shift. Sometimes you'd get twenty-two and he'd pay you out as twenty-one. The other thing he would often do, if you got a blackjack, is pay you and leave your cards and then pay you again when he went round to the hand and paid every-body else out. So we'd get paid 3–1 at blackjack. He didn't last that long, probably about six months.

'One of these times that we were playing blackjack at Luton a couple of other players got up, and I said, "Where are you going?" And they said they were going to go and play in a poker tournament, so off I went. I didn't win but that's how I started playing poker. I played a lot at Luton and then started to get into other games. By the time I actually gradu-ated from college I was making quite good money playing poker.

'Pre-Internet there were a lot of private games in people's homes. There still are quite a lot. In north London particu-larly there was a game every night of the week.

'Ram and I used to run a game in Hendon, from my flat

in Hendon; Barny and Ross eventually turned up and that's how we all met. We ran it as a business and we made good money. We would rake the game. An average game would run for ten or twelve hours but sometimes a game would run for three or four days. We did it properly. Everything would be laid on, a really nice room, really nice seats, we'd have waitresses and food, free cigarettes and cigars, a dealer, the best cards and chips. Everyone would be well looked after.

'Then we started travelling to European tournaments, bigger events. In 1996 I won my first major event in Amsterdam – £7,000, an absolute fortune for me at the time. I remember I was still sharing a flat with one of my college buddies and I phoned him about three o'clock in the morning and sang, "We are the champions" down the phone. I was very drunk. That was the first taste of real success and then mostly with the other three guys, Ram, Barny and Ross, we'd go to Paris, Dublin, and this is how we really started to become known as the Hendon Mob. We'd walk into an event, a big card room, or we'd walk into Paris and someone would shout, "Here comes the Hendon Mob."

'What really put the Hendon Mob on the map was *Late Night Poker*. We were in Vienna in early 1999, the four of us, and Nic Szeremeta was there talking about this new television show, a brand-new concept with the table cameras to show people your cards. And the majority of the poker players he was talking to were saying they wouldn't do that, because people were going to see how they played. But we thought it was a really good idea. So we all put our hands up and said, "We'll play in it." And all four of us went off to Cardiff some time in 1999 and played the first *Late Night Poker*. Dave "Devilfish" Ulliott knocked me out in the final.

'But *Late Night Poker* became a cult success, an unbeliev-

able success. All of a sudden, people started recognizing us. Students, people in pubs, people in restaurants, people at sporting events: "You're that guy on *Late Night Poker.*" And then we did another series and another series and then everyone wanted to be on *Late Night Poker.*

'Barny said, "Let's set up a website; we need a point of contact because people are going to try to get hold of us and we want to get sponsorship" so we set the website up as a bit of fun. A very good friend of ours set it up and it cost us like £100 and we started to get emails from all over the place and we set up a forum and now we can have 15,000–20,000 people a day visiting the site and it's a big business. It costs £100K a year to run the website. Then one of the top guys from Prima Poker got in touch and we came up with the concept of the Prima Poker Tour, enabling us to travel around the world playing a series of tournaments. And on a handshake at a railway station, we agreed a $500,000 deal. For a six-month contract. The tour was a huge success. We had a lot of success in the first six months and then in 2004 we renewed for a whole year, for $1 million. It covers our costs and the buy-ins. And we keep the winnings. By 2005 it was up to $1.25 million. But the Prima Poker Tour is a sponsorship deal with four of us as four individuals. The Hendon Mob Ltd is a separate company, obviously we are the four directors, but it runs the business side of things. We're bringing out a set of Hendon Mob poker chips and we're going to have a lot of merchandise. We're setting up a mobile phone website at the moment because mobile phone downloads in the UK are hugely popular.

'When we're playing poker we have 5 per cent of each other's action. So if Ram cashes a $1 million, we all get $50,000 each. It's good because we share in each other's

success but it's a small enough percentage that it would never make any difference. And we actually have a reputation of playing very hard against each other. For instance, Barny has been knocked out of more tournaments by Ram than any other player. When Ram, Barny and I went to Australia two years ago, all three of us made the final, and we had three of us in the final of the World Series in Vienna. We had three of us in a final in a Four Queens event. It happens.

'We all play very hard against each other and we have a very good reputation for integrity and honesty.

'One of the good things about the Hendon Mob is that usually at least one of us is doing OK, and obviously in poker there are highs and lows. And some of those lows are where nothing goes right for you when you're abroad and you've lost a lot of money and you need some help. The support I get from the other three and vice versa is very helpful and we're always borrowing money from each other. We've always got running tabs with each other and we're always transferring money to each other's accounts, lending cash or having bets with each other and all kinds of stuff, and it goes on all the time.

'Another thing about the Hendon Mob is, we've never claimed to be great poker players. We're winning poker players, we're professional poker players, but we've never claimed to be better than anybody else. And we're all still ready to learn. We all want to be better.'

RAM'S STORY

'I did $200,000 on the Internet last week – I lost $120K in one pot.'

I gasp. 'One hundred and twenty *thousand*? On *one hand*?'

Ram 'Crazy Horse' Vaswani is surprised that I'm surprised.

'That's the sort of swing I have. But I'm playing in the biggest games, like 100–200 no-limit. It's not a problem; so far this year I'm winning over $1 million playing online.'

Ram, also known as 'the Looks' – Joe is 'the Elegance', Barny is 'the Humour' and Ross is 'the Glamour' – looks amused at my amazement.

'I've always been a big gambler and had big ups and downs. But I like to think I win. Of course, there've been years when I lost.'

I dare not think what, or how much, that means.

The youngest of the Hendon Mob, Ram is *the* gambler, mega-mega gambler, the man with the *Sporting Life* in one hand and a mobile phone in the other. One of the older pros told me, 'Ram is unique in this country. No one else gets near him when it comes to bleeding his winnings. I hear Ram's won a million in a week on the Internet; I see him and I say, "I hear you're getting a lot" and he says, "I'm skint, I've done it all." I saw him win £170K over a period of two days. He done the lot in an hour. If he's not playing poker he's betting mega on the sports. He's probably one of the most talented poker players . . . but he's a complete nutcase.'

'Nutcase' or not, he's also reputed to be the brightest of the Mob, and the best poker player.

He's also the best snooker player, having been a professional for two years when he was nineteen and twenty.

'From when I was thirteen or fourteen I was bunking off school to play snooker and I was OK at it; but I was just below the top hundred ranking and I knew I wasn't going to get to the top. It was natural to go into poker because it's a similar scene to the snooker scene. You will have noticed how many snooker players also play poker – Jimmy White, Steve Davis, Stephen Hendry and so on. When you're hanging around snooker halls all the time, there's always little poker games going on in a corner.'

His first big professional win was in the Master Classics of Poker in Amsterdam in 1999; he won $130,000 in that event. He went on to win tournaments in London and Vienna in 2000, and continued on to high places in a wide range of events all over the world, ending 2003 with back-to-back wins in Luton's Christmas Cracker festival. The following year he made a remarkable three final tables at the World Series, finishing seventh in a limit Hold'em event (winning $50,000), fifth in a pot-limit Hold'em event (another $50,000) and third in a no-limit Hold'em event ($142,000). He went on to his biggest payday a few weeks later, coming second in a big London event and winning $230,000. Late in 2004 he won $117,000 with first place in the main event at the Irish Winter Tournament and then began this year with a second place in Copenhagen ($95,000) followed by a third place in Las Vegas ($101,000). But his big winnings come on the Internet.

What no one knows is how much comes in the poker door and goes out the horse racing and other gambling windows. Joe Beevers says, 'Ram has $100,000 in his pocket one minute and he's broke the next. The next day he'll have twice that in his pocket and he'll be broke the next. But it never fazes him. It's extraordinary.' Barny says that Ram is someone he would trust with his life – 'but not your pin

number, because your money would be gone in a flash. But he'll always pay you back.' Ram and his wife Jackie live in a comfortable three-bedroom house in Mill Hill and he drives a snazzy car, so clearly losing from time to time doesn't affect his quality of life.

Everyone reckons Ram is one of the few British players capable of pulling off the big one in Las Vegas – the World Series title. Even now there are over 5,000 players competing for it. He's got that kind of talent. Even the Devilfish, not one to go out of his way to praise other British players, lists Ram as a genuinely world-class player on his day, one who, when the cards are falling right, can raise his game to beat anyone.

Ram may be a gambler, but he doesn't think poker is gambling. 'I would take the luck factor out of it because luck evens out for any player over a period of time. And you have to think of poker as not today's game, or tomorrow's game, but as a game that goes on and on, and it's what happens over the long term that decides if you're a winner or not. The luck in any one tournament or whatever really doesn't matter, it's irrelevant. You just have to accept it and get on with it. The thing about the luck element is how you deal with the luck and how you deal with a bad beat. It's how you control your emotions and how you continue to use your skill and not let the luck affect your skill and not let the luck affect the guts. That's the way that luck comes into it.

'Three things come into poker. One is knowing the maths of the game. You've got to know the odds, especially when you're putting someone on a hand; you have to know the odds on every kind of hand. The second thing is you have to have a feel for the game; getting a feel for people and picking up tells and understanding betting patterns. And the third thing is guts. It's having the courage of your own convictions.

It's about knowing the right thing to do and *actually doing it*. There are some players that I can think of who are scared to put their money in with the best hand because they're so scared of losing. They may have the skill but they don't have the courage of their convictions. If you know you have the ability to make the right decisions, you have to make those right decisions irrespective of whether it's a big bet facing you; if you're worried about the money then you're either playing in a game that's too big for you or you shouldn't be playing at all.

'When you're playing poker, money shouldn't come into it. After you've worked out the maths of the pot and got a feel for everything in the pot, then you make a decision, and that decision should be based on those two things alone. Poker is about decisions. You should make a decision. The money side of any pot, whether it's cash or chips, should never make a difference to your decision.'

Ram may be a gambler, but in poker he reveals himself to be a clear and logical thinker.

But Ram *is* a gambler and people gamble for kicks. Doesn't he get bored, sitting for hours waiting for the right hands?

It's his turn to look surprised. 'Every time two cards are dealt, you're beginning a new hand. You don't know what those cards are. You don't know what's going to happen in the next few minutes. How can that be boring?'

Barny Boatman comes in. Like Ram, he's wearing jeans. Whereas Ram, who's a young-looking thirty-five, has a touch of charisma about him, you wouldn't particularly notice Barny if you were sitting opposite him on the street. But as I know from my travels, this works for Barny.

♥ ♦ ♠ ♣

BARNY AND ROSS'S STORY

Barny Boatman is not a huge winner, but he's probably the most liked, and undoubtedly one of the most influential of all the pros on the European circuit. With his relaxed commentaries on television, especially on *Late Night Poker*, and his Poker Channel programme *Barny's Home Games* (he goes out and plays with ordinary mortals in their weekly game), he's become a link between the professionals and the recreational poker player. Barny is both one of them and one of us. Because of this, it's not exaggerating to say that he's a key personality in the British game.

And, of course, he gets additional notice by being one of the brothers Boatman, the other being his younger brother Ross, an actor and for years one of the stars of the popular television drama series *London's Burning*.

Barny lives with his partner Sally, an artist, on the top floor of a roomy house in Archway that they shared with Ross until he and his partner Stephanie decided they wanted to raise their son Buster in a 'proper house' and bought one in Holloway.

Barny says, 'Our dad worked for the council as an architect. He was very idealistic. Socialist, both of my parents were or are. And he wanted to do public work. Ross and I have both been influenced by our parents' values. We both believe in equality and we're anti-racist and anti-totalitarian . . . quite left-wing in our ideas.'

'How does poker fit with this?'

'Well, good question. Obviously poker doesn't fit in . . . well, actually, it does and it doesn't. It's a great leveller, poker. It's a great human experience and a great opportunity to meet

people from every background, because when you walk into a poker room you look just like every other poker player, and no one knows who you are or where you come from and no one cares.'

Barny came to the poker scene relatively late in the day. Like most of the Usual Suspects, he left school at sixteen. From his teens to early twenties he worked at all sorts of things, from being a barman to a builder. He was an English teacher in Barcelona. He worked as a journalist and in a law centre in south London, representing people in tribunals, helping them get the right benefits. He kept changing what he was doing. 'I just don't like to be pinned down for too long.'

He puts his relaxed persona at the poker table down to having come to the game 'fully formed as a personality. There have been a number of things that have given me a sense of perspective. I had a bad motorcycle accident when I was younger. That made me appreciate just being alive. One of the most influential things that has happened to me, definitely the saddest, was that my younger sister Jo, who I was close to, got cancer and died. I spent the last couple of years of her life with her nearly all the time and nothing else mattered during that time at all. When you've been through that experience you can never have the perspective that what happens in a poker game really matters.'

Barny played the spielers for a while. 'I remember a game upstairs in a pub in Kentish Town where the pub locked up at 11.30. The manager of the pub and the rest of us sat around a little table in the room upstairs and it was all cash. A lot of the time in those days people would play with ten or twenty pound notes, and you really realized what you were parting with. The people who ran the spielers lent money to

players and they employed professional dealers so they were quite professional operations.

'Once you were on the scene there was no problem about knowing about a game. It's a cut-throat business really because they'll always say, "Oh, we've got so and so, he's a real star," and they're probably saying the same about me to somebody else. A star means someone who's a bad player, by the way, capable of losing a lot of money. Like a fish. I remember being called a star once really early on in my poker career. It was actually just after I won a couple of tournaments at the Vic. I assumed it was a compliment. I was walking around smiling because they'd called me a star! It certainly isn't a compliment.

'This is the slightly less pleasant side of the game. People are leeching on each other and the person that runs the spieler befriends all these people and keeps the whole thing going. Of course they're providing a service but in the end they're trying to keep people coming.

'I never play in the spielers any more, by the way. I don't like them. I don't like the fact that they're built round these stars. The people that run them tend to think that they own these stars, and they get them into the game, sit them there and they butter them up, invite other people – you know: "We've got so and so here."

'Very often, whether you're aware of it or not, there may be one or two people in the game who are basically a mark. I'm not saying it in a high-minded way that I wouldn't sit down if a multimillionaire was in a game and I got a signal that he couldn't play. I'm not saying that I wouldn't play but it's not usually as cut-and-dried as that. It might be some guy who owns a restaurant or a newsagent's and he's gradually running his business into the ground and he can play a bit

but you know he's slightly out of his depth. Of course, you might find exactly the same people in a casino but the business of running a cash game in a casino is built around providing the service to everyone, and they don't really care who sits down in the game. They get their bit of money regardless, and the game goes on. Also, it's a lot safer and you're sure it's all going to be above board.

'That's one of the reasons why a lot of us prefer tournaments. Somehow or other, in tournament poker the competitive element is less dehumanizing, less brutalizing than it is in the cash.'

Ross, his brother, knew from when he was a boy that he wanted to be an actor and went to RADA and from there fell on his feet with the part in *London's Burning*. He famously turned down a part in *Lock, Stock and Two Smoking Barrels*, having just appeared in another gangster film and figuring he didn't want to get typecast, especially by appearing in a low-budget film with little chance of success!

Ross remembers that as a kid he heard laughter from downstairs and went to the top of the landing and he could just see, framed in the stairway, coins and cards on a green baize cloth. Barny had friends round to play poker. 'I remember looking down and thinking that it looked really exciting because there were colourful cards and money changing hands, and I'd probably watched for twenty minutes before I plucked up the courage to go up and say, "Can I play?" and Barny said "There's no way you can play, we don't want to take your money" and I begged him and said I just want to learn, and I think Barny had taught me the rules of seven-card stud some time earlier so I had a little idea of how to play the game. So we sat down and after about half an hour I was probably winning £4 or £5 and this is like thirty years

ago and I was really excited about that. I remember raking in these big pots of shiny coins. Looking back on it now, they were probably letting me win a couple of hands so they could get rid of me. But of course that was it. There was no getting rid of me. I was hooked for a lifetime of poker.

'Later on in my early twenties I had a regular pool of friends I had played with right from my teens, and Barny had a group of friends that he played with as well and the game kind of merged. I remember eventually I was cleaning out all of my friends and they all owed me thousands of pounds and none of them wanted to see me any more and the same thing was happening with Barny and we decided to stop playing these little games with our friends, and we heard about this casino called the Vic where they ran £25 Hold'em tournaments and I remember going in and paying £25 for my first tournament and I was used to winning and losing bigger amounts than that. I was about twenty-five. I was earning good money at that time doing *London's Burning*, but I remember I was so excited, my heart was thumping, pumping like a steam train; I was so excited by this and being in a casino. I can't remember how I did in my first tournament but I became a regular at the Vic and it wasn't long before I won a tournament.'

The likeable brothers became a familiar part of the poker scene. But while obviously close and loyal to each other, they also lead very different lives. Ross is now an established actor, and in a profession notorious for high unemployment, seems to have few problems finding parts. He played in *London's Burning* for the first eight of its fifteen years, appearing in around 100 episodes. At its peak it had nearly 20 million viewers. This double life distinguishes him from most poker players, as does his proclamation that if he had to choose

between acting or poker, he would choose acting, not that he wants to have to make that choice. Barny is much more at the heart of the Hendon Mob 'business'.

Both have significant achievements to their name. Barny came second in a World Series of Poker event in 2002, winning $77,000 at pot-limit seven-card stud. Also, that year he and Ross became the first brothers ever to appear in a World Series final together, the pot-limit Omaha. Ross was top European money-winner that year. The following year the two brothers came first and second in the pot-limit Hold'em event at the Four Queens Poker Classic in Las Vegas, Barny beating Ross in the heads-up. Barny also won two European tournaments in 2003, each worth about $30,000, but since then both have found it tough-going as the game has become more competitive, although Ross won a British Open event earlier this year (2005).

♥ ♦ ♠ ♣

How does one sum up the Hendon Mob? Likeable guys. A great team, genuine friends. Perhaps below the top rung of poker players but all capable of a world-class performance . . . Ram, the gambler, with the flair; Joe, the businessman, with the mathematical mind; Ross, the actor, with the table presence; Barny, the enthusiast and the idealist, with the imagination. Put it all altogether, and the resultant player would be unassailable. As it is, the record is impressive.

Recently they had been to Dublin to play four top Irish players in a four-man team challenge. Ireland fielded a world-class team – Donnacha O'Dea, Liam Flood, Padraig Parkinson and Scott Gray.

The 'prize' was a crystal trophy. But the players also put their own money on the table to create a cash prize.

'How much do you want to play for?' asked Donnacha.

'How much have you got?' Ross replied.

It was a substantial sum.

The Hendon Mob won 4–nil.

10 / Las Vegas – the World Series

If you play poker, this is where you have to be. Nowhere else in the world matters . . . in fact, there IS nowhere else in the world.

A. H. Macaulay, online poker player, on seeing 2,500 players in action on day one of the main event

It's late June, and over 5,500 poker players descend on the state of Nevada from all over the world, about 300 of them from England and Ireland. This is it, the big one, the Olympic Games of poker, the six-week festival in Las Vegas known as the World Series of Poker (WSOP).

Just about all the Usual Suspects are on their way. The flights from London are packed with gamblers. If there were twenty-first-century airborne versions of the highwaymen of old, this would be payday, because many of these players carry with them a small fortune, admittedly some of it in bank drafts, but also some of it in cash. (Poker players like cash; I've seen players with rolls of £50 notes the size of wine barrels.) If they're going to play the whole festival – and, of course, few can afford to – they'll need about $100,000 in tournament buy-ins alone, plus a bankroll for the cash games; then there's the hotels, the restaurants, the taxis and so on.

A handful are heading for glory in the form of a gold

bracelet for winning one of the forty-odd separate events; the majority will have their ups and downs – you win some, you lose some – and will have fun and hopefully make enough to pay their way. Others are destined to suffer defeat, despair, even disaster. They'll spend days hustling around the fringes, trying to raise the money for the latest game, barely able to pay for food. Some of the best-known names in British poker will end up standing on the wrong side of the ropes unless they're helped by friends, fellow players, or anyone else from whom they can beg and borrow and not quite steal.

But all this is for later. For now, on the plane from Gatwick, it's all optimism. This is a flight of fantasy, it's destination a dream – first place in event no. 42, 'the main event', the $10,000 buy-in World Championship of Poker. For this someone will win the richest prize offered for any recreational event staged on the planet – $7.5 million.

And who's to say any one on the plane can't win it? Have not non-professionals won the main event three years in a row?

If you do have to endure a twelve-hour economy flight, you could be worse off than finding Neil 'Bad Beat' Channing sitting beside you. You can forget the headphones and the films; this boyish-looking thirty-seven year old can talk for the whole flight without taking a breath. Not that this matters – he's an engaging chap and a fount of knowledge on gambling and poker. He should be, because he's been betting and taking bets since he was eleven when he and Keith 'the Camel' Hawkins (now another well-known poker player) teamed up at their comprehensive school in Berkshire. By the time he was sixteen, Neil was the school bookmaker and spending every spare hour at race meetings.

His dream was to be a bookmaker – *the* bookmaker – the

king of bookmakers. He made a humble but practical start. 'I met a bookie and went into business with him on the dogs but he was a bit wild and used to drink all his money away. Then I went into partnership with another on-course bookmaker. But it was small-time. It was dead man's shoes; you couldn't move up through the pitches unless somebody dropped out. And nobody ever did because it was a licence to print money. Then they introduced auctions for pitches and there was a real gold rush and the prices went up and up and up. I bought quite a lot of pitches out of gambling winnings, and I borrowed some money from my father to buy some more, and it went well for a couple of years. But the market fell out of the pitches because Internet betting came in and various things like the end of tax in betting shops, and fewer people were going racing because you could watch it at home on satellite TV. So I'd spent £300,000 on these racecourse pitches and now they were worth about £30,000. Which was pretty bad for me.'

A really bad run, and the collapse in the value of his pitches, caused him to go broke. 'I didn't have a shilling, I'd lost everything. And that was my lifelong dream, to be a racecourse bookmaker and be the top racecourse bookmaker in the country. I wanted to take on everybody and be the king in that business. I supported that dream, I pumped everything I had into it, all my winnings from sports betting and poker.'

He had been playing poker on and off for years, but now began to play it more seriously, becoming a regular at the Vic where he's now a familiar face. He claims to win between £50,000 and £100,000 a year in the £100 buy-in Hold'em game played there.

I am embarrassed whenever I meet Neil by memories of a

hand we shared at the Vic. It was the worst hand of poker I ever played. I had committed the cardinal sin of returning to the table after drinking wine with dinner. I was £700 up on the Vic at this point and plonked it down in front of the recently vacated seat two and found myself in the big blind with pocket kings. I reraised before the flop, and only Neil, who had initially raised from seat three, called. The flop came ace-10-7 – all diamonds. I had the king of diamonds, so now I had both a pair of kings and a draw for the nut flush. I raised the pot and Neil called. The turn card was no help. By now I should have been getting worried by Neil's continued presence in the hand; after all, Neil could have had an ace, or two diamonds. But I wasn't thinking as clearly as I would have been before dinner. So I raised the pot further. Neil called. The river card was no help, either. So now I had missed the flush and the kings were looking vulnerable to the ace. Wine or no wine, I knew better than to raise further. I checked. Neil then bet £400. Now this was the moment to concede defeat, kick myself for ever having sat at the table, look at my watch and mutter, 'My God, is it that time? My train . . .' and flee. Did I do that? No, I did not. I convinced myself that Neil was bluffing. I called, Neil turned over two diamonds, and I left the table humiliated. And serve me right.

Now I ask Neil about that hand. Basically, is there any way I could have played it worse? Neil, who has no wish to discourage a fish, let alone a minnow, is kind. 'I think you're a bit harsh on yourself about that hand. Basically, you made two mistakes.

'I'll tell you what I was thinking. The hand I had was the 4-5 of diamonds and I raised from an early position and it got back round to you, and you reraised. There's no hand that you're going to reraise me with that's worse than 4-5. So

I know that you're beating me. What I have to think about is how much it's going to cost me to see a flop with this hand, and this is a really easy hand to play, 4-5, because you either hit it or you don't. It either comes 4-4 or 5-5 or I flop a straight or I flop a flush or I've done with it. I know when you reraise me, you're going to show me ace-king, two aces, two kings, two queens, possibly two jacks, two 10s; this is pretty much the range of hands that you're going to have. All I have to decide is how much it's going to cost me to see this flop, and have you got enough money in front of you to make it worth me taking the chance of experiencing some kind of miracle and getting all the money.

'So I looked and I think you had around about £800 in front of you and I decided that was enough. If I called a tenner, which I think it was going to cost me, or fifteen quid, that was a good enough risk with a chance of winning £800 from someone who's a fairly inexperienced player. The other key factor about the flop was that I would have position. You would be acting first throughout the pot, so I would have a chance to see how you reacted to each of the cards as they came over. So this was a big factor in my thinking. So I called and obviously it *was* a total miracle flop; it came down three diamonds. It was ace-high. So you were first to go, and you quite correctly bet the flop.

'Now I don't think you made any mistake here, I would have done exactly the same thing with your hand. You have got pocket kings, and you had the king of diamonds . . . you're thinking that I didn't reraise you back again before the flop and therefore I probably don't have a pair of aces. The chances are I've got some small pair or some kind of suited connectors.

'What you must do now, if you have a pair of kings and it comes an ace-high flop, the first thing you want to do is pretend that you have an ace. So I think you did exactly the right thing, betting to represent the ace.

'What happened then was I decided to call you, because I felt that you might have a hand that contained an ace and a diamond. That seemed like the most likely thing; if I raise you at that stage you're probably going to call me and I'm not going to know much more about your hand. I don't really want to put in a lot of money in this pot until the turn card comes down and it's not a diamond. As long as the turn card isn't a diamond I'm going to be happy to stick the lot in.

'Now I call; the turn card isn't a diamond.

'This is where I think you made your first mistake. You now decided to bet again. When I called you on the flop, whatever you were thinking I had before the flop, you should've now revised your opinion. Because I've called you on the flop, it now becomes possible that I've got an ace, or that somehow I've managed to get two pairs. The alternative is that I've flopped a flush. It's not very likely but it's possible. The other alternative is that I have a high diamond in my hand, possibly with an ace. These are the possibilities.

'I think on the turn, you should have checked and waited to see what I did. I might have decided to check behind you if, say, I had a pair of 9s with the 9 of diamonds; I would probably have just checked behind you and the pot would have played a lot smaller. What in fact would have happened in this case is that you would have checked with your two kings and I would have bet. I had to bet here because I didn't want you to catch another diamond so I would have bet the

pot which would be a lot smaller than it in fact became after you bet the turn. If you had checked, you could then have afforded to call my bet and get to the river more cheaply.

'Now the river comes without a diamond. Effectively, you don't really have a hand now. Either your kings are beating my one diamond and one other card like my pair of 9s with the 9 of diamonds, or more likely I've got an ace and I'm going to win. You should have been thinking that you'd been unlucky; you'd had kings before the flop and I'd had an ace and I'd hit an ace but, you know, that happens, and you've got to sometimes just cut your losses. Your saving card up to now was the fact that you had the king of diamonds. This was not a saving card for you any more; there were no more cards to get a flush with.

'So losing a lot of money on the river is probably the worst mistake you made in the pot. When I bet, you should have known that I now had the stronger hand and you should have got out. In my view, you were too preoccupied with your own hand, and you were too reluctant to accept that it hadn't improved but probably weakened; you should have thought more about *my* actions and what I probably had.'

I had, of course, worked this out for myself over many hours of self-recrimination but was fascinated to hear Neil describe it, not least because this was just one hand amidst hundreds and hundreds of thousands Neil has played, and weeks have passed since that night, yet he remembers it almost exactly and can discuss it as if it were played only yesterday and was the most critical hand he ever played. The ability of the pros to recall even the most minor hands exactly, years after they're played, never ceases to amaze me.

OK, I'm in so deep now, I decide to get Neil's impression of my game.

'Well, you've got a fairly straightforward style. You haven't shown a lot of creativity or flair, and that's OK because creativity or flair can get you into big trouble and you need a lot of experience to use creativity and flair. You appear reasonably disciplined and you have a good understanding of where you are in a lot of the pots. There have been one or two that you've told me about where I've noticed more than one mistake that you made in a pot but I've watched you play other hands quite well. You don't play to a bad standard. I think you're probably, in terms of the leisure players, just about above average. I think you could be a good player but I'd have to say that at present professional players don't have much to fear from you.'

This will come as good news to all the American poker stars who've been fearing my arrival. What it does for my own confidence is minimal. I'm not a complete write-off, but it hardly suggests I should invest $10,000 in the main event.

It's over 100 degrees in Las Vegas. The good news is that it's not unbearably humid; it's a dry heat, but the bad news is it's so hot and dry you can't breathe. Unless you get into a taxi quickly you will suffocate and die, and the queue is full of poker players who look as if they're about to do just that. Of course, it could be the shock of seeing daylight that makes them look like this.

The short taxi ride itself is a revelation. You think you're in Las Vegas, but that huge pyramid on your right says Cairo. That's until you come to the Empire State Building and the New York skyline. But, wait. Is this the Eiffel Tower I see before me? So it's Paris, then. This city is insane. It no longer

knows what or where it is. Which probably explains why the foyer of the Rio is a complete and utter madhouse.

Not one square inch of this place is wasted. Not only are there rows of slot machines in its vast foyer, but blackjack tables, bars, half-naked girls serving food from a variety of restaurants to hundreds of people milling about, spending money as if it's going out of style – *and this is just the foyer*. It would easily be possible to never get from the front desk to the lift; all you have to do is stop off at a blackjack table on the way, order a drink and a snack, lose your holiday money and go back to the airport without unpacking.

Of the UK players it's the Devilfish who hits the ground running. The first public event of the 2005 WSOP, a $1,500 no-limit Hold'em tournament, is huge – at this point, the second biggest poker game ever staged, with 2,305 players taking part, only 273 fewer than the 2004 main event. The Devilfish takes it by the scruff of the neck and after 2,296 have been eliminated he's on the final table. He ends up in the final three, but at a chip disadvantage. The leader, Allen Cunningham (already the winner of three gold bracelets), has 1,900,000, the Devilfish has 845,000 and Scott Fischman has 680,000. With the gap between himself and the leader growing, Devilfish decides to go for broke; he has jack-10 of hearts in the pocket and the flop produces two more hearts. He now has two chances for a flush and goes all-in. Cunningham calls him with two 8s and the pair stands up.

But Devilfish has made a stunning start to his World Series, leaving 2,302 players, including many of the world's best, in his wake and winning $232,205. As much as the money, it's a big boost to his confidence. The Fish is in form. And if there were any doubts that he's world-class, they've been put to rest.

But when I finally catch up with him, he's disappointed. 'The money doesn't matter to me; it's the bracelet I want. I'm really disappointed to have got so close and not got it.'

I watch this opening tournament with amazement. Television doesn't do the World Series justice. What it doesn't convey, and probably can't, is the breathtaking spectacle, the colour, the sound and, more unexpectedly, the movement of nearly 2,500 people playing poker at more than 200 tables in a hall the size of a football pitch, while scores of spectators mill around behind the ropes, looking for the action, soaking up the atmosphere, staring at the stars. It really is stunning to see.

And what's extraordinary about this event is that anyone can play – anyone with the buy-in money, that is. This is not like Wimbledon, or the British Open, or the Olympic Games, where only a tiny elite can qualify to actually play. Poker is the ultimate democratic activity. It doesn't matter whether you're a poker television star, a seasoned pro or a dreamer, like me, you pays your money, you gets your chips. And it's informal, and I don't just mean the clothes, even if it is about the worst-dressed crowd in the western world, from the 'professor of poker', the famous Howard Lederer, a big man, looking like an American footballer in an ill-fitting Full Tilt sweatshirt and cap, to defending champion Greg Raymer in unflattering shorts. It's both well-organized and wonderfully chaotic, both big business and lads' night out. It's a one-off international reunion for anyone and everyone in poker.

I queue up at a desk to register as a player for the six weeks. I am now an official WSOP player. This doesn't cost a dime. I then queue at the cashier's window to buy in to any event I wish to play and I'm handed a ticket designating my

table and seat number. And I'm in; I can now say that I've played in a WSOP gold bracelet event.

At the table the dealer awaits me, nine neat piles of chips lined up in front of him. I hand over my piece of paper and sit down at the designated seat, and he pushes the chips towards me. The other players arrive; if you're sociable, like me, you say 'Hi' and ask your neighbour where he/she comes from. If you're not, you give everyone a cold stare, put on dark glasses and an iPod and, having hopefully psyched everybody out, retreat into hostile silence. Fortunately, the latter are in a minority.

When everyone's seated the tournament director says what he has to say and then cries out, 'Shuffle up and deal' and a sudden silence descends. The game's afoot.

Over the hours that follow, players begin to be eliminated, and the remaining competitors are consolidated on fewer and fewer tables, until nine end up on the final table. As the tournament grows smaller, the part of the room devoted to cash games correspondingly grows, with tournament players seeking to repair their bank balances and revive their morale in hand-to-hand combat before another tournament opportunity arises the next day.

By now the satellites have also started. These go on throughout the six weeks and are the way that players like me, who cannot possibly justify investing $10,000 for the main event, try to get in by winning a seat at either a super satellite, involving hundreds of players, or a single satellite. The single satellite costs $1,000 a seat, with the winner – the sole survivor of ten players – ending up with $10,000 and entry to the main event. The super satellite costs less but there's less chance of winning.

For the ordinary player – me being as ordinary as they

come – the most exciting thing is that you can end up playing with just about anyone. In a media-celebrity event I take a hand off former world champion Tom McEvoy, admittedly helped by a nut flush. And he says, 'Well played.' *Well played!* This is *Tom McEvoy*, first main event winner to qualify via a satellite, winner of four gold bracelets, author of some of the books I've been buying and studying, *that* Tom McEvoy – the one now pushing his chips in my direction – who says, '*Well played*'! Wow! (I had the nuts. Mickey Mouse would have won the hand. But who cares?)

I have a camera with me and I'm having trouble getting the flash to work. 'Hey, let me help you with that,' says someone at a nearby table. I look round. Ye gods, it's the film actor James Woods.

I run into Tony Holden, author of the cult book, *Big Deal*, describing his year as a professional poker player fifteen years back. Tony and I have known each other for nearly thirty years and together we now take a taxi downtown to Binion's Horseshoe for dinner.

Las Vegas is like two cities in one.

First, there is the Strip. You hit it almost immediately you leave the airport. This is where the vast majority of holiday-makers and all but the more down-at-heel gamblers spend nearly all of their time, the holidaymakers by the pool in the daytime and in the casinos and restaurants and theatres in the evening, the gamblers in the places the sun can never reach. This is where the Rio is, just down the road from Caesars Palace, the Mirage and the Bellagio.

And then there's downtown, the Fremont Street area, known as Glitter Gulch, definitely the downmarket, rougher end of the city, but with some of the most famous names in Las Vegas history, above all, Binion's Horseshoe and the

Golden Nugget. It's nearer this end that you find the less salubrious wedding parlours, and also the bail-bond shops, the pawnbrokers, the strip joints and the smaller casinos where the rules for blackjack and other games are, shall we say, questionable.

It's to the Horseshoe that Tony Holden and I make our way. I'm surprised by the wave of nostalgia that strikes Tony as we walk in the door. This, of course, is where Tony came in 1988 to write *Big Deal* and where he played his part in knocking out the legendary Stuey Ungar by taking nearly a fifth of his chips in the opening hand. There were 167 entries that year and Tony reached ninetieth place. That year, and the following year, he won his entry into the $10,000 world title event by winning satellites. The second year he came 111th, his one-year career as a poker player ending as he 'reeled away badly winded, as if I'd been punched hard in the stomach – a real physical pain, gradually giving way to a deep spiritual bruise, throbbing away with a relentlessness that only hardened professionals feel'.

Now he's visibly moved as he points out where he sat in the card room that had once been home for the World Series. We go together to the 'Hall of Fame', in fact, just a series of photographs on the card-room wall, but with all the most famous players there . . . including Doyle 'Texas Dolly' Brunson (of course), but also three-times world champion Johnny Moss (winner of eight gold bracelets), 'Amarillo Slim' (still playing poker at seventy-five), 'Puggy' Pearson (world champion in 1973 and a familiar figure at the Rio this year), Bobby 'the Owl' Baldwin (1978 world champion and now a big-time Las Vegas businessman), Stu 'the Kid' Ungar (who won over $30 million but died broke at forty-five), Jack 'Treetops' Straus (who died at fifty-eight while playing poker and was down to

just one chip in the 1982 World Series and came back from there to win the title), Tom McEvoy (first player to win the World Series via a satellite, now better known in the Wilson household as the man vanquished by me in this great hand at the World Series 2005) and Johnny Chan (two-times World Series champion, well known beyond the game for his appearance in the poker film *Rounders*).

What were my chances of making this list? Tony thought about 6,000 million to one, a figure more or less equal to the sum of human life. The requirement, he said, was that you had to have played consistently well for high stakes with acknowledged top competitors, maintaining all the while the respect of your peers while doing this over many years.

Oh well, there's always food. We make our way to the top floor and the famous ranch-house restaurant; this, Tony is pleased to find, has not changed a bit. Still all dark wood, white tablecloths, elderly waiters in dinner jackets, huge steaks and a spectacular view over the downtown area, over mid-Las Vegas, and all the way up to the towering palaces on the strip.

Over more than one bottle of red wine, Tony tells me the story of Binion's Horseshoe and the World Series.

He knew Benny Binion towards the end of his life and described him as a small man who wore an enormous white stetson and cowboy boots, and had three-dollar gold pieces sewn on his suits instead of buttons.

In 1946 Binion had fled Texas, leaving behind a police record that in addition to theft, unlawful gambling and various other offences, included two counts of murder. Somehow he had persuaded the judge it had been self-defence. (He eventually returned to Texas to plead guilty to tax charges, and served three and a half years in prison.) There's no

question that Binion was a hard man, always ready to solve problems with a gun if a baseball bat wasn't at hand, but he was not without energy and entrepreneurial talents, and took over a run-down casino and renamed it Binion's Horseshoe. He wanted no part of the fantasy worlds being created in the hotel-casinos on the strips; he wanted a simple place for gambling, and he understood the attraction to gamblers of reasonably priced food and big helpings, plenty of gaming tables, and minimum overheads to pass on to the players.

So how did the World Series start?

Tony explains: 'There was a man called Nick "the Greek" Dandalos, who made a fortune gambling on the East Coast, and came to town and told Binion that he wanted to play a big game. It had to be heads-up, with just the one opponent, and winner-take-all. Binion contacted his old Texan friend, Johnny Moss, who he believed to be the best poker player in the world. Moss had already been in a non-stop game for three days, but he immediately set off for Las Vegas, and the game duly began on a Sunday in January 1949.

'It lasted five months. They only broke for sleep every few days, and even then the Greek would chide the younger Moss. "Whaddaya gonna do?" he would say. "Sleep your life away?"'

In the meantime, Benny Binion had placed the table where it could be seen by the maximum number of people, and from time to time others were allowed to join the game, although they were soon broken.

Tony says that Johnny Moss, who he subsequently interviewed about it, would not disclose how much he eventually won, but it's believed to be in the vicinity of $2 million. It all ended when the Greek finally stood up and said simply, 'Mr Moss, I have to let you go.'

Nearly twenty years passed before Benny Binion decided to try and create a similar event by asking the world's leading poker players to compete in public, the winner to become world champion. The first year, the professionals ended up electing the champion – Johnny Moss.

From then on, it was competed for properly, slowly growing year after year until it's become the premier poker event on the planet, its main event, with the title world champion, the gold bracelet and an ever-growing prize, becoming the stuff of every poker player's dreams. In 1973 the main event was televised for the first time. In 1974 the tradition of awarding gold bracelets was established. In 1983 the then tournament director and famous Las Vegas personality Eric Drache invented the satellites. Tom McEvoy won it that year, by taking the satellite route. And Donnacha O'Dea became the first non-American to get into the money.

Now, finally, in 2005, with Benny Binion dead, and the Binion family having lost the Horseshoe, it has become too big for the now rather tired-looking old gaming hall, and the rights to it have been purchased by Harrah's who have moved it to the Rio.

So back to the Rio and the card room where the Usual Suspects don't have to wait long for a second success after the Devilfish's opening gambit. This time it's fifty-six-year-old Vic veteran Jeff Duvall putting up a fight in the $1,500 Omaha high-low tournament. Nearly 700 players and he's on the final table. This is a considerable achievement for someone who prefers cash games, although he's scored reasonably consistently in European events, notably winning the 2002 European Omaha championship in Paris and with it nearly

$50,000. And at the World Series in 2003 he was in the money twice, including a fourth in the £1,000 pot-limit Omaha.

By the time I get to talk to him, he's out in third place, having won $77,000, and looking pleased with himself.

'Well, that's more or less paid for my World Series; I'm not staying for the main event anyway. I don't have a hope of winning it; it's $10,000 dollars buy-in and I'll only burn my money.'

Jeff's a real pro. Feet on the ground. What you would expect of someone who's seen it all. And loves the game inside the game. Because this man is pure Damon Runyan. When he's wearing his thirties-style gear, especially the hat, he could be on the stage of *Guys and Dolls*. And he's never without a smile, winning or losing. And in his day he's done plenty of both.

♥ ♦ ♠ ♣

JEFF'S STORY

If anyone is born a gambler, Jeff is. His mum actually starts having contractions while she's at a dog track (Jeff was probably trying to get out of the womb in time to place a bet on a dog in the 7.30!).

The family lives near the dog track; it saves time getting there.

When he isn't gambling his dad's a carpenter, but both Jeff's parents gamble on whatever is moving at the time – dogs, horses, whatever, and, of course, cards. They play cards at home and Jeff joins in. When he leaves school at sixteen he goes straight into the industry, as a trainee manager in a betting shop.

'It didn't last long. I had a few problems. I was a big gambler then. I was doing dog tracks every night. All around London, from when I was sixteen. I was really compulsive, but not as bad as my brother. He became secretary of Gamblers Anonymous. He had a big problem. He was a professional fighter and a big seller of ticket money but he'd do it in gambling before he even got into the ring, so that lots of times he was fighting for nothing.

'For a while I managed pubs. Then in my late twenties I got into blackjack. I played blackjack professionally for a number of years. I started card-counting. Counting is the minimum level of what you can do in professional blackjack. Then there's shuffle-tracking, there's all sorts of sequential tracking. Lot's of things follow on from card-counting but you need the basis of card-counting to be able to do the other things that give you a bigger edge. I was getting barred everywhere. You don't even have to be winning to be barred. They know you're playing with an advantage. What happens is your name gets put around, your picture gets put around. I mean, I've been barred out of the Vic at least four times. The last time we were marched out by the police, which was in 1988. We refused to leave. There was a team of three of us and we were losing about £10,000 and we were eating in the restaurant when they came.

'We went everywhere, everywhere there was a decent game. We would play as high as we could possibly play. We had a very, very big edge. Card-counting, you may get a 1–1 and a 0.5 per cent edge, but we were playing, when we had the big bets, with upwards of 20 per cent edge on the bet. It was all about remembering sequences of cards . . . it's patterns of cards you're looking for. And to get this you have to have poor shuffling. We were looking for casinos that weren't

shuffling properly. Basically, in the eighties, that was all of them. None of them were shuffling properly. Now there's shuffling machines.

'If you knew that the next card was an ace, you had a 52 per cent advantage. Even if it was going to be in the next three cards, then you played three boxes and you'd still got an edge.

'It's a good way of life when it's going well. But we kept getting barred just when we were really making money. The other problem was that I was losing a lot of it on the horses – not all of it, but a good proportion of it. Most gamblers, poker players, have some sort of leak, and horses have always been my leak, and a bit of sports betting as well. Cricket, I lasted on cricket for three weeks when spread betting was booming. I didn't know anything about cricket. Nothing. I did a fortune.

'I was trying to balance it with family life. I got married at twenty-one and I've got four daughters now. I had two at that time. They were having to tell their schools what their parents did for a living and things like that. That was the sort of thing that was awkward. My youngest daughter used to tell everyone I was a fireman!

'We then moved to the States. They were looking for people to do options trading on the Stock Exchange, who could manage risk around gambling, and that's basically all that options trading is, a form of gambling. So I went there in '86 and had a fantastic year, brought everybody over, sold the house. Then the crash came in '87. I was making probably between $20,000–$30,000 a week that year, on the market, and we lost it all in one week. There was over half a million in the trading account and after the crash I was half a million the other way. So I had to get out of that.

'To give you an idea of the effect of the crash, before it I was paying $6,000 a month for the seat to trade. You had to rent the seat in the American Stock Exchange. After the crash, you could get the same seat for $200 a month. That shows you how much business had gone, just went out of the markets.

'So now we're broke, owed plenty of money. I spent eighteen months commuting to Atlantic City, gambling, but it was tough. So off we go to Vegas as a family. Turned up in Vegas in '89, broke. We had a couple of friends there who put us up and we got going again. Things were pretty good. We got a blackjack team going and I started winning, found some good games. They're very funny, the Americans. They think they know everything about gambling. We had something they'd never seen before, the ace-tracking. Then, all of a sudden, we're barred everywhere. We had a lot of problems. We got arrested. They thought we had computers, all sorts of things. We were just doing sequential tracking, but every time we were betting, an ace was coming out and they were convinced we had some sort of computer device. I was arrested a couple of times, never charged, but it became crazy. I couldn't walk into a casino without somebody giving me a hard time. We were getting ground down.

'That is when I switched to poker. I bought a couple of books. Friends had already made the transition from blackjack to poker and I had two or three years grounding in low-stakes poker.

'We came home in '92, basically because I couldn't play any more blackjack and I wasn't making enough from playing low-limit poker at that point. I went back to work; no gambling for a couple of years. I went to work for Canon. I was selling photocopiers. I did well for a couple of years but then

I couldn't stand it any more. It was hard coming home at 6 p.m., sitting down for your dinner and watching TV.

'Anyway, I felt that this wasn't for me so I went back to poker about ten years ago now, at first struggling and just about paying the bills, but it was a struggle. And then gradually I got on top of it and I've been doing OK for most of the last ten years.'

In fact, he's become one of the most respected players in the UK, as well as one of the most liked – friendly, good-natured, good fun. He also has plenty of common sense to share with those who have ambitions to be poker pros.

'Most of the top fifty players in this country, they all play as well as each other. The biggest difference is how they play when they're losing. That's the key; what they're doing when they're having a bad time. You've got to still play well. Most people, when they take a couple of bad beats and they're losing, start to play more hands and play hands they shouldn't be playing. And they get themselves into more trouble. And they crack up. It's called steaming. The very good players, they don't do that. People think it's because they've got better reading skills, they've got better mathematical skills, but most of that's nonsense. We all know the odds and I've got a good idea when you're bluffing and you've got a good idea when I'm bluffing. But when I'm losing, I think you're bluffing more than you are because I want you to be bluffing. So I call you more . . . it's how you play when you lose.'

And what's happened is that Jeff has become more and more a professional poker player and less and less of a gambler. 'The gamble has gone. I would say I'm a professional poker player now and probably a reasonably conservative one. I go about it professionally. I work out the hourly rate. I

keep records of every day, how many hours and then at the end of each month what games I've played; the hourly rate in each game, the minus rate in some tournaments, over a period of time.

'I'm basically a cash player. I'm careful about tournaments. It's hard to make money in them, they're so big now and the cost of playing them is equally big.'

As always, I'm interested in the difference between cash and tournament players. Jeff supplies some of the answers.

'In tournaments you have to make sure you don't call with inferior hands. You can bet with inferior hands but you can't call with inferior hands. Your awareness of where your chip stack is in relation to the rest of the field is another skill, whereas in a cash game it's not, because whenever your chip stack is low you can just call for more money and just top up and make sure yours is the biggest chip stack.

'In a cash game, if you're to have an edge you should have the biggest stack or one of the biggest in relation to the size of the game. They have such a disadvantage, low stacks in a cash game. So you immediately adjust that so that doesn't come into it. When you're in a tournament you can't add to those chips so you have be totally aware of where your chip stack is in relation to the other players. If you're getting short on chips, you need to know how much the blinds and the antes are on any particular round and how much it's going to cost you per round. If you don't have many chips then you've got to bet your chips or you're going to be antied away anyway. If you have lots of rounds you can be more choosy about how you play them. It might be that you're going to play them more aggressively. It depends on the make-up of what's happening on the table. If you're on a table with loads of lunatics you can't be aggressive, it's impossible to be. So

you have to play passively. If there are a couple of aggressive players, I'm not going to be an aggressive player and I'm going to try to let them bet their chips away to me. If they're passive players then I'm going to try and steal everything I can from them so I'm going to be aggressive. You've got to be able to adapt. And that goes for cash games, too. You have to be able to adapt. I've been the loosest and most aggressive player in some cash games and within an hour the make-up of the table has changed and new people have come in and all of a sudden I've become a total rock; a very tight player. Because now I can see that there are people playing very loose and hopefully I'm going to trap them into giving me their money. So you've got to be able to adapt, but with tournaments your chip stack is the key. I've never been antied away in my life and any good player never would be. You should never be putting in your blinds and continuing to put in your antes, and never playing a hand and then suddenly finding yourself so far down that you can't play a hand. That would never happen to a good player. As soon as they start to diminish their chips they're looking for a position where you make a bet and they can move all in, regardless of their hand. If I detect a little weakness in you I'm now going to move all my chips in.'

Jeff acknowledges that he's getting on a bit compared with a lot of the guys round the table these days. And as big tournaments run into four and five days and go on till three or four in the morning, stamina is becoming a factor.

'What worries me is now I see top-class players in their late sixties and they're not the same players as they were, so I can see where I'm going as well. There are legends playing at the Vic, in their late sixties, who were the biggest poker players in London in the seventies and eighties. Now . . . well,

they're OK, but they're not the same. I think that probably your mind goes a little bit and you lose your balls a bit as well. You become more conservative. You go through the motions. I'm thinking now, What the hell's going to happen in another ten years?'

And what's he going to live on? Does he have a pension? Do any of the Usual Suspects have a pension?

'I doubt it. I haven't. And it's on my mind a bit. I don't think I can even get a state pension. I don't really exist. I don't have a clue where I stand. It never did worry me. Now there's a few niggling concerns about what happens when I get old. Most of the good players have had that little bit of a carefree, couldn't-care-less attitude . . .'

He pauses. Then . . . 'You've worried the life out of me now!'

I pay for dinner. It's the least I can do.

It's not fair to worry the life out of a man who should be celebrating winning $77,000.

It's time to explore the Poker Lifestyle Show. This is almost worth the trip on its own; this is poker paradise. The famous Las Vegas Gambler's Book Shop operates the bookstall. There are stalls selling poker chips, packs of cards, and even poker tables, buttons and T-shirts and caps, poker specs and deodorant (it gets a bit sweaty in the card room). There are stalls for all the big Internet sites. They're selling poker cruises, poker weekends, poker academies and more poker magazines than even this fast-growing game can sustain. And what it's all saying, loud and clear, is that poker has become big business.

Back to the card room and Andrew Black (about whom much more later) makes his first impact on the World

Series. Black is the overnight chip leader in a 2,500 no-limit Hold'em event, but becomes involved in a huge pot with another UK player, Harry Demetriou. Black has ace-king but loses it to pocket 8s. He eventually comes tenth with $25,210 (Demetriou comes second).

The following day the Hendon Mob begin a series of small earners; they may not add up to a lot of money, especially with their expenses, but their performances have to be seen also in the context of the number of entries. For instance, Joe eighty-fifth out of 1,071; Ross seventy-third out of 1,049 and sixty-fourth out of 1,403; Barny fourteenth out of 699 and sixteenth out of 560; Ram twenty-first out of 826.

Dave Colclough makes money in one Omaha event and Julian Gardner, the self-effacing Manchester lad, makes the final table in another.

Julian is still three years short of thiry, yet he's a millionaire, earning £100,000–£150,000 a year playing poker, and sometimes a lot more. 'It's not that hard to win £2,000–£3,000 a week. It's only £300–£400 a day,' he tells me matter-of-factly.

Julian is the only player to have been in the money in the main event for the last three years. But I haven't seen much of Julian on the circuit; this is because he doesn't play a lot in tournaments, preferring what for him appear to be easy pickings on the Internet, and life at home with his beautiful girlfriend of seven years, Kerry, and their eighteen-month-old daughter India in a four-bedroom, two-storey house in Wilmslow, south of Manchester .

He had a gambling father, Dave Gardner, and followed in his footsteps, starting to play professionally as soon as he got A levels, mainly in the north-west – Leeds, Blackpool,

Sheffield, Stockport, Bradford, Liverpool. He first hit the big time by winning a Paris tournament and then in 1997 won a tournament in Holland. From the start he's had his feet on the ground. This is about money. He couldn't care less about publicity or television fame.

Why is he so good at this game?

'I wouldn't say there's a lot that's special about my game. I just think that I've got a lot of experience and I don't make that many mistakes. You have to make a decision at poker and everything is about your decision. If you make the right decision you're playing well and if you make the wrong decision you're playing badly. And in the long run in cash games, good decision-making decides whether you make or lose money . . . In tournaments anybody can get on a rush and win as long as they're playing aggressive. You don't have to be a great player to win a tournament. But in cash games in the long run the best player will always win if it's a straight game and there's nobody cheating. The best players will win the most and the worst will lose the most.'

I want to know what it was like when he came second in the main event in the World Series.

'It was mind-blowing, really. Well, I was disappointed not to win, but I wasn't unhappy or feeling down about it. I remember I left just after we finished playing and got into a limousine and went to the Bellagio and we had the cash in the limousine with us and I remember walking in with all the money in a holdall and I felt like I was on class A drugs.'

'You had the *whole million in cash*?'

'Yes, you can have it in cash if you want it. We were going home the next morning and had already booked and we wanted to leave the money at the Bellagio and then get it

wired but they wouldn't do it unless we were going to gamble with it. So the following morning we got the money out of the safety box and took it home on the plane.

'Actually, I didn't get the whole lot. I had a few who had bought into me, and John Shipley had 5 per cent of me, so I ended up with about half of it. But that's quite common. It's kind of good in a way because at least when one of you wins all your mates get a few quid as well. And obviously they were all there rooting for me in the final.

'We changed the money the next day. They didn't say much because they knew me in the bank and they knew I was a gambler and I used to be in there every two or three days. It had been in the newspapers and it wasn't a shock to them. I mean, going back, the first mortgage I got with my bank, the girl that did my mortgage said, "I can't put down that you're a poker player, I'll put down you're an IT programmer." So I got my first mortgage saying I was an IT programmer.'

Meanwhile, in the poker room, the tournaments, satellites for the main event, and cash games are now in full swing, day merging into day, hand into hand, Coke into Coke, hot dog into hot dog. There's no longer a world outside. There's only the Rio, the coffee shop, Constitution Avenue, the exhibition, the card room, play beginning at twelve noon and going on into the early hours – it's become a way of life.

Not that it's boring. Take event no. 20. Not only is the Devilfish playing (he comes fourteenth for $13,000), but so is John Gale who is an inspiration facing a challenge. He's an inspiration because he's made every middle-aged man's

dream come true. And his challenge is to prove it wasn't a one-off – that he really is a world-class poker player.

♥ ♦ ♠ ♣

JOHN'S STORY

Let's turn back the clock to January. It's freezing in Bushey, Hertfordshire, where John Gale lives, but he doesn't know that, because he's in the Bahamas, at the huge Atlantis Resort and Casino, to be precise, where it can take twenty minutes or more to get from your bedroom to the card room.

This is the first televised World Poker Tour event of the year, and it's taking place on a grassy bank under palm trees beside the beach. Instead of being hunched, bleary-eyed, over the final table in a crowded card room, the survivors of the 450-player field are relaxing in the sunshine. There's never been a final table like this. They're playing for $3.4 million of prize money and a first prize of $865,000 – *eight hundred and sixty-five thousand dollars!* – plus a $25,000 buy-in to the WPT championship, yet it's all hugs and handshakes as the game ebbs and flows. Not for these finalists the unflinching stare across the table, the drawing in of the winner's chips without so much as a sympathetic glance at the loser in the hand. When there's an all-in they're putting their arms round each other while they await the flop, they're hugging each other at the turn, they're virtually rolling in the surf together at the river. As I said later to John Gale, if I didn't know better I would have assumed this was the final of Gay Poker.

It is John who is the cause of all this. The truth is, he doesn't know how to behave. This is only his second live tournament. No one has told him you're supposed to sit

tight, emotionless, expressionless, as you drive your luckless opponents into bankruptcy. No one has told him this is a game without sentimentality, where the strong flourish and the weak go to the wall, and who cares? The fact is, John is a good guy. He likes his fellow competitors. He plays poker for fun. He's only in the Bahamas because he won his entry in a qualifying event on the Internet.

Of course he wants to win. He hasn't slept all night, he's so excited. Oh, he definitely wants to win, but the thing about John, the thing that makes him special, is that he doesn't want the others to lose. And so, as each goes out, he's on his feet, arms round shoulders, hugs . . . My God, if you have to lose at poker, you want to lose to this man. By the time he's done with you, you're glad you've lost.

And lose they do. Because John may be a kindly winner, but he's a ruthlessly aggressive player. You would expect someone catapulted from nowhere into a World Poker Tour event to be a bit cautious. Forget it. He's decisive. He's dominating the table. Above all, he's not afraid.

'I was a bit shocked when I got to the Bahamas and found Greg Raymer, Daniel Negreanu and Erik Seidel and these kind of guys sitting around. I thought, What the hell am I doing here? Let's go back to the pool and just have a holiday. And I had a few butterflies on day one but after about ten minutes I thought, These guys are playing the same game as me and they don't seem that great; I can play them, and I started bullying the table a bit. At the end of the day I had 31,000 chips. I was in about fortieth place. I didn't actually have any cards but I played very aggressively. On day two it all seemed to fall into place. There were a few names, Alan Cunningham was one, at my table but I wasn't intimidated. I played my own game and by the end of the day I was up about 160,000

chips in third place. On day three I was chip leader a long time, building and building and building my stack but just before the end of the day I suffered a huge knock-back. I really can't remember that hand. It really annoys me, but I can't recall it. Anyway, I went into day four as a short stack and came out of it as chip leader. I hit some cards and played better than I ever have before. I didn't sleep all night. I wasn't nervous, just excited. I must have walked about thirty miles, just walking back and forward. I really thought I could win. The final table was the friendliest the World Poker Tour has ever seen. But I'm always like that. I think poker's a fun game.'

The other players are having a little less fun than John. One by one they're eliminated until it's heads-up with a New Yorker called Alex Balandin (a relative unknown who apparently makes his living trading in shares and has also been a member of a blackjack counting team). Although their stacks are about even, it takes only ten hands for John to knock him out. In the second to last hand, John raises and reraises the big blind four times with king-queen to Alex's ace-7. John flops a queen and the pair holds up. Then a now desperate Alex goes all-in with 8-7 only to find John has pocket jacks. The pair holds up and it's all over.

More arms around shoulders. More hugs. And then John, in tears, tells the world how he feels. Humble.

There isn't a dry eye in the house.

♥ ♦ ♠ ♣

Now it's June. Back to Vegas, and Barny Boatman says to me, 'I've just played for the first time with John Gale and I can see why he's succeeding, he's very, very strong. Fearless.' Barny says he likes the way John is clearly revelling in being

part of the scene. 'He's like someone who's been let into a club he always wanted to be part of, and he's loving it.'

I pin John down for lunch.

Who exactly is this fifty-two-year-old, chain-smoking, genial poker enthusiast?

'I was born in London in '53, in Stoke Newington and grew up in Hackney. I left school at sixteen and went into menswear, eventually opened my own shop, then another. After a few years I started manufacturing video cassettes when the video boom was under way and VHS cassettes cost about £1.50 to make and were selling for about £10, so it was unbelievably good money until the market caught up. For the last twenty-odd years I've been in consultancy, taking companies to market and coordinating flotations. I was doing that until after the Bahamas trip.

'I know everyone says I came from nowhere, but I've been playing poker for most of my life, I'm not a newcomer to the game. I've been playing cash games over the last thirty years or so, in the Vic mainly. In fact, I used to play at the Vic too often. It got ridiculous, four or five nights a week, so when online poker came about I thought, This is great, I don't have to go out, I can play at home. I won a lot of tournaments, a lot of cash games on the Internet.

'But I prefer playing live. I love the interaction with the other players.'

I ask about the contrast between his aggression at the table and his relaxed personality off it.

'I'm a very competitive person. I played a lot of sports when I was younger and always wanted to win. I'm basically very easy-going, don't like confrontation, don't like arguments and I don't like bad blood between anybody. But when

I'm competing I like to win. And I'm decisive. I know what to do.

'Most of the top players, if they're faced with a life or death decision, will call or pass or raise pretty quickly. They don't need to sit there and think for ages. Poker isn't just about cards, it's not just playing cards, it's playing people, playing your instincts, playing your gut feeling. I am aggressive at the table. If I'm not, someone else is going to be. I like to be the table bully.'

Now John is away to play in event no. 20; he's paid $5,000 buy-in for a pot-limit Hold'em tournament that's attracted 239 entries. There's a prize pool of over $1,120,000 but for John there's more at stake than the money. He wants a gold bracelet. Because he wants to show that the Bahamas wasn't a flash in the pan. No one can argue with both a World Poker Tour title and a WSOP gold bracelet; only the Devilfish among British players has done it before. And that's where John wants to be – up there with the best, and recognized as such.

It goes well. As the numbers dwindle he finds that one of the survivors is the same Alex Balandin he beat in the Bahamas.

After about four hours John makes his first big move, keeping betting in a hand to force Amir Vehedi from California all-in with a queen-high. John has ace-5 and gets another 5. It's good enough.

He drives on towards the final table and gets there with 64,000 chips in seventh place. Above him are an impressive group including Barry Greenstein's son Joe Sebok from San Francisco, former gold bracelet winner Cyndy Violette from Atlantic City, Steven Liu, Brian Wilson from Florida and Allen Cunningham from California.

John later tells me, 'I decided if someone was going to be the table bully I wanted it to be me. I got very, very lucky early on against Cyndy. She raised the blind with pocket queens and I went all-in. I had ace-jack of hearts, so I thought, There's no way I'm putting it down and I can't just call it, I've got to go all in. Cyndy called, she hit a third queen on the turn, and I was all but dead. But I flopped a heart, hit a heart on the turn, and then a heart on the river, very fortunately. That last heart kept me in.

'I decided to change gears and move up a tempo, just try to take control of it and gradually build. I did, I played, I thought, especially well. I did get a couple of good hands and I really thought I could win. I eventually went into the heads up with Brian Wilson with a slight chip lead, then there was a hand that I under-played badly. I had the ace-4 of diamonds and Brian had (unbeknown to me, of course) king-10 and the flop came ace-king – the king of diamonds. I checked, he bet and with top pair I just called. Now the turn card, another diamond, so I had top pair and the nut flush draw. I checked, Brian bet, and I thought, This is the time. Move all in, put it all on this. Then I thought, Hold on a minute, if he's got an ace in the pocket with a high kicker, and I don't get a diamond, I've only got the 4. Am I really going to put the whole tournament on the line here? Then I thought, Well, what if he doesn't have an ace, what if he's just got a king? He's not going to be putting down, so I can take him here and now. In the end I just called it. Down came the river, I checked again and he checked. He turned over the king, so he had two kings and I had two aces, no flush. But he also had a diamond, so had I moved all-in on the turn he would have definitely called and that would have been it. It would have been over. I think I played that badly.

'Anyway, I was just gradually whittling his stack down and down, and then we had a classic confrontation, ace-jack against 6-6, all the chips in, and 4-7-8 on the flop. I hit a jack on the turn and I got very excited. I really thought I had it. He had to get a 6 for a set or a 5 for a gutshot straight so maybe I was celebrating a little prematurely. He got the 5 and doubled up.

'However, I was still up on chips. But the next hand he had pocket 4s and I had pocket 10s. All the chips went in again and he hit a 4 on the flop. It was quite unbelievable. We took a break, we were both drained. I regrouped, came back, gradually whittled him down again and then totally overplayed a hand. I had king-jack and he had ace-queen. I totally overplayed it. I don't know if I had a mental block or what. But it was all-in and I never improved. The rest, as they say, is history.'

It's not the money that gets to him. 'I'm gutted. Devastated. I so wanted a gold bracelet to go with the WPT title.'

Just the same, John has won over $200,000 and proved to any doubters that he's a competitor who can hold his own at the highest level – and under intense pressure. That final table lasted nine tense hours.

And he's given the British contingent one of its best days in Las Vegas this year.

On the twenty-second day, the Devilfish makes his second final table, winning $47,000 in ninth place in a no-limit Hold'em event. He follows this up with thirty-ninth out of 1,072 for nearly £6,000 a few days later, while Mickey Wernick is beginning to hit form, coming thirty-fourth out of 1,056 in another no-limit Hold'em event, and then making a

final table, coming eighth in an event on day thirty, picking up nearly $20,000 in this one.

Dave Colclough and Paul Maxfield then get involved in a big hand in a $1,500 Omaha event. Paul raises pre-flop, with aces, but Dave has a 6 in his hand and, with a flop of 6-6-5, calls Paul's all-in bet. However, an ace on the turn in a huge pot sends Paul on to the final table. He eventually comes sixth, to win $20,000.

Barny Boatman and John Duthie get into the money in other events but it's Derek Baxter who achieves the next big result, coming fourth in a pot-limit Omaha event for $124,000, with Simon Trumper also on a nice little earner in fifth place.

In the meantime, the Devilfish, who has won about $40,000 in one cash game and lost $10,000 in another, for a satisfactory profit, is having a disillusioning time in the Omaha tournaments. I find him sitting by the pool reviewing three events.

'The first tournament I go out of, I actually flop a set of 8s against a guy with two aces and we get all the money in on the table, one card to come, and the other guy who has been in the pot suddenly announces he's folded an ace. So I know this guy with the aces, he's only got one ace to catch to beat me. And he catches the ace and knocks me out the tournament.

'The next Omaha tournament I play, there's me and two lunatics in the pot who don't really understand the game. One of them raises and I call with 5-5-7-8, double-suited. It's the perfect flop for my hand, 5-6-jack. No flush draw there. So I've actually got a set of 5s and I've also got the up and down straight, so I've more or less got this hand strangled. Unless somebody out there's got three jacks or three 6s, in

which case I'm in bad shit. So anyway, I'm odds-on to have the hand strangled, so I check it for once . . . into these two lunatics who usually bet anything, but they're both a bit scared of me at this point so they check it back, and the next card is a 10. Now a 10 is one of the worst cards I want to see because it now puts 10-jack there and he's got a lot of straight opportunities. And it kills my 9; I can't catch the 9 now because somebody might have made the biggest straight. Well, I still like my hand so I come on and bet the pot and one of the lunatics, he raises, he moves all-in, and I call him and he's got in his hand ace-king-queen, which means that while I was at point odds-on favourite to win the pot, he's caught his straight with the jack-10, so that was me out of the next Omaha tournament.

'The third one is even worse, an absolute nightmare. It's actually quarter to three in the morning, and it's the last hand of the night. In fact, they're even putting the plastic bags on the table, ready for us to put our chips in. We're the only table that gets dealt this last hand because the clock is more or less ticking down, this ten seconds is ticking down. The dealer decides to carry on and deals the hand out. I'm actually standing up, talking on the mobile, so I wasn't even supposed to be in the hand. Anyway, the hand begins so I check my cards and I've got king-king-jack-10. So I play and get another king on the flop. I go all-in and then get beaten by a guy who picks up a 5 on the river for a straight. I actually went out on a hand that probably shouldn't have been dealt. My hand should have been dead because I was on the mobile, away from the table. So it was like a really bad blow. So if I sound a bit disillusioned with Omaha, it's because I think what makes me a good poker player is that I just love to win, and I'm never happy with my results unless I win. I don't like

to be second best, or third best. And I hate losing to players who shouldn't be in the hand.'

Now comes one of the UK's best moments at the 2005 World Series, a remarkable win in the $2,000 buy-in no-limit Hold-'em event by Lawrence Gosney, a forty-one-year-old well-built, dark-haired property developer and part-time player from Leeds. He's only been playing for two and a half years but now, cheered on by his mates, he beats 1,071 players and wins $483,195 and Britain's first gold bracelet of the year.

A blunt Yorkshireman who usually plays in rugby shirts, Gossa, as he's known, is not a conventional player. Tony 'Tikay' Kendall, one of the shrewdest observers (and players) in UK poker, says, 'He calls and even raises with cards many of us would muck without a second thought, and he's got an uncanny ability to place opponents precisely on hands. He's also prepared to gamble to accumulate a deep stack from the outset, enabling him to assume the position he's most comfortable with – table captain; 3-4, 9-7, jack-9, these are the range of cards Lawrence could easily be holding when he takes a flop. But his brusque manner and blunt comments hide a shrewd, tactical brain.'

After getting his bracelet, Gossa calls his friends to a party in his room. They drink $9,000 worth of champagne.

Carlo Citrone should be celebrating too, because he comes eighth in the same event for $60,000. Anyone else would have been thrilled, but Carlo, as ever, has that coveted gold bracelet as his aim, and is clearly disappointed.

Now it's time for my big moment. Apart from the two satellites, and the media-celebrity event (there's supposed to be a celebrity at every table; Tony Holden tells me, 'I looked round my table for the celebrity and realized it was me'), and

a few cash games, I have decided to devote my resources to one gold bracelet event, not because I have expectations, but because I don't want to be buried with the words on my tombstone, 'Here lies DW . . . He never played in the World Series.' I never scored a century at cricket, played a scratch round of golf, or ran a four-minute mile, all childhood aspirations. But I *could* play in a gold bracelet event and by God I'm going to. I have chosen a $1,500 no-limit Hold'em event without re-buys. A freeze-out.

I notice the Flying Dutchman Marcel Luske on the next table, and John Gale two tables away. And there are plenty of other stars sprinkled about. But I'm not worried about them because I have made a flying start, chip leader on my table when I'm moved, and am still the chip-leader on my second table when disaster strikes. By now, one or two of the British journalists have spotted me and curiosity has drawn them to my table just at the point where I find myself with ace-queen on the big blind. Everyone limps into the pot so I raise and attract only one punter, an American in his thirties, sitting immediately to my left. The flop comes down ace-queen-3. I now have top pairs, aces and queens, and I make a substantial bet. The American calls. The turn card is a 9. I add to the pot and the American calls. The river card is a 7. I'm convinced I've won the hand but decide to check. The American bets. What? There's no possibility of a flush or a full house, no straight at this point. I call. The American turns over pocket 7s to give him trips. I try to look gracious but I'm furious. The idiot should never have gone to the river with a pair of 7s in the face of an ace and a queen; he was losing all the way. What the hell was he doing? 'Nice hand,' I mutter, wishing I had a machine gun handy to mow the lunatic down. (Why do poker players always say 'Nice hand' after they've been

beaten in this way? Everyone knows what they really mean is, 'May you, your family and entire village burn in hell'.)

I'm sent to another table, get king-9 in another big blind, no raises, so I go into the flop and get another king and another 9. The momentum of the previous hand is repeated, only this time the guy has 8s in the pocket and gets an 8 on the river for trips. Another one who should not have been there by the river. Who are these guys? Don't they read the books? Anyway, I'm out.

Later I tell myself it's my own fault. I should have bet a lot more earlier in the hands, probably pre-flop, and got them out. But would they have gone? If you ignore an ace or a king on the flop *and* a series of raises and go all the way to the river on two 7s and two 8s, are you capable of rational thought? Should you be allowed out on the streets without the company of men in white coats?

Never mind. To this day I have my entry ticket on the wall of my study at home. Event no. 43 at the World Series of Poker, gold bracelet event, $1,500 buy-in, table 188, seat no. 7. Somewhere buried in the WSOP records *I am there* and always will be there, albeit as D. Wison, because they misspelt my name.

There's no time to grieve because word is spreading throughout the UK contingent . . . Willie Tann is on the final table of the last major event, apart from the main champion-ship event itself. And everyone wants Willie to win. Because in British poker Willie has a special place.

Willie has not had a good World Series and looks tired and lacking in confidence when he sits down, but this man never stops telling younger players that two of the keys to success in poker are patience and perseverance, and now

these qualities are paying off. I get there just in time to see Willie climax thirty years at the poker table by winning the gold bracelet and $188,355.

♥ ♦ ♠ ♣

WILLIE'S STORY

Willie Tann's story is one of triumph and tragedy, endlessly repeated, often on the same night.

Willie has what's known in poker as 'a leak' – this means that much of what he wins at poker, and he *does* win, because Willie is a top player, a world-class player, he loses, literally leaks away, at the dice table. Or on the horses.

Willie, whose nickname is 'the Diceman', is a gambler. And has been for nearly all of his sixty-four years.

His triumphs are many: just this week the gold bracelet and nearly $190,000; last year the UK Open (just under $100,000), plus wins in events at the Irish and French Opens; altogether in 2004 he reached thirteen final tables to make him by November of that year the European number one. He's been performing well at the top of the game longer than almost any other UK player. He's a poker legend.

His tragedies are more or less of equal number.

This is a man who has based his poker game on what he calls the five Ps – patience, perseverance, psychology, practice, position – and then gives it all away with the throw of a dice. At the dice table, patience and perseverance are irrelevant. You can't practise. Position doesn't matter. The only one of the five Ps that matters is psychology, the self-awareness to know that what you're about to do is crazy, backed up by the self-control not to do it. And this inner-intelligence that

Willie applies so well at the poker table as he sits for hours analysing the other players, waiting his moment, he totally abandons at the dice table.

If there's a dice table between the poker room and the exit, Willie is doomed. If there's a horse running somewhere that is destined to lose, no matter how good its form or arguable pre-race chances, Willie will be on it.

The effect of this is that Willie, who could be a relatively rich man if he stuck to poker, is often playing under greater pressure than others who are not in his league as poker players; he can rarely relax, because he's always running just to keep up. Often he has to win not only to make ends meet, but to pay back borrowings. One of the saddest sights I am to see on this poker journey is in a poker room in Barcelona . . . This great player at nearly four in the morning, his face grey with fatigue, his eyes hardly open, fighting like a tiger to win at a cash game to fund his entry to the main event the following day.

But is the worst of it over? There's no doubt that as Willie gets older, the 'fun' of losing is beginning to pall. Willie has the virtue of not being a liar to himself. Unlike some gamblers, he doesn't hide behind a wall of fantasy. Tell him he has a leak and he'll nod sadly. Yes, it's true. That's the way it is. Then he'll brighten and say, well, OK, he has a leak, and OK, he's thrown away a fortune, but he still has a lovely home in the country, a wife of thirty years and a son he helped to Westminster School and Oxford and who's a lawyer and of whom he's inordinately proud. This is achievement, too, he will say; there are men with a fortune in the bank who cannot claim as much.

As for the gambling: 'I've cut down a lot. I've got few years

to live and now I'm determined to change my ways. It's never too late, I hope. People know I'm a gambler and I'm not proud of it. I've got a number of younger players who I'm teaching poker who are gamblers. So I tell them about the mistakes I've made in life and I hope they listen to what I say and don't do what I did. I tell them it's no use doing what I've done. I'm ashamed of it. I won't say I've enjoyed it, but it's done. That's forgotten. I try not to do it so much now.'

Willie also makes a fair point: that his gambling experience can help at the poker table. In particular, he plays without fear of losing. 'At the poker table, I'm a poker player, not an out-and-out gambler. It's like this is my real business and the other gambling belongs to another world. When I'm playing poker my gambling instincts are there, but they're under control. Sometimes the gambling instincts work in my favour . . . because I'm not afraid of big bets. If you've gambled big in your lifetime, when you go to a big poker game you're not so frightened of losing. You can stand your ground. It means you can play in any game. I can play in any game, big or small. So being a gambler definitely helps to some extent. You've got to have courage.'

Willie goes back a long way in British gambling and poker circles. He's been a card room dealer. He's been a bookmaker, working at race courses with a friend who had a licence. And he's been a gambler for over forty years. But he also owned a Chinese restaurant in Soho for a couple of years in the seventies, and ran a company supplying hot towels to Chinese restaurants all over London.

So where does he come from?

'I'm Chinese. My parents came from China. They came to Singapore and I was born there in 1941. I came to London,

England when I was twenty to study at Lincoln's Inn to be a lawyer. I've been married for thirty years to Sally. We've one son, Jason.'

There's an extraordinary contradiction between Willie the gambler and Willie the poker player. The gambler wants the immediate effect – either the thrill of winning or the impact of losing; it's all about immediacy, highs and lows, action. Gambling is about now; the time is now. Poker is about later; the time is when the cards come, or the opponent is weak. Poker is all about discipline and patience. Willie knows that: 'Patience is one of the cornerstones of playing poker. If you haven't got patience, you mustn't play poker. You can't play any two cards to win a hand. If you risked 3-4 against ace-king every time you would definitely lose. You must have a hand to play.'

'There's no game like poker. Poker trains you how to survive in life. Poker is life.

'I don't think you will ever get bored with poker because in a lifetime of playing you play thousands and thousands of hands and virtually every hand can be played differently.'

Willie points out that it's not just his other gambling that applies pressure on his finances. There's also the cost of playing. 'I play tournaments but I play quite a lot of cash games as well. Two or three times a week, at the Vic. I play on the Betfair site quite a lot because I've been sponsored by Betfair, so I try and get players on the site for them. But playing can be expensive.

'Of course, I go broke now and then. If you show me a gambler who has never gone broke then you will be showing me a gambler who must be lying. All gamblers go broke. We understand that. We help each other. I borrow a little bit from my friends and so on. We gamblers, poker players

understand when someone goes broke. Sometimes people will put you in a tournament and sometimes they'll buy your action, depends how good a player you are. We are all friendly as well as being competitive. There will always be losers and winners so you've got to accept that.

'There's more money in the tournaments but these days there are more people to beat. It's more difficult now. When I started playing in the World Series about ten years ago there were about 300 or 400 players. Last year and this year it's been just phenomenal.

'To make it work as a professional, you have to win in the cash games, and that's where experience comes in. Every player has got a chance. It depends how you play. I mean, you know the basic rules of playing poker, but maybe you don't know as many moves as a professional player. Or maybe you don't know how to get maximum value out of a hand. Maybe I know better how and when to bluff. And, above all, you have to know how to win the marginal hands. Marginal hands can be quite decisive. In those marginal hands you must shine. You need to know how to put a man on a hand, to work out what he's got. The ability to read cards well and read opponents well – all this matters.

'I think there's a huge difference between an Internet player and a player who plays live. I think Internet players lack the experience. They usually only play in competitions and their best move is all-in, which cuts down the art of playing poker. It cuts out the skill factor a lot. Most of them would not survive a live cash game with reasonable players.

'At the end of the day, experience counts for a lot. Anybody can learn the no-limit Hold'em game. The rules and how to play, within an hour, but to master the game, to play really well and properly, that takes a long time.'

Willie is popular with the younger players, always has time for them. He marvels at how the game has changed. 'Nowadays it's so cool to be a poker player. When I started to play poker, I was playing in very dimly lit, very seedy places, spielers. I was playing with, maybe, shoplifters, thieves, drug addicts. In those days it wasn't the "in" thing to be seen in a poker den, you shouldn't be doing this. I love the respectability it now has.'

Unless he's playing in a tournament elsewhere, late every afternoon Willie leaves his country home and drives to one of the casinos with a card room in London, often the Vic, parking in its underground garage and playing in the cash games. He's not there for the fun or companionship, he's there to win, often with a target in mind. 'It depends on the game. You can't win five grand in every game. Whether it's a big game or small game, you've got to set the target differently.'

And what does Sally think as she sees him drive off for the umpteenth time to chance his luck and pit his skills for their very living? 'My wife is a diamond, a real ace. She'll be with me when I'm broke, with me when I have money, so I love her tremendously. I know I have her behind me all the time. You need sympathy, love and warmth when you get home after a hard day. You don't want to go to a wife who attacks you for losing. You want her to be with you.

'I've lived, I've seen everything in life. I regret that I'm not a big businessman, and I haven't got a big pension behind me. But I've got a wonderful son who's doing well. He's a good lawyer. I've done my job for my son, and I've lived. After all, what is life? Eventually we all have to die. As long as you're happy, that's the main thing. You've got to be happy in life. I know it has ups and downs, but you've got to

look on the bright side of life. We all have ups and downs. You handle it, you just overcome it and survive through it.'

Willie has had bad nights. He will have more bad nights. But this is a good night – a great night. A gold bracelet night. No one in the world of poker will tonight deny him the joy he feels . . . and shows.

There's just one problem – how to get him and his $188,355 past the dice table on the way out.

♥ ♦ ♠ ♣

But every show has a finale, and the finale for the World Series is the 'main event' – the $10,000 buy-in world championship in poker. I feel so envious of the players taking their seats in front of piles of chips 10,000-high. I decide there and then to launch myself into an Internet qualifying blitz for 2006.

The atmosphere is electric as opening speeches are made, and then the tournament director issues the famous command, 'Dealers, shuffle up and deal.' There is a roar from the crowd, a cheering and stamping of feet, and then a sudden silence as the cards hit the deck and the big event begins.

The field for the first two days is halved because of the huge number of layers, and the survivors of that stage merge into one field on the third day and then to smaller fields on the fourth and fifth. It's not a big year for the Usual Suspects; Andrew Black and Joe Beevers are the only ones to make the top 150, Joe coming in at exactly that spot with $46,245. But apart from Andrew Black, for me the three stars are Tiffany Williamson, Neil Channing and Conor Tate.

When Tiffany emerges as the leading woman in the event, coming fifteenth with $400,000, all the Brits are wandering around saying, 'Who the hell is Tiffany Williamson?' Turns

out she isn't really a Brit, but an American corporate lawyer who works in London and plays at the Gutshot Club. Her journey to this result actually began with a Gutshot event back in March, when she spent £10 to play in a satellite that won her a £1,000 seat into a super satellite where she beat up a lot of players to win a $10,000 seat in the main event. She actually gets to seventh place in the main event before slipping back to fifteenth, but it's a stunning performance.

Conor Tate is an Internet pro from Bury, reputed to be making a fortune in online cash games and to be not much of a tournament player. Well, you could have fooled me . . . and the whole World Series field, because he comes twelfth and clears $600,000. He's a close friend and confidant of 'Action Jack' who tells me, 'Conor is completely calm about it – to him it's just another day at the office.' *Another day in the office?* Six hundred thousand dollars? Where do these people come from?

In the meantime, I've enjoyed witnessing the energy, good nature and optimism of the talkative Neil Channing, and am pleased to see him end in the money for two consecutive years. Neil eventually comes in number 202 – remember, this is out of 5,619 entries – and wins $33,197.

He gives me his side of his final assault on the peak.

'I got into the money on day three. I now knew I was going to pay my way, so I could start thinking about winning.

'Predictably, everyone else is having the same thought. For an hour from here they're dropping like flies as people gamble wildly to get back into contention. I just steal a few here and there and advance with no dramas. I get in a couple of pots with a wild young Swede, who's massively arrogant and doesn't like being reraised. He's in the big blind on my scariest hand at the tournament. The guy in seat three raises

to 8,000 (blinds 1,200–2,400 with a $300 ante). I have 9-9. I could push in, but I reckon I can get a small 'limpathon' started and maybe the Swede will be tempted. I call the $8,000 and so does the small blind. The Swede pushes (as I hope he will) and the early raiser lays down. I now have to trust my read and call for all my chips. I so nearly bottle it, but find a way to push him in. Now the small blind calls as well. This isn't in the plan. It turns out he has the other 9-9 and the Swede shows king-7. We sweat the five cards and split the pot.

'Despite such small victories, I've only around 100,000 and the average is reaching 300,000 while the blinds are 2,500–5,000 with a $500 ante. I need to make a move. I decide on some reraises while I can still afford it. The first one, jack-10 against an annoying, noisy, geeky redhead, works. The second one I try on another guy from London. He has made a $20K in early position and I move in for $85K from middle position with my familiar 9-9. He calls instantly with pocket jacks, and . . . well, that's all, folks. I'm out.

'I go to bed thinking it's not too bad coming in 202nd (better than 205th last year in a smaller field). I try not to think about the three minutes I'd have needed to last to get $6,000 more.'

He could take comfort, too, from the fact that only two of the Usual Suspects were above him, and most of the famous names in both American and European poker were knocked out before him.

Devilfish was one of many top European players who went quietly and early. So did Dave Colclough, who says, 'I was up for it. New iPod, sunglasses and cap. There will be no mistakes. I know exactly what few hands I will play in what situation. Discipline and patience. Patience and discipline.

The time for aggression will come later. So what happens? I reraise with queens. The original caller sees the flop with 10-jack suited. The flop of 9-10-jack is good for both of us, but it doesn't improve and he wins the hand. Then I call a raise with ace-queen of hearts. The flop king and jack of hearts and a 2 of spades looks good. A queen on the turn keeps me in, but a blank on the river leaves me with an impossible decision. There was $12,000 in the middle and I was facing a bet of $2,000 and I had $2,200 left. It broke my heart to pass but I knew I was well beaten.

'Having built back up to $7,000, I played ace-jack suited in an unraised pot, and flopped ace-jack-2. I raised my opponent on the flop, believing he either had a flush draw or two smaller bets than I had, and I fired another $3,000 at him on the turn but couldn't shake him. My heart sank when a 2 of spades hit the river. He moved all-in and whether he had two pair or a flush was now irrelevant because this card hit both hands. Once more, it broke my heart to pass for my last $3,000 chips when I could have won a $12,000 pot.

'Anyway, I built back up to $4,500 and got queens again. The table machine-gunner over-raised the pot so I decided to move all-in. Unfortunately he was holding ace-ace and my dream of winning the World Series was over for another year.'

But as the heads roll, and the event moves from day two to three to four to five, and the tension grows, the eyes of the British and Irish contingent focus on one man.

It's Andrew Black.

Andrew has already captured everyone's attention by fighting to defend the rights of a player who failed to return to the table after a brief break because he was under the

impression that it was, in fact, the full lunch break. The player's chips were disappearing under the impact of the sizeable antes and blinds. Andrew protested they should wait for the player, and he tried to organize a go-slow.

Now he's fought his way through to the final table, cheered on by the considerable number of Irish players present, and by the rest of us. We've all settled for the fact that we're not going to be world champion this year. The only thing left now is to support this man we call 'the Monk'.

He arrives at the final table in terrific shape. He's got a real chance. We hold our breath.

ANDREW'S STORY

Andrew Black grew up accustomed to confrontation. His home was in trouble-torn Belfast. The family lived in the south of the city. 'My father would have been next on the hit list after the parish priest. He was a public health doctor, but he was the first Catholic doctor there . . . his second name was Black and he was from Glasgow, so when they employed him they thought he was a Protestant. So he engaged in a fifteen-year war of attrition, where they were intimidating him and treated him like they wouldn't treat a rubbish collector in mainland UK. I lived there until I was seventeen and got into Trinity College to study law. But I was never really interested in law . . . I was interested in cards although I didn't really play poker. But one day, about three or four years into my degree course (I finally qualified in 1989), I stumbled upon a card club, the Merrion Casino Club in Dublin. It was then known as the Griffin. I went there because

they had free sandwiches and free coffee and free entry into a tournament. From there I started playing £5 tournaments regularly.

'I think because of my background I tended not to borrow money, so I was scratching around for years. I played in the smallest games and when I went broke I never borrowed any money or got into any debt. I think the most debt I've ever had was £2K all the time I've been playing poker.

'In those days I was partying a lot. I drank a lot and did a lot of soft drugs and so I'd win money and go off and party and then start all over with a fiver. For many years that was the kind of pattern. But my record in tournaments in Ireland, few people can match, and that's how I made a living for many years.'

What was it that made him such a winner?

'It's funny, but at that time it was discipline. In smaller tournaments, what gets you there consistently is discipline because most people are playing badly. The higher up you go, that becomes not good enough. You can do well if you're a disciplined player but if you want to do really well at the higher levels you've got to have more game and more bluff. So originally I started out as a much more conservative player and I was pretty conservative for many years. I had to pay the rent and I had to eat so a lot of those years it was about survival. Rent day was the day I'd invariably win whatever tournament was there because I had to win it.

'Still, it was a good eight or so years and a lot of the top guys were now all scuffling around and most of us were broke and scuffling around for a few hundred quid. A lot of us would all be sitting in the same game with a few hundred quid on it. We played until seven or eight in the morning. I dealt occasionally but I would never deal for longer than a

few weeks; just long enough to get a bankroll and get back into the game. For years I didn't see daylight. I remember once or twice I'd happen to be up at nine for some reason and just seeing people coming into work seemed so strange and I'd wonder what was going on. What were their lives like?

'Each year I'd build myself up to play in the Irish Championships but for quite a few years I had a horrible run of luck and I'd get all hyped up and I'd get quite a distance in but never win the damn thing. So eventually I build up a bit of a bankroll and I go to Vegas in 1996 for the first time with £3K and I turn it into £10K. I don't play in the main event at the World Series but I decide I'll be an American professional and I end up going to San Diego and I blow my money in a week.

'In 1997 I build myself a decent bankroll and go back to Vegas. I end up playing in the main event for the first time and I finish fourteenth to the legendary Stu Ungar. A year later he was dead of an overdose. In this World Series I was to the right of him and he already looked like he was dead; he was about six stone, grey-green and he smelled pretty bad. But he made friends with me and I gave him all my chips a couple of times.

'But I was upset not to do better. I felt that I was the best player remaining, apart from him; but maybe I wasn't. I got £30K but when I was knocked out I felt I'd blown my chance to win the World Series and I was incredibly distraught. So I started thinking about trying to change my lifestyle, so I began wandering along to the gym and I stumbled into a meditation class in Dublin and I started working on my mind and improving myself, with very quick results. I was tapping into a latent spiritual side of myself and I read a book on

Buddhism and I realized that I was a Buddhist, which was a great shock to me because I was very anti-religion (and in some ways I still am). So then I got totally into that.

'But I'm still playing poker and now I'm really getting my game together and beginning to play professionally in France, and I'm doing very well and beginning to build up a decent bankroll; like £40K–£50K. But all the time I have this massive pull to Buddhism and one day I have this vision. I'm sitting in this room and I'm surrounded by these angry ghost types from a number of realms of existence. There is Heaven and Hell. And the animal realm where you're just interested in food and sex. And the titan realm where you're just interested in warring, and a ghost realm where you're just an addictive being and you keep eating and drinking and your stomach gets bigger and your mouth gets narrower. And there is a final realm. I'm surrounded by these ghosts and it dawns on me that maybe I'm one, and the final realm is the human realm, and what's fascinating about this is that in the human realm you've got a choice and you can choose to engage in developing your spiritual side and widening your consciousness and begin contemplating death.

'I realize I have to go to this thing called a solitary retreat where I can experience things a lot more vividly. And I realize by the time I get to the World Series in 1998 that I'm going to quit poker for a period because I want to explore Buddhism. So shortly after that I just quit. I go off to live in a Buddhist community in Cambridge where I do all sorts of living and working with people who are trying to develop themselves and become a bit wiser and a bit kinder. We agree that this world is not something you can rely on. And somehow, intuitively, you get a sense that there's something beyond. And the more you embody that, the more you see

greater truths. I was there for three years. I came out for a few days to make a few grand to keep me going for the next year.'

Now, I have to confess to becoming slightly bemused by all this. I can see how Andrew got his nickname, 'the Monk', but how can he balance this spiritualism and apparent rejection of popular values with playing poker and often impoverishing people in the process?

'This is what's fascinating. For years I was playing poker and then suddenly I throw myself into this Buddhism and there's this painful clash between these two things. I'd think poker was about hurting people and taking their money and that's not great but I decided to come back to poker about a year and a half ago and in some ways it's like I've integrated the two. I know that poker isn't the answer but it does seem to be my path. So while I'm in it and have achieved a celebrity status in a growing market, I think I'm ideally placed to bring developmental tools and make them accessible to this vast array of poker players coming in. If what you're doing is not the best thing in the world, you can conclude that just the same you can have a massive impact.

'I seem to have reached a point of being at peace with what I'm doing. I can only say it's been a journey getting here and for a long time I was torn, but now I'm quite content. I'm involved in an activity where, yes, people do suffer a lot but what I would like to do now is books, TV, public-speaking, and try and encourage people to gamble or play poker responsibly. I know that people like bookmakers say they want people to gamble responsibly, but how deep is that? I hope that by expressing these views and going into them in depth, I can make a difference. Within a realm like poker, if you actually present it in an intelligent, wise and thoughtful manner, having care and awareness for those who

struggle at it and are not able to play it, then you can develop it into something else. I want it to go towards a thinking man's chess and not the way that Devilfish presents it, more like professional wrestling. I want to be a balance to the Devilfish's projection of poker.'

He's now talking about six worldly winds. 'These are three pairs: gain and loss, pleasure and pain, fame and infamy. And what happens is we come into this world and we get caught on these winds and when you get too caught up on these they don't ultimately bring you happiness. You have to see them for what they are. If I'd won the World Series in 1997 I'd probably be dead by now because I was too immature and too wrapped up in myself. But now I've got some things I do, meditation and so forth, that control this kind of ego thing.'

So what is he going to do with the money?

'It's a good question. Only about three or four people who have won the World Series still have some money. What I did last year was I bought my mother a house in England for £250K. She's eighty so she'll live in that before she passes away. So that's money put away. And I'm also buying other property. But because of the way poker has gone and because of my skills, I'm just in the process of hiring a sports agent. What I'm going to do is *use* the celebrity of Andrew Black and not get too caught up in it.'

Now, I might have been looking a little askance at all this stuff about using celebrity well if I had not known that Andrew had already given his particular sense of self some practical expression. He was known in poker for 'going missing'. At one of these times he was in fact spending two years working for the Karuna Trust and personally raising over £250,000 for the untouchables. He also went to India and

worked in schools and conducted literacy classes and engaged in a variety of other projects.

But then it was back to poker. He returned to Ireland partly because he has a son called Zach, who is six now, and he wants to be more involved in his life (Andrew has never lived with the mother).

'I started back in January 2003 playing poker with £100 and I fortunately made £150 by winning the first tournament and got into a cash game and turned that into £6K. By the time I reached the World Series I'd built up about £100K and was winning consistently in Ireland.'

Being a Buddhist apparently helps. 'The higher up you go and the better the players are, the more they're looking for opportunities all the time. Your hand doesn't matter that much; you're just constantly looking for opportunities to win chips. You also get a better idea of the relative value of hands and you can begin to calculate the likely hands of individual players. Gradually, you get more of a sense of the time people take to make decisions and the amount they bet and how they look, and you get people to talk and they give stuff away. Also, the more you play with people, the more you build up a pattern, a picture, so whenever everyone's in this zone it all comes together and it's all incredibly clear. As a Buddhist, you know everything is interconnected, so in a sense we know what's going on and what's happening at any given time. Most of our communication isn't variable; how we look and the tone of our voice and all of these things come together to build up a picture. And most people who are playing poker are not building up that picture. They're worried about the two cards they have which, in a sense, is the last thing to worry about. The thing you need to worry

about is what everyone else is going to do. And if there's a chance that your hand is better than theirs, then you make a move.'

This, then, is the Andrew Black, both Buddhist and ruthless poker manipulator, who comes to Las Vegas for the World Series. He has planned it meticulously – to take £50,000 and play in twenty-odd tournaments. So many poker players and aficionados in Ireland wanted to back him that he's sold shares in his performance. 'I sold the shares at the value of the buy-in and expenses. I decided to sell about 33 per cent and I mentioned it to a few people and the main shares were snapped up in twenty-four hours by all the shrewdies who had known me for a while. There were about eight or nine main shareholders who had 10 per cent, 2 per cent, 4 per cent, that sort of thing, and the biggest investor put in about £3,700. Then one of my friends who works in one of the clubs sold his grand's worth in £50 lots so there were about fifteen to twenty people, doormen, dealers who had these £50 shares in me.

'So a lot of people had shares in it and I ended up committed to giving away $600K of my winnings, but I got another $100K for wearing a T-shirt over there, so that helped.

'I did reasonably well in two events before the main one, so I had come into a bit of form. I was going through the players and meditating every day, so I was really working, working really hard, so by the time I got into the main event I was in a good state. I played some good poker there. I only had about three bad sessions out of thirty-five.'

So to the main event itself. What happened?

'I created chips early in the tournament and was doing OK but day four or five I suffered a horrendous knock-back and

I was then playing defensively for seven hours. I played two hands in seven hours but I slowed the game down without being caught. I knew I had to get to the next day when there'd be fifty-five players left. So I sneaked through to the last fifty-five, ranked fifty-fourth in chips.

'Then there was the famous incident with the player who didn't turn up. That was weird. I arrived back from a break and there were about thirty-odd people left in the World Series. Where there should have been this player, who I didn't know, there was an empty chair and a stack of chips sitting there. There was another tournament going on and the announcement of its dinner break coincided with an announcement of our shorter break . . . and some players heard the wrong announcement. A number of people, including me, thought it was dinner break. I got called back by my name but obviously one guy hadn't got the message and I thought the only thing you could do was stop the tournament until he got back, but the tournament directors wouldn't stop the tournament. I went back to the table, fully believing that the players would back me up but nobody did and I was so upset about this, I was in tears. I was very upset and I wouldn't play until they found the guy. Until then they came along and put the clock on me every hand and I just wouldn't play. Eventually he came back and we played on.

'We get down to the last twenty-seven and I have Phil Ivey and Greg Raymer on the table. I had decided the night before that I wasn't going to let them bully me, so I take that to great extremes and I play the best hand I've played in the World Series. I have ace-2 of diamonds and I have 2.5 million and Phil Ivey 3.5 million. He makes it $150K on the button and I'm on the big blind so I make it $450K and he makes it $1 million and I've only $2.1 million but there are a load of

small chips there, so I just shove the whole lot in for a reraise. I'm thinking he's bluffing and he knows that I'm thinking that he's thinking that he's bluffing. Still, he chucks his hand away and I turn over the ace-2 which I wouldn't normally do but I turn it over anyway. And he just laughs and says, 'How much did you have there?' Because the chip stacks were uneven and you couldn't really count them. I pull off a similar move on Greg Raymer. So I feel the two big threats were put in their place. And I kind of run over the tournament a bit coming into the end and I get to the final table lying third. Then I change my style a bit. I don't play quite so aggressively and I build up to the chip lead, with over 22 million.

'But I'm tired now and not quite focused and I feel like I lose it when I go with a $7 million–$8 million bluff. It's the stupidest call I've ever made. Remember, this is seven days of playing, fourteen hours a day, so you're tired . . . you can't even express how tired you are. There are only nine guys in the world that have played tournaments that long, and that's the nine in this event. This is the longest tournament ever. So I make a stupid bluff and that gets me down to about 12 million.

'But then I make one of the great calls in the World Series. I have 9-10 and someone raises the blind to $600K and there are three callers, and I call, and the flop comes 9-6-5 and two clubs and I bet a million. Then Stephen Dannenmann goes all-in for about $8 million–9 million and I read it perfectly – that he's on a bluff. There are a lot of reasons: above all, the time it takes him to make the decision and what he says. I call him with 9 million or 10 million of the 13 million I have and he turns over ace-6. So I'm leading with two 9s to his

two 6s. It's a great call. But unfortunately not even that call is enough, because the river gives him an ace. If the river hadn't been an ace, I'd be very close to winning the whole thing.

'So I'm down to 3 million and get it back up to 8 million and then I make a mistake with the same guy. I make it $800K and he makes it $2 million and I should just call with a pair of 10s and see the flop because I have a perfect read on it, but I go all-in. I think this is down to tiredness, too. Anyway, he has ace-king and he gets another king – and that's me. Gone.

'I feel terrible because I was playing to win the tournament.'

'Does it still feel terrible?'

'Oh yes, it still feels terrible. I'm working on it a lot. I still think about it from time to time . . . I run over the hands. It's a great opportunity but I didn't quite get it together and I give myself a hard time for not making the best decisions at that point because I think it was a relatively soft line-up at the end.'

'What happened afterwards?'

'Well, we had to go and sort out the money, which was a bit of a shambles because there were a few drunk Irishmen with me. The support was like the World Cup in smaller fashion, both in Ireland and in Vegas, and there was a great buzz about the whole thing and it was exciting. There were a lot of investors but there was also the Irish patriotism stuff as well. Coming back, I was a bit of a celebrity, but . . . it's hard to explain . . . I was not totally happy, because if you're the kind of player who's just playing to make money, then you've made $1.75 million, but if you're somebody who wants to become a legend then your goal is to win these tournaments

and the biggest tournament in the world and you've failed. So, yes, it's success, and, yes, I'm a millionaire, but I also failed and I feel that very deeply.'

Can he still do it? Another year?

'It remains to be seen whether there is a possibility of regularly conquering these big fields. But there's the possibility that if you get chips together at some point it's easier to hold on to them if you're a very good player, and it's easier to duck and dive and win these little pots.

'I love tournament poker. There's something about somebody ending up with all the chips that appeals to me. I'm hooked on the experience of tournament poker even though I realize it's not the answer to anything. I do feel that presently it's my path.'

So he's come fifth out of 5,619 players and he's won $1,750,000, just under a million pounds. It's a fantastic effort and the Irish celebrations shake the foundations of even Las Vegas.

And it's all over. The $7.5 million championship goes to an Australian, thirty-nine-year-old Joseph Hachem.

This is another relative unknown, a chiropractor by profession, and is another strike for the new breed over the old school . . . a strike over the entire elite of professional poker. Hachem has outgunned and outlasted the best.

The warning signs are now firmly posted on both sides of the Atlantic. Other players from another generation and from other countries and, in many cases, from another world – the Internet – are emerging in growing numbers and taking the game by storm. The World Series has been invaded and, to some extent, it's been conquered.

I talked to former champion Chris 'Jesus' Ferguson on day one of the main event and suggested that the final table

would be made up of complete unknowns. He didn't agree. 'When it gets to the closing stages the experienced players will come to the top, because they know how to handle it,' he said. In fact, only one recognizable name, Mike 'the Mouth' Matusow, made it to the final table.

The World Series, with its multiple gold bracelet winners, may never be the same again.

Just the same, next year 'Texas Dolly' Brunson will still be there . . . so will all the other stars of the past . . . so will the Usual Suspects . . . and so will I . . . because there's no event like the main event, no poker occasion like the World Series, no poker town like Las Vegas.

You have to make it to the World Series, if only because, as the days and years roll by, you can say to some bored barman over a last late-night whisky . . . 'I was there!'

11 / Paris . . . London . . . Barcelona

A man's gotta make at least one bet a day, else he could be
walking around lucky and never know it.

Jimmy Jones

A summer's evening in Paris, late July. The open-air bars and
restaurants on the Champs-Elysées are crowded. As I sit a few
metres down the slope from the Arc de Triomphe enjoying a
glass of dry white wine, I notice some of the Usual Suspects
negotiating their way past doormen in tailored suits and
entering the Aviation Club just opposite. The circus has
moved to France and the big attraction is the only World
Poker Tour event taking place outside the US.

The Aviation Club is unlike any other casino on the poker
circuit, more like one of those gentlemen's clubs in London's
Pall Mall. A wood-panelled staircase leads to a series of small
rooms, furnished with oil paintings and green baize tables
under sparkling chandeliers, each forming part of a circle
around a central lobby with comfortable armchairs and tables
with magazines.

Apparently, this classy joint opened just after the First
World War, became a high-class baccarat place, men in din-
ner jackets, women in expensive gowns, until in later years it
gave way to more popular casino games and to the modern
penchant for open-necked shirts and poker.

The tournament director is an attractive and highly competent young woman called Sabine, but even so it's clear who is really running the show – it's Bruno Fitoussi, former World Series final table player, a ball of energy, always moving, always talking, always in charge (even if he isn't really in charge, nod, nod, wink, wink, because there's some complicated legal reason why he can't actually be the boss – officially). But there's someone who matters even more than him; because with the World Poker Tour comes the renowned Mike Sexton and a television crew, and wherever Mike is, he's the star. This man is mega.

Not that he makes a big thing of it. He's amiable, helpful, still an enthusiast, despite being a veteran Las Vegas cash game player who's also won a World Series gold bracelet. In poker, he's famous – and, I suspect, rich. He became famous when he emerged from the shadows of the card rooms he frequented with the old-school players to co-host with the amiable Vince Van Patten the *World Poker Tour* television series, and he's rich because he's also got an interest in PartyPoker.com. He's also the guy who came up with the idea of the Party Poker Million, a tournament on a cruise ship attracting about 750 players, all of whom pay over $12,500 for the privilege.

Yet he still loves the game. He talks about it with energy. He talks about the 'heart' it takes to play on the circuit. 'Even if you play your heart out for a day or two and you get your money in with your best hand and you're 4–1 favourite, and you can't get much better than that, a guy can make a flush or whatever and knock you out, and now you're on the rail and it's very tough to take mentally. Because you win so rarely out there, if you can't take defeat then tournament poker is not going to be for you. It will drive you crazy.

'You're always trying to turn a toothpick into a lumber-yard when you're out there playing on the tournament cir-cuit. You have to put the hours in. Nobody's bringing you money to your doorstep. Yes, you have the freedom to play when you want, and you can take days off whenever you want, but make no mistake about it, you've got to put hours in to make money from playing poker. It takes hours and hours of play to make your money.'

I ask him about the luck factor. 'Many poker players believe in the long run that luck is no factor and that the best players will ultimately get the money. And I happen to believe that also. Everyone knows, in the short run, on a given hand, in a given session, in a given tournament, any-body can catch cards and can win, and that's the beauty of the game.

'As a professional poker player, you don't look at one hand or one session or one tournament of poker, or at least you shouldn't. You should think of whatever game or tour-nament you're playing in as part of a year-long tournament or a year-long game. Then look at the bottom line at the end of the year. If you're in the plus column, you're a winning player, and if you're in the minus column, you're a losing player. And what you'll see is virtually year after year the better players are in the plus column at the end of the year.'

But then he has good news for minnows like me. 'I believe anybody who wants to, anybody in the world who wants to make an effort to become a winning poker player, can do it. To be a winning player you don't have to be anywhere near the best poker player in the world, and you don't even have to be the best one or two or three in the game that you're playing. All you've got to be is better than a couple of guys at

your table who play pretty bad. And you can make money playing poker.'

Good thinking . . . but does he think professional poker players are predators? He does. 'Poker is a jungle and it works just like a jungle. The strong feast on the weak and that's the way the poker world is. It seems cruel to outsiders that you literally look for weak prey, and you attack them like a shark would and just gobble them up when you sense blood, but that's what happens in the poker world. When you get "live ones" in the poker world, guys that have a big bankroll and want to play and don't have the crucial extra ability the pros have, these are guys that you want to play with. I've often said you can go to the Bellagio, probably the best poker room in the world, lavish settings and all that and they have all these big games, but I could set a trailer up across the street and if we have the "live" poker players and they're going to play in the trailer rather than play in the Bellagio, then that's where we'll play. You don't want to sit down at a table everyday looking at all world champions because it's going to be very tough to beat them.

'My favourite story in the poker world is about this guy called Eric Drache who used to run the WSOP. Eric was a good poker player himself, played seven-card stud, and this reporter had been interviewing him, and after he did that he went to Doyle Brunson and said, "I understand Eric is a pretty good seven-card stud player," and Doyle says to him, "Boy, he sure is. In fact, he might be the seventh best seven-card stud player in the world," and the reporter said, "Really? Wow! I didn't have any idea he was that good." And Doyle says, "The problem is, he keeps playing the top six." '

I tell him I'm amazed at the sums of money involved in

some cash games, and how players risk going broke. 'It's because money is not their driving force. Especially the old-school players, it's not just the money . . . what they want is to be recognized as one of the best. To play the best, and to play in the high-stake games. These kind of guys are a different breed entirely. To them it's about gambling at the highest level, taking the most risks and walking on the edge. All these great players you see who play the high-stakes games, the Brunsons, Ted Forrests, Phil Iveys . . . they're gamblers at heart.

'This is what separates the new younger players, who come via the Internet and television and play for the money and the fame, from the old school . . . With the old school the game's the thing, win or lose, whereas for the Internet generation it's the result that matters. I mean, back when we were playing the road in poker games, you had the thugs and the robbers, the thieves, the cheats and you had to play all these guys all the time and it was more or less like that. A lot of the older guys started playing poker in the back of the pool halls and they were in shady places with gangsters and all this kind of stuff. When the Brunsons of this world started playing, you fought fire with fire and you did what you had to do to survive. And guys were cheating and robberies were taking place and you did what you could to get the money and get out alive.'

I could listen to this man all day and all night, but things are happening in the poker room. Dave Colclough strikes a blow for the Usual Suspects by winning the €25,000 first place in the Omaha event. The other preliminaries are won by relative unknowns, apart from the charismatic Dutchman, Marcel Luske, who succeeds in defending his Hall of Fame title and winning nearly €120,000 in the process.

But it's the World Poker Tour event everyone's got their eye on and the players, no matter who they are, queue up with everyone else at a registration desk, to pay their €10,000 entry fee, 160 of them competing for a prize pool of €1,520,000.

By the end of the first day it appears to be Stuart Nash who is doing best, with over 50,000 chips, Carlo Citroni has 26,000, Andrew Black 23,000, but the Devilfish is not far away from his starting point some eleven hours earlier, and a number of the other British players have already left the game.

The next day I arrive an hour or so late to find the Devilfish is already out and departed. He's soon followed by nearly every other well-known name and the event is eventually won by a British player most of the Usual Suspects haven't even heard of – Rolande de Wolfe, who is only twenty-six and is a journalist. He wins €479,682, having played aggressively to reach the final table with a third of all the chips in play. He beats three Americans and three Frenchmen on the final day.

So, strike two for the Unknowns v the Usual Suspects. The latter compete for last-minute bookings on the Eurostar, after another disappointing overall result, but are looking forward to a lively time in London, because the poker powers-that-be, if they exist, have managed to pack a lot of activity into just a few days.

BIG WEEK IN LONDON

It's the beginning of August, and this is London's biggest ever week of professional poker. We all know the Victor (Chandler) Poker Cup (basically a television event) is to share the week with the European Poker Championships at the Vic, and that the Poker Million begins filming at the end of the week, but without coordinating it with the others, an Internet site called the World Poker Exchange has decided to stage its own tournament in London and guaranteed a whopping $2 million in prize money. Do the pros come running? You bet they do, even the legendary Doyle Brunson and others from the US, and most of the big names on the European tour, including most of the Usual Suspects.

But first the Victor (Chandler) Poker Cup is played in a television studio at Teddington, with ninety-six players contributing £5,000 each to compete for nearly half a million in prize money. As well as the defending champion Harry Demetriou, and the Devilfish (who admits 'I bluffed my way out of it' on day one), there are a number of top overseas players including Gus Hanson. Ben Roberts, in a relatively rare tournament appearance, comes third and wins £50,000, but the winner is a guy who once worked for Victor Chandler, Tony 'the Lizard' Bloom. He gets £200,000, not that he needs the money.

Tony Bloom is only five and a half feet tall and is not a full-time pro, but he scares the hell out of those who are. That's because he's a clever and thoughtful player, one of the *Late Night Poker* stars, with a string of impressive performances behind him including the £180,000 first prize in the 2004 Australian Open. He plays when he feels like it, turns

up all over the world, and is afraid of no one. He's the only Brit who's so far had the nerve to take up the Daniel Negreanu challenge.

Negreanu, the brilliant young Canadian-born player now living in Las Vegas, was at the time being paid a fortune to be the Wynn Casino's resident drawcard and had offered to play anyone in the world in a million dollar heads-up game of their choice. While Tony was there for the World Series he put $500,000 on the table and challenged Negreanu to a game of pot-limit Omaha. The game lasted five hours before Negreanu won with a flush to Tony's straight. Tony walked away as calmly as he had played. After all, what's half a million to a lifetime gambler who is said to be one of the biggest in sports betting, and who founded and later sold Premierbet.com, the Internet site specializing in Asian handicap betting (a way of betting on football that's particularly popular in the Far East and involves adding a handicap to even up the chances).

If Tony ever decided to play poker full-time he could do real damage.

But back to the Victor (Chandler) Poker Cup, and I notice Xuyen 'Bad Girl' Pham also makes the final table, ultimately coming sixth and taking away £16,000.

And herein lies a story . . . you could say poker's love story.

STEVE AND XUYEN'S STORY

It wouldn't have happened if 'Smokin'' Steve Vlader, a former grammar-school boy and Birmingham University graduate, had fulfilled his dream to be an RAF pilot. He nearly did. He

was one of only two out of forty candidates to pass all the aptitude tests when he went to Biggin Hill but was failed because he suffered from hayfever. It was a real blow. He eventually ended up in his father's business installing internal partitions in buildings. A keen cricketer, he began playing cards with other cricketers after their weekend games, and went from there to playing in card rooms. He began winning tournaments, won half a dozen around the £35,000 mark, appeared on *Late Night Poker*, and became one of William Hill's sponsored players. Steve's preferred place of play was the casino at Luton and it was there one night that he met Xuyen Pham.

Xuyen was born, the youngest of seven children, in Hanoi in North Vietnam in 1968 in a country apparently destined to always be at war. Her father was in the army, her mother a botanist. She left school at fifteen, spent a year in the army, serving her time in Russia, and after a life of ups and downs ended up in the UK in 1999 with three children. Somehow she found herself at the same Luton casino as 'Smokin'' Steve and became fascinated with poker.

'My friend told me about poker but only about pairs or three of a kind, and I didn't know about straights or flushes; each time I didn't have a pair or trips I threw my cards away, and one time the player next to me saw my hand and said that I had a straight, 7-jack, and asked, "Why did you throw your hand away?" and I said, "There's no pair," and he said, "You've got a straight and it's better than a pair." And I didn't know that and the dealer knew I was only learning and asked the inspector if I could have my hand back. And he said yes for the first time but the next time no. And the dealer tried to explain to me that a straight was very good, and also about a

flush and a full house and four of a kind, and I found this very exciting.

'My English was very bad then and I couldn't talk to anyone and I would stand behind people at the table learning how to play seven-card stud. There was a tournament and it was only £10 to enter so I said I'd give it a try. I made the final although people were laughing about the way I played hands and how I called the hands, but I loved it. Then a few people tried to teach me how to play poker.'

One of those people was Steve Vlader. 'Xuyen was a very wild poker player. I mean, wild doesn't describe it; she was fearless and aggressive and as a result she would sometimes get a massive pile of chips. And that's how she made that final . . . she drove everyone else out. Because they didn't know she didn't really know what she was doing. So I tried to help her. I tried to teach her a little bit of action management and she slowly integrated that into her game. Then I asked if she wanted to go to Walsall because there were a few tournaments up there. I played the festival tournaments and she'd play the smallest one, but her game developed there and that's how she started to get into the bigger games and realized that she could possibly make it in this game. And once she'd harnessed her powers and got it into some sort of framework and structure, she was away and now she's one of the best women players around.'

If she's one of the best around, it's largely because Steve helped her to be, and Steve put all his time into it because Steve was in love. For some time after they met Xuyen was involved with someone else, and Steve was for a while cast as friend and mentor. But 'she's very friendly and very tactile. She always used to give people a little hug, a little hello, and

I used to look forward to these little hugs and I'd hold on a little bit longer and a little bit longer. The hellos got a little bit better, a little bit better all the time.

'But because she had this other involvement, we used to just meet in the casino. I used to eat there before the tournaments so I'd invite her to come to dinner. Then I started to pick her up and bring her to the casino; she was actually on the way from where I used to live. We used to chat in the car a lot and then, when I was bringing her back, we used to sit in the car and talk for a time; then it was in for coffee . . . It was a slow burner, it wasn't a wham-bam sort of relationship at all.

'Our first kiss I'll never forget because she was still with the other chap. She was actually playing at Luton at the time and I was stood behind her at the rails just watching her play this hand. And she made a small mistake in the hand and I laughed, and when the hand was over I said, "You know you should have done this and that," and she turned round and smiled and laughed. Our faces were so close that I just kissed her, it just seemed the natural thing to do. She said, "Hey, you can't kiss me on the lips, you're not my boyfriend." But from that point on, that was it, and we knew that we were meant to be. She extricated herself from the other relationship over a period of time and we came together.'

But if the story ended there, this would be purely Mills and Boon . . . What makes it a match for George Bernard Shaw, Professor Higgins and Eliza Doolittle is that Smokin' Steve had encouraged and nurtured a champion.

Within an impossibly short time Xuyen, playing in the World Poker Championship in Dublin before the television cameras, fought her way through the ranks in the pot-limit Hold'em event, ultimately meeting Joe Beevers in a heads-up

on the final table, where the first prize was £250,000 and the second £125,000. Joe says, 'I lost a couple of big even money shots but I wouldn't take a thing away from her. She's a great player and completely fearless and she can match anyone on her day. And, unfortunately for me, this was her day.' It was indeed her day; she came from way behind to win the title.

As for Steve: 'I was bursting with pride. I cannot tell you what it meant to me for her to do that.'

Now they travel everywhere together, and when they're at home, they sit side by side at computers, playing online, Steve playing cash games and Xuyen playing tournaments. 'And we talk all the time – this is happening, that is happening, and how are you doing?'

And how did Xuyen become known as 'Bad Girl'?

Steve says, 'I sort of invented "Bad Girl". In one of the early tournaments we played against each other, she had got pocket kings against my pocket jacks in Hold'em and the flop comes king-jack-something and by the end of the hand she's got me out of the tournament, and I go up to her and say, "You bad girl" and it stuck a little bit with her, and when we actually had to find a name for her because of our joint William Hill sponsorship, I said, "That's it – we'll call you 'Bad Girl'."'

A week after our chat they were married.

Joe Beevers, the vanquished of Dublin, was one of a number of poker-playing friends who were at the wedding.

♥ ♦ ♠ ♣

Back to the big week in London, and, to the understandable annoyance of those who had been organizing the big tournament at the Vic, it's the latecomer, the $10,000 buy-in World Poker Exchange event, now called the London Open,

that has become the week's poker epicentre, its \$2 million prize pool acting like a magnet. It's held on two floors of the old Billingsgate Fish Market. A red carpet leads all the way from the street and around the building to a downstairs area that has been turned into an immaculate-looking casino. Upstairs there's a bar–restaurant–rest area with a view over the play. There is a huge party for over a thousand people on the opening night. Entertainers include Grace Jones. The poker pros are impressed. They're not accustomed to this.

The following day I find myself enjoying the free food and drink on the balcony, overlooking 150 top players at fifteen tables, all thoroughly enjoying being treated like stars.

The Devilfish, immaculate in a suit, is positioned at a centre table, and is competitively positioned with 37,000 chips in front of him when I witness a surprising episode.

A marketing man turns up and reminds him that he's due at a children's toyshop where he's to officially launch his Devilfish poker chips. Apparently a lot of kids have turned up, expecting to play at a table with the man himself. Now, with 37,000 chips in front of him and a chance of winning serious money, the Devilfish needs this like a hole in the head, but he reluctantly rises from the table, climbs into a taxi and heads off to Regent Street, with me in hot pursuit.

Then the Devilfish, looking, it has to be said, every bit a star, is led upstairs to a tiny corner, where a bunch of starry-eyed teenagers are waiting beside piles of the Devilfish's chips.

He sits down, and for two hours he deals the cards, offering comments and suggestions on the kids' play, and undertakes this desperately ill-timed personal appearance with grace. It's a surprisingly impressive performance.

By the time he returns he's lost 7,000 chips and all his

momentum and he never recovers, being knocked out early on the second day.

Willie Tann continues his Las Vegas form to come sixth and win $75,000. But the $750,000 first prize is contested in a four-hour heads-up between Mikael Thuritz of Sweden (you just can't keep these Swedes down) and the eventual winner, a relatively unknown Welsh player called Iwan Jones. He's a television producer who has never won a live tournament before (so, strike three for the Unknowns, although, unnoticed by the Usual Suspects, Jones had got to 296 in the main event at the World Series).

Later in the week I meet Paul Jackson who tells me an amazing story about this big win.

'I was in London on my way to a holiday in a caravan in Dorchester. I was with my friend Nick Gibson and this World Poker Exchange event was due to start in the morning and Nick said, "We've got to play in this game because the value is going to be immense." And I said, "I can't play because I'm going on holiday," and he couldn't play because he was going to his friend's wedding, so he said to me, "We've got to find someone to play this game for us because I've got such a good feeling about it." So I phoned up my friend Iwan in Cardiff at one in the morning on the day of the tournament and said, "Get down to London quick and we'll all put a third in and you play and we'll split the winnings." We knew him from playing online with Ladbrokes and thought he was an even better live player than he was on online. So he headed off for London straight away. He didn't even have time to change clothes and in the televised stages he was playing in an old tatty shirt with cigarette burns.

'And, would you believe it, he won, and we all had a third of the winnings each. So he got $250,000 from a tournament

he didn't even know was on at one o'clock that morning, and I got $250,000, my biggest-ever poker win, and I wasn't even there. I was in a caravan in Dorchester!'

This story finally convinces me that the poker world is unlike any other.

♥ ♦ ♠ ♣

So, to the festival at the Vic. It's spread all over the casino, occupying all the tables in the main card room, filling up the bar area, and with further tables upstairs in the earlier stages of the festival.

Mickey 'the Worm' Wernick achieves an outstanding three consecutive final table appearances, a second, a fifth, and an eighth and goes back to the Midlands with over £23,000 for his week's work. In fact, Mickey, who made the money in three events at the World Series too, is having a storming year and has set his heart on leading the European rankings before it's over. Mickey, sixty-one, would be a leading candidate for the Willie Tann/Ram Vaswani gold cup for leaks, because, as he admits, he's what is known as a 'sick gambler'. Despite his success at poker, he's always going broke. He can't resist a dog or a horse, but unfortunately they can resist him. 'I've had to sell my house to get a stake, we're living in rented accommodation,' he says cheerfully. 'I'm a gambler. Always have been, always will be. I'm . . . well, mad is the operative word.'

Mickey's family came to the Midlands from Warsaw during the First World War and Mickey went into the family business, sectional building. Then he and his gambler father Solly left it to open a poker club in an upstairs room at the old Victoria Hotel in Wolverhampton, with Mickey as dealer.

'Sometimes I dealt for twenty hours at a time. I used to

deal to Solly, who was no good, he was the fish, and I would watch him lose and think to myself, Fold, for God's sake, but what could I do?' The two of them worked in the casino business in the area for years. Mickey, who was a Midlands lightweight boxing champion when younger, was one of the first Brits to go to the World Series in Las Vegas; he and Solly first went there to see a big fight and he's now been going there to play poker for twenty-five years.

Mickey is out every night playing poker. You organize a tournament anywhere in the UK and he'll be there, this week Newcastle, next week Brighton, the following week . . . well, you name it. Telephone his long-suffering partner and ask where he is and she'll laugh and say, 'How should I know? I'm a poker widow.'

But he's a good player having a great year. Consistently in contention. All he needs is to win the big one: 'I just need one of the big ones and I'll buy another house.'

Now, where have I heard that before?

On the eve of the main event I have dinner with Bambos – full name Charalambos Xanthos (no, I can't pronounce it either) – and his fiercely loyal wife Stasia.

Bambos is one of the old school. He's been around for years. He's one of those who emerged out of the shadows on to *Late Night Poker*. And in his sixties he's still high in the European rankings. He's at the Vic almost every day. He's a man with a reputation for being both one of the real gentlemen of the game and at the same time one of the fiercest fighters at the table, as liked in the game today as he was feared – and suspected – in the past. It was Bambos who some years back finished Gary Whitaker's Leeds game by wiping everyone out over three consecutive weeks.

Bambos, who is a Greek Cypriot, began as a dealer in a

club in Woking, Surrey, where he and Stasia live to this day. As well as dealing, he played poker and won, but had the sense in his early days to invest some of his winnings, becoming part-owner of a hotel in Sussex Gardens in Paddington . . . He says at one time the partnership owned three. In the sixties he could be found playing five-card stud in many of the illegal clubs and spielers around London. He was a professional in the fullest sense of the word, not just playing to win, but managing his money. 'A lot of them today, they say they are professional but really they are not professionals. If you ask if they can support their own family playing cards, they wouldn't be able to. But that's what a professional does.'

Each day Bambos, who admits to getting a little weary now and no longer plays the hours the other pros do, leaves his Woking home, always immaculately dressed, looking like a business executive on the way to the office. He drives to the Vic, parking in its garage at about five in the afternoon. He will then play in a cash game for only about three hours, until about eight, and hope to make enough profit for the day. He will dine upstairs in the Vic restaurant and then go home. 'I still love the game – really, I'm enjoying myself while I'm trying to earn some money.'

He still turns up at the big tournaments and still scores goals from time to time. This is not a man to be treated lightly. He's a *real* poker player, one who knows how to play cards. Put him into a heads-up with a young gun and he would always be even money, their flair and almost crazy lack of fear matched by his experience and knowledge of when to hold 'em, when to fold 'em.

The following day is final table day, and I find Stuart Nash trying to keep calm in the bar as the television crew gets the

lighting right on the nearby set. Stuart is on the final table, coming in on the short stack, and is probably more concerned with trying to pick up a place or two and a bit more money than actually winning the event. Because Stuart has come to the circuit not by choice, but by necessity.

At fifty-nine, tall, with grey hair, he looks like an antique dealer. In fact, he *was* an antique dealer, until the Inland Revenue took his business apart, alleging that he was a better antique dealer than he was a bookkeeper, and bankrupted him.

'I was an antique dealer for many years, and I still dabble a little bit online, mainly books. I've had shops and sale rooms, I've exported, I've worked in every aspect of the business. But, thanks to the taxman, I was effectively driven out of it.

'At the same time I got divorced. This was in about 2000. So there I was at fifty-four, walking away from thirty years of marriage with £140 and a second-hand car. That's all I had in the world. But it was very cathartic because I'd had to endure so much pressure over it all that it was all a relief.

'Also, when things seem that low, the only way is up. I was left with not a lot of options. I'd never worked for anybody. I was unemployable. So I decided to try making a living from what I enjoyed, and that was poker.

'I had been playing, mainly recreationally, for forty years. I started as a teenager, playing seven-card stud and strip deck, a game you play with thirty-two cards. I started playing in backstreet clubs in and around London. I've been coming to the Vic for very nearly forty years.

'I didn't start playing tournaments seriously until this year. I was mainly playing cash games. I came second place

in the big tournament they had at the Vic at the beginning of this year. We did a deal on the prize money, the winner and myself. That was $114,000, my biggest payday.'

In fact, Stuart has made a real mark on the circuit. By the end of this year Poker Europa has him high up in its European rankings, in the same league as Dave Colclough, Willie Tann and Bambos – not bad for a long-time amateur coming so late to the big time.

He's called away to the final table where, as expected, the short stack proves an insurmountable obstacle. Nevertheless, he gets off the bottom rung and wins £16,000 for his three days' work.

The formidable twenty-eight-year-old Tony G, an Australian who was born in Lithuania and whose real name is Antanas Gouga, is making a big impact in Europe, and he comes into the final day with the chip lead, loses it and finds himself in a heads-up with a Swede (inevitably) called Sverre Sundbo, but eventually gets triple 8s to beat Sverre's pair of kings to win the £260,000 first prize.

As well as winning consistently at his 'hobby', Tony has interests in Internet sites, including Dave Colclough's Blonde Poker site. Hobby or profession, Tony G loves his poker. You would think that after winning £250,000 he would take the next day off and celebrate. But the next day I see him back in the card room playing in a cash game.

So ends a remarkable week of poker in London.

Well, not quite.

On the last day at the Vic there's a £300 buy-in no-limit Hold'em tournament and I decide it's time I play in a significant tournament; there's £45,000 at stake. As I wait for it to

start, I plan how I'll spend the money. However, confidence begins to ebb away as I notice that all the Usual Suspects are playing too. Having fallen by the wayside in the big one, they're hoping to clean up in this smaller event to pay for the week in London.

I start well. I'm the chip leader on my first table. A young professional tries to bluff me out of a hand; I call. It's a big win, as much a boost to my confidence from calling correctly as from the chips I add to my pile. I'm moved to another table, and I'm also chip leader there when I'm moved again. I then knock out a player I've seen on television when I go all-in with the nut flush and Mel Lofthouse calls with three 9s.

So comes another break, and I'm told that after it I will move to yet another table. So, as I've done at the time of the earlier table changes, I pocket my chips, only this time there's a twenty-minute break. I chat to Neil Channing and others, and then make my way to the new table to find all the players sitting in front of neat piles of chips. There's only one empty spot – mine. I begin to sense that all is not well. As I pull the chips from my pockets there's a gasp from the other players and the dealer nearly blows a gasket.

Where have they been?' he asks.

'In my pocket,' I reply.

All hell breaks loose. Do I not realize this is a hanging offence? Who knows what's been happening with the chips? I could've bought some chips from another player. Or sold some. Andy, the nearest floor manager, is called, then Jeff Leigh, the tournament director.

While I'm waiting to hear whether I'll be thrown out, I look around the table and my eyes fall on a tall, well-dressed man sitting in seat five and looking at me with amusement.

Oh my God, I think, it's 'Gentleman' Liam Flood, not only a legendary Irish player, a star of *Late Night Poker*, but an experienced tournament director in his own right. What on earth must he be thinking?

But Liam is not known as 'Gentleman' for nothing; he reassuringly urges me not to worry and cheerfully tells the officials that he's positive everybody on the table would wish them to overlook what is clearly an honest mistake. Jeff Leigh makes a friend of me for life by writing me off as a cretin rather than a criminal and allowing the game to go on.

But I'm a broken man. After being moved to another table, I allow my chips to begin to fade away as the blinds rise, and am finally knocked out (not in total disgrace – I saw off 70 per cent of those who entered, including half the Usual Suspects).

Later that evening I have dinner with 'Gentleman' Liam in the Vic restaurant.

'I want to thank you for being so kind,' I say.

The Irishman laughs. 'Kind?' he says. 'I'm afraid not. I was thinking that you clearly didn't know what you were doing and we should do what we could to keep you at the table. I wanted those chips.'

I was rapidly becoming an older and wiser man.

But I still liked Liam Flood.

LIAM'S STORY

Liam Flood stands out in the company of the Usual Suspects. For a start, he's nearly six and a half feet tall. And he's the best dressed, preferring tailored suits, matching tie and pocket handkerchief and shiny shoes to the jeans and jumpers or

sweatshirts of many of the younger competitors. While he's the most companionable of men, good fun at the dinner table, he's equally at ease in his own company, a bit of a loner. When he's waiting for the start of a tournament, or just been knocked out, you'll usually find him pushing coins into the slot machines, rather than chatting in the bar. He doesn't play the same number of tournaments as the others (describes himself as a 'retired bookie', not a poker pro), yet his strike rate is good. And of all the Irish players, he carries with him a sense of the history of the game. He was there when it all took off in Ireland and then in England.

Liam was born in a village in County Kildare in 1942 and has lived in the same house for all his sixty-three years. His father was a bookmaker, and even as a kid Liam often accompanied him to race meetings. But he didn't immediately go into the bookmaking business. When he was seventeen he went to Dublin and began working in a big shop there. He then went into other forms of selling, but when his father became ill he was the only one of the family able to help out, and so at thirty he became a bookmaker, working firstly with his father and then later taking over the business.

He did this for the next fifteen years, becoming a familiar sight at the track, standing tall and immaculately dressed on his box, rain or shine, always operating under his father's banner, 'Tom Flood – Bookmaker'. And, of course, he got to know the country's most famous bookmaker, Terry Rogers, the driving force behind poker in Ireland.

Liam may in dress and manner appear conservative, but under that cloak of conventionality there's a gambler always pushing to get out. He lost his first week's wages on the dogs, always had an eye for a promising horse, and got into cards in his early twenties, ultimately playing regularly at Terry

Rogers's Eccentrics Club and wherever else poker was played in Dublin.

He first made a mark on the professional scene in 1984 when he was on the Isle of Man helping Rogers run an international poker tournament there. It had attracted some of the top Americans and the first prize was £33,000, a lot of money for poker in those days. Liam decided he wanted to play but couldn't afford more than 10 per cent of the buy-in, so a number of others bought into him for the remaining 90 per cent. He won, knocking out that year's world champion Jack Keller and a number of other big names.

Unfortunately, he only got 10 per cent of the money. When they got back to Dublin the photographers were waiting. Rogers, always one with an eye for publicity, thrust an empty briefcase into his hands and said, 'Here, hold this up high, pretend it's full of money and smile.' Liam, still smarting from the 'missing' 90 per cent, looked at him in disbelief: 'I have nothing to smile about,' he said.

Liam was one of those who regularly travelled to Las Vegas with Rogers. One year the two of them ended up in prison, charged with illegal gambling, and that takes some doing in Las Vegas.

'Terry was keeping a book, – i.e. taking bets – but I wasn't involved. I was actually on my way to the pool and I thought I'd go and see how he was getting on, see how much he was holding and if he had many liabilities. I was only there two minutes, but while I was there he asked me to write down an entry and just after I did that the IRS arrived and I was now implicated, and we all ended up in Clark County Jail. Terry was there for twelve hours and I was there for fourteen.

'It was a busy jail and they were coming in all the time. We were put into a cell on our own at the beginning but it

was only until the cells across the corridor filled up. Every time someone came in Terry would ask them, "What are you in for?" and they all replied the same: "Misdemeanour". For all we knew, they could have killed somebody. Eventually, he asked one of the new inhabitants of our cell, "Why have those prisoners over there got television?" He was told, "Oh, they're the baddies." So after we were fingerprinted and mugshot we were disconcerted to find ourselves put into the baddies' cell, but then came the *Six O'Clock News* and there we were, on the screen: *"Irishmen arrested for illegal gambling in Vegas."* Well, from that moment we were the celebrities in the jail and they were all proud to be sharing our cell.'

In 1997 Liam won the European Championship at the Vic, his first really big win. 'I would have been about a 200–1 shot at the beginning and "Mad Marty" Wilson was raising every pot and I was on his left, so I say to him, "You'll do it once too often. You've raised every pot; you're not giving me a chance." A few minutes later Marty raises and I look at my cards and I've got a pair of aces so I say, "I warned you," and I reraise. So it goes around to him, and he says, "Wrong time, Liam. All-in." But it's the wrong time for Marty; he has king-7 off-suit.

'We come to the last table and we're looking at the prize money and we all need the money. There are three left, Devilfish, Surinder Sunar and myself. So we sit down at the table and I say, "Well, lads, are we doing any deal?" and they look at one another and say, "No, we don't do deals." Well, I play the best poker of my life and the most aggressive poker of my life. And I win. And they end up doing a deal between themselves for second and third. It was a big moment. I felt on top of the world. Mainly because I needed the money badly. I won £44,000.

'The only sad thing about it was my mother passed away two years earlier and she would have been so proud of me.'

This reminded me of a good thing I had heard about Liam. Evelyn Callaghan, wife of Frank, another veteran Irish player, once told me that Liam took two whole years out to look after his mother when she became ill. 'He took such care of her, it was inspirational to see,' she had said.

Liam, who is also highly rated as a tournament director, has six first place finishes in major tournaments behind him, including a Helsinki no-limit Hold'em event in 2002 and another no-limit Hold'em event at Walsall in 2004. But this year, 2005, has been one of his best. He won two events in Scotland earlier in the year and then took second place in the Party Poker World Open at Maidstone, winning around £80,000. As this year's end he performed brilliantly to reach the final of the William Hill Grand Prix, knocking out a number of top names in his heat and showing what a good player he is, even at sixty-three.

'Gentleman' Liam Flood is a gem in a world of rough diamonds, a man who bridges the back-alley card rooms of yesterday with the televised tournaments of today and adds a touch of class to them both.

The following week sees the filming of the Ladbrokes Poker Million. (By now half the major events are made-for-television series, actually played in television studios.)

This event really brings home how difficult it is for any of the Usual Suspects, or any of the major professionals, to win these events any more, such is the standard of the players emerging from the Internet. Donnacha O'Dea is probably the best player in the event, definitely the best man to put your

money on, if only because he's the holder of the title and knows what it takes to win it. This year he's once more made it on to the final table but he's on the short stack. The others are relatively unknown, and the $1 million prize eventually comes down to a clash between a warehouse-worker called Tony Jones, who won his seat from an Internet satellite, and Helen Chamberlain, a television sports presenter. Jones wins.

This is the second unknown Jones to win a huge prize in a week. I decide to change my name to Jones. Maybe this is the key factor. If not, O'Dea will do. Because Donnacha is one of those players who, like his friend Liam Flood, has stood the test of time and is greatly respected.

♥ ♦ ♠ ♣

DONNACHA'S STORY

In the world of the Usual Suspects, Donnacha is unique: he's not only won a gold bracelet at the Olympic Games of poker, the World Series, but he's actually competed in the *real* Olympic Games – as a swimmer for Ireland in Mexico in 1968. There's hardly an Irish swimming record he hasn't held.

Unusually for poker players, he comes from an affluent background. His father was Denis O'Dea, who acted in Dublin's famous Abbey Theatre, and later became a film actor, and his mother was the even better known actress, Siobhan McKenna. Denis was not actually a film *star* but he played many key supporting roles; film fans will have seen him in the lead supporting role in *Niagara Falls* with Marilyn Monroe, and in *Mogambo* with Grace Kelly and Clark Gable, in *Captain Horatio Hornblower* with Gregory Peck and in *Treasure Island*. Siobhan McKenna was the first actress to win an *Evening Standard* award, for St Joan. She played the leading

role in the West End and on Broadway. Perhaps her best-known film role was in *Dr Zhivago*.

Denis O'Dea also played cards. Donnacha says, 'I don't know how he started gambling, but my mother met him when they were in the same play and he asked her to go to the dog track and back a dog for him, because he was on stage for the whole time and she was on in the early part of the play and then in the last act. And she was mad enough to go from the Abbey and rush up to the track and bet on the dog. The dog lost and she came back, but she didn't get a chance to see him before they met on stage in the last act. He knew when he looked in her face that the dog had lost. In those days you earned about £10 a week and she had £200 on this dog for him. But, right there in front of the audience, he gave her a nod to tell her it was all right.'

Denis, said to be one of Ireland's best poker players in his day, ran a card game, the biggest private game in Dublin, involving senior business people and even politicians, including one who was to become prime minister, Sean Lemass. They played occasionally at the O'Dea home, but more usually in a hotel, most notably the Gresham.

Donnacha went to Trinity College, Dublin, but even while there it was clear that gambling was going to be his life. In addition to poker, he engaged in sports betting, usually on golf or tennis, and, like Liam Flood and Terry Rogers, he worked as a bookmaker, having opened a betting shop when it became so clear to other bookmakers that he was getting such good tips that they wouldn't take his bets. But poker has been his main source of income for thirty years or more. He was one of the first European players to compete with success in the World Series, making the final table in the main event in 1983 and also came second to Tom McEvoy in the limit

Hold'em event; he's still disappointed that he lost what was at one time a big chip lead in that event. In 1998 he won his one gold bracelet, in a pot-limit Omaha event. There was only one year in the 1990s when he wasn't in the money in at least one World Series event. And, of course, his biggest tournament win was in the Poker Million last year, 2004.

But despite this tournament success, Donnacha has always been more of a cash player than a tournament player. He was a regular in the big games at the Barracuda and Vic in the eighties, flying over from Dublin for three or four days a week. And he played in Las Vegas. He became a high-stakes player, fit to sit at the table in Vegas with Brunson, Chip Reese, Jack Straus and the other high rollers. And he played for big money in London, too; when you consider the cost of weekly flights from Dublin, hotels, food, table charges, etc., and the necessary bankroll for the game, and add that to the maintenance of a high quality of life for his family, you get an idea of how much money he must have been winning. (Talking of family, his son Eoghan is now also a highly promising poker player.)

Donnacha says opponents would see him 'as a tight, conservative player, but aggressive when I'm in a pot. I don't play in that many pots. I don't think I'm as tight as I used to be, actually.' Liam Flood says that one of Donnacha's strengths is that he never goes on tilt.

A charming man, Donnacha. But you could say he's led a charmed life.

Except that he's been winning for thirty years and he's sat down with Brunson and Co. in the big game in Vegas and come out alive. That takes skill and it takes steel. There's a ruthlessly disciplined computer of a mind behind that smile.

♥ ♦ ♠ ♣

Back to Barcelona for a heads-up tournament and an EPT event. Most of the Usual Suspects are here, but the place is overrun with Scandinavians. They run in packs. Because we have to fight for a seat at the cash games, when one of them sits down, the others stand around watching, adding their money to his, and assuming the right to comment on or criticize his game. But you can't help liking them. They just love this game and, unlike some particularly obnoxious French kids who I had to play with one day, they are impeccably behaved.

More evidence of the changing world of European poker: the European Poker Tour organizers have simply not anticipated the size of the turnout. There's a queue to register for the main event and not everyone can get in. They use some of the smaller heads-up tournament tables and squeeze in eleven to a table, but still some miss out. People start offering each other money for seats. Tempers get frayed. Even the amiable John Gale is fretting over the way spectators are allowed to wind their way between the tightly packed tables. Players find it difficult to concentrate because of the high volume of the speaker system. And in order to get the overcrowded event finished, the blind levels are raised extremely quickly. As Roy the Boy justifiably complains with typical understatement: 'The pain associated with a skilless "Shut your eyes and shove it in" elimination, after hours of methodical play, is akin to having one's already shocked and damaged ears being removed by a cheese grater.'

By the end of the week there's mutiny in the air. I can't help feeling, however, that the real problem is the staggering pace of the growth of the game. Tournament organizers just haven't caught up with what's happening. It seems to me inevitable that there will need to be qualifying tournaments

for these big events. Those who get results will automatically qualify; others will have to qualify in knock-out qualifying events in their own countries. After all, if you're not ranked, you have to enter qualifying events to get into Wimbledon or the British Open. Otherwise every aspiring tennis and golf player in the world would be there. And that's what is happening with poker – everyone, including me, is turning up. It needs to be sorted out.

Anyway, back to the poker, and the week begins with the first event on the new heads-up poker circuit. Over sixty players from fifteen countries compete. There's a clash of the giants in the first round – El Blondie v Devilfish, the two Daves, Colclough and Ulliott. El Blondie wins. I ask him how it went: 'Well, the organizers weren't too happy about drawing me and Dave together in the first round because they hadn't got any television planned for the Friday night. It was fairly tense because it was a match that we both wanted to win quite a lot. Fortunately, it just went totally in my direction. We played for about forty minutes where I was chipping away, just wearing him down bit by bit, until he'd had enough and put all his chips in with 7-9 calling one of my bets. But he got lucky in that hand and he got level. So we were back where we started almost an hour in, then he got dealt pocket aces, I raised with queen-9, he decided not to reraise me and to try and trap me, but what he actually did was trap himself because the flop came down queen-9-8, so I got a lucky flop and we went all-in and my hand held up. So it was a bit unlucky for him, but all I can say is I put all the chips in with the best hand.'

'So what did he say at the end?'

'Nothing complimentary whatsoever! Most of it was, "Lucky" . . . expletives . . . and things like that.'

The heads-up is won by a young American and the main event by an experienced French player.

Back in the bar for a last drink and Action Jack is telling me about a small satellite he saw played at the World Series. Yet another Irishman, Mike Magee, is playing. In the first hand one player loses fifty chips. In the second hand Mike, in the big blind, picks up an open-ended straight flush draw on the flop and checks; on the turn he gets the flush and goes all-in. His opponent, holding a set, lands a full house on the river and Mike gets up to walk away but the dealer calls him back because his opponent is the player who lost fifty chips earlier. So Mike has fifty chips. He's now on the small blind and puts twenty-five chips down and then folds with an unplayable hand. He's now down to twenty-five chips. He now goes on a rampage of all-ins and fights his way back to win the satellite and 5,000 chips from that near-impossible position.

'That's Mike "the Man" Magee,' says Action Man. 'A fighter. And a great player. And a gentleman – takes bad times well. Never complains about a bad beat.'

And who should walk into the bar but 'the Man' himself. Mike may not complain about bad beats, but he can graphically describe them.

'It's a £15,000–£20,000 event at the Russell Square casino and we get to the final table and I have more chips than all of the remaining finalists combined. I'm sitting there with £180K in chips and the other nine players between them have about £173K. I'm odds-on to win this.

'I go out of the tournament on hand three. And I have really good cards in those first three hands. It's unbelievable.

'It's the first hand and I'm looking at two red aces and the guy in first position raises £28K. I say, "How many chips have

you got left?" and he says, "Another £30K" and I say, "Stick it in" and he does and he turns over ace-queen off-suit. Another guy next to me says to him, "I don't fancy your chances, I passed a queen." I'm thinking, I have the pot won. The flop comes 2-4-6 and then the turn and the river come queen-queen. I've just done about £60K in chips.

'The second hand I'm sitting with ace-9 of spades and the guy on my right says, "All-in" – £42K. I call instantly. He turns over ace-8 off-suit and the cards come 2-4-jack-jack-8 and he wins with two 8s and I'm shell-shocked.

'The third hand, and I'm on the small blind with ace-king of hearts and everyone passes to me. I'm not going to slow play this so I go all-in, and the big blind says, "Gotta call you, Mike" and he turns over 10-8 for all his chips. The flop comes queen-jack-2. Then a 3. Then he picks up a 9 on the river for a straight. I was out after bad beats on three consecutive hands – the first three hands of the night.

'I get into my car and I drive around Russell Square and as I approach the lights I let out a scream of agony. The lights are red and in the few seconds while I wait I quickly mentally calculate the odds against me losing those three hands in the fashion that I did. It was 90,000–1.

'The next night I went to Luton. As I opened the door a young woman called Debbie approached and said, "Mike, you're not going to believe it," and I said, "What?" and she said, "Last night I had aces and this man had jacks and I lost," and I said, "Shit, Debbie, that's unbelievable. A whole 4–1 shot!'

It's a story told with passion, because for Mike poker is a passion. He thinks about it, reads about and talks about it all the time, and can he talk . . . this man would give Simon Trumper a run for his money. Surprising, really, because he's

so impassive and self-effacing at the poker table that he's almost unrecognizable off it . . . but then he's Irish and he was a salesman, so a gift of the gab shouldn't really come as a surprise. As Action Jack says, you can listen to Mike all night because when it comes to poker he knows what he's talking about.

I'm told he's brilliant at reading cards . . . Come to think of it, it's Mike who tells me that.

'Poker is all about decisions . . . pre-flop, on the flop, on the turn, on the river. It's all about making decisions. But you are given feedback before making that decision. Not just from the cards you can see; it's from the players, the way they behave, talk, bet.'

We're now sitting in a corner of the yet-to-open restaurant and a waiter comes in and turns on the lights. I think, Maybe we better get out of here, but Mike wants to illustrate his point: 'Look, we've got a waiter just come and turn the light on. You're a little disturbed because you feel we shouldn't be here. You're thinking of suggesting we move.'

How the hell did he know that?

'I sensed it. I *knew* that's what you were thinking. That's what I'm doing at the poker table, looking for just a fraction of a second's glimpse of what's going on in your mind.'

As we leave the room I make a mental note never to play poker with the man.

Not, of course, that I need fear anyone. Oh no. Having crashed out of a super satellite for the main event when I lost 10,000 chips in one ill-conceived bet, and had a couple of break-even cash games, I hit form (i.e. strike it lucky) on this last night. Unable to get into a cash game because of the numbers queuing, I succumb for the first time to the allure of the nearby blackjack tables and win €300 in just a few

minutes. Buoyed up by this I finally get into a cash game and, helped by a run of good hands, wipe everyone out, playing on until 4 a.m. when the place closes and I have to be dragged from the table, clutching a huge pile of chips. I pass Stuart Nash on the way to the cashier's. 'Did you win?' he asks. What kind of a question is that? How many chips do I have to have before it becomes obvious?

I soon cool down outside. After days of glorious sunshine, mornings at the pool, lunch on the seafront and fun in the bar in the evening, Barcelona decides to show its other side on this second trip. It's raining – torrential rain. The queue for taxis is drowning. Stuart and I decide there is no alternative but to walk to the H10 Marina Hotel and get wet. And get wet we do. By the time we get there we're soaked to the skin and drip puddles in the lift.

I get to my room and find all the euro notes I've won have become a sodden ball. The notes are hardly recognizable as money. I spend much of the remaining night laying them out in lines on the floor and doing my best to dry them, at one point even using a steam iron I find in the room. When the maid opens the door in the morning all she can see is drying euro notes, spread all over the bed, the chairs, the floor. She quickly backs out, no doubt convinced she's stumbled upon the scene of a crime.

I don't know whether she reported it, but the next time I applied for a room at the H10 Marina they claimed they were full.

12 / Shoot-out at the Vic

When you would rather have the truth, no matter how disappointing, over a false hope, no matter how desirable – then you're a player. The hand you're on slips into a stream of a thousand other hands, no one of which, because of your lofty view, seems unduly important. And because no hand seems unduly important, no false, fearful emotions rise within you. When you gain the peace of lofty perspective, you're a player, and when you're a player, you're free.

Rick Bennett, *King of a Small World*

October, and it's time for the last big shoot-out in London this year, the World Masters (poker has more 'world' events than any other activity in . . . the world). Nearly all the Usual Suspects are here, most with their eyes on the £3,000 buy-in main event. The main absentees are the Devilfish, who's obliged to play in UltimateBet.com's World Poker Tour event in Aruba and Roy 'the Boy', banned from the Vic for threatening to hit someone over the head with a chair (to be fair, he was drunk at the time and also sorely provoked, but the Vic is unsympathetic to this defence).

The week begins with a hard-fought no-limit Hold'em tournament. It takes two days and comes down to a deal

between the last four players, who huddle over the table and decide to share the money. They each take home £22,000. One of them is a cheerful Jeff Duvall.

While the preliminaries are taking place, I decide to visit the Western. This proves easier said than done. An out-of-sorts taxi driver more or less dumps me on the A30 near Park Royal, claiming there's no way he can get closer to where the Western is supposed to be. It's raining now, and dark, and I walk rather miserably down Western Avenue, the after-work traffic roaring past, and I actually pass the Western without noticing it, so understated is the building and its entrance. Finally I discover it. There's a letter 'W' on the door, the only sign to what turns out to be one of the country's best poker set-ups. Two spacious floors have been converted into two big card rooms full of brand-new poker tables. There's a separate card room for smaller games and a superbly appointed snooker room. But the place to be if you want to see high-stakes poker is one floor up, a luxurious inner sanctum set up for the high rollers, with its own bar, armchairs and buffet facilities. This is where the biggest games in London, possibly the biggest in Europe, now take place, where you can win or lose £100,000 or £150,000 in a night. I know Ben Roberts has played in this room and he only plays where the peanuts are gold-plated. That said, I'm also told his presence was short-lived because he was too good. It's to this place that the Western consortium attract a group of high-stakes players, mainly from the City, people like a financier in his thirties called Nick Gold, who I'm told likes to push the stakes up even higher. What I'm probably looking at is an upmarket Barry's. Who, I wonder, of the players who come to the Western's big game, is the London equivalent of Barry's builder? Because someone has to be losing in here – big time.

And it's hardly likely to be any member of the consortium running the show.

At the time (late 2005), it's virtually empty. Apart from one game at one table, the poker rooms are deserted, the snooker tables are covered and the whole place has a strange atmosphere, like it's there but it's not there.

The boss man is Derek Baxter, the veteran poker player who ran the game at Barry's. Grey-haired, with a 'lived-in' face, and, judging by our meeting, a chain-smoker, Derek is one of the consortium, a number of former players (one being George Crawley) who absconded from the big game at the Vic and put together the money to create this place. But there's clearly a problem. They're trying to sort out a legal tangle to do with 'change of use' of the building. Then they have to see whether they can actually operate within the law. The plan is to avoid what would probably be illegal table charges and instead profit from membership fees, catering and that kind of thing. Clearly they're hoping that if the Gutshot Club can get away with it, so can they. (Problem: the Gutshot has recently been raided by the police.)

Things may have moved on by the time this book is published but I've clearly landed upon this rather desolate place at a tricky time. I can understand Derek Baxter's frustration. Whatever some may think of some of the partners in the Western, and this is one of the tougher outfits on the poker scene, the gambling laws are now completely out of sync with the way poker has developed as a respectable and popular pastime. The game needs clubs and will be better and safer for having them.

Derek takes me into his office, opens yet another pack of cigarettes and, from behind a cloud of smoke, tells me the now familiar story of a gambling background. 'My father was

a snooker player and a hustler and he used to run a private poker game in the fifties and sixties and that's how I got involved. My father was a compulsive gambler. He used to bet on snooker, horses, dogs, anything. Whatever he made at snooker, and today he would have been a top professional, without a shadow of a doubt, he used to lose on the horses or the dogs.

'I got a job as a croupier at the Rainbow Casino in 1964. And I played in spielers, both in the Midlands and in London. To get the job at the Rainbow Casino you had to be a player. There were times when the action there was a lot better than the Vic; in those days, when the Vic was playing maybe one or two games a night, we were running ten in the Rainbow Casino. I eventually became the manager. I left in 1968 and I've now been playing professionally for nearly forty years . . . primarily cash games.'

Behind the tough, even cynical exterior, there's a dream. 'I'm sixty-seven and this has been a dream of mine for thirty-five to forty years – to run a poker club that's run by poker players for poker players. Not an off-shoot of a casino, designed to pull players in to lose their money at blackjack or roulette, but a proper poker place where they feel welcome and safe and get a good game of poker. Like they have in California with the Bicycle Club and the Commerce.'

Of course, it helps if there's money in it. For Derek and his partners. But I don't doubt the sentiment is genuine. However, sentimentality is not a characteristic of the way he plays poker. 'I play according to the odds and percentages. Obviously a big part of my game is bluff because I'm capable of putting a big bluff in, but most people know that and so it's about being able to read situations. And I think I'm a good reader of the game – I've got an edge over most people

I play with. There is a lot of luck involved with poker and I don't care what people say. They can tell me for the next 10,000 years it's 80 per cent skill but it's bullshit. So you have to play with care. Great care. If I go into the Vic and sit down in a poker game, nobody there wants me to play because they know they're not going to get any mileage with me. They know there's no loose money there. I'm not guaranteed to win because the luck factor is there but I'm not going to give any money away, whereas a lot of them do. And there's another thing: discipline. When things are going bad for me I just tighten up and I become the biggest rock on the planet. I only gamble when things are going for me. I put bluffs in that people wouldn't dream of putting in and I never show my cards. I've got a reputation for being a very tight player and I'm not, but people think I am. I'm very rigid in what cards I play and I don't play with rubbish. I play with combination cards all the time.'

As he walks me to the door he tells me about his biggest poker cock-up. 'I'd had a good run in Las Vegas and I decided on my last night to go out and have some fun. I finally got back to the Horseshoe in broad daylight and I was drunk and there was one game going on. They were playing seven-card stud, $300–$600 limit. I asked what the buy-in was and they said $10K. So I sat down and I remember winning the first pot, which was $26K, but I don't remember a thing after that. I woke up in my room at three or four in the afternoon and I tried to think what I'd done and what had happened to me. I'd lost all my money in that game, every cent I had worked so hard to earn, probably about $80K. I've never had a drink while playing since.'

I leave him with his memories and his hopes for the

Western (and his money; he tells me he earns a steady £100,000 a year playing poker) and go back to the Vic.

On the way I think more about Ben Roberts. Now there's a name to conjure with. You can argue for hours about who's the best UK tournament player, but when it comes to cash games, I hear one name more than any other: Ben Roberts.

He's not well known. I'm told that's because he eschews celebrity, rarely gives interviews and even more rarely appears on television. While the Usual Suspects are pushing on around the European circuit, Ben Roberts is apparently more likely to be found at one of the top tables in Los Angeles or Las Vegas, playing with the hardest men in the business for the highest stakes.

In UK poker circles he has a huge, if contradictory, reputation, as both a single-minded 'win at all costs' player and as someone with ideal poker table manners. That's what they all say about Ben, he's a poker gentleman; at least, everyone who's met him . . . because I've been on the circuit and around the poker rooms for weeks and not seen him once. To me he's a mystery man. But now at the Vic I track him down.

It turns out he's always been about thirty yards away.

He has a luxury apartment – and I mean luxury – in a block directly across the street from the casino. (He also has a beautiful home in Stamford in Lincolnshire, two cars and has put three children through private education – all from poker winnings. So, this is not just a high-stakes player, this is a big money winner.)

I knock on his door. He's small, boyish-looking for a forty-nine-year-old, friendly, and he's eating a bowl of melon and reading a book called *Unlimited Power: The New Science of*

Personal Achievement. Clearly he believes in keeping both body and mind in good trim. He also believes in keeping his spotless apartment spotless – I'm asked to take my shoes off at the door.

♥ ♦ ♠ ♣

BEN'S STORY

He's not Ben Roberts at all. He's Mehdi Javdani. He changed his name when he got married so that his children would have English names.

He was, in fact, born in the north of Iran and was sent to England on his own when he was eighteen. He knew no one, had little money and couldn't communicate. While he had a grounding in English, everyone spoke it too fast for him to understand. Even now it takes him an age to write out his address on a piece of paper and his handwriting is almost childlike. Which is not to say that he isn't as bright as a button, because his approach to poker is frighteningly intellectual and has been since he first became obsessed with the game at college. He played every night then and didn't study at all, just going into college to eat. He was living on about £10 a week, 'half for a trolley-load of stuff from Tesco's and half for the rent'.

But he couldn't face his parents if he didn't pass an exam, so he went to a college in Newark in Nottinghamshire for six or seven weeks and really worked and passed the exam and went to Rugby Polytechnic to do computer studies. But by then he couldn't care less about computers; he had only two loves: snooker (he could have been a professional) and the game he settled for – poker.

'I think I was twenty-three when I started to think about

it seriously. There were games around where we were living and I got the idea of having my own game in my house. That was on Wednesday nights in Peterborough. But now I wanted to play every night and eventually came to London and realized that there were games going on here all the time. So I started playing regularly at the Vic.'

He married at twenty-one and his wife Heather 'loved watching the game and would sit behind me reading a little bit and she enjoyed that. And we were making a bit of money; not too much but enough to make a living. Expenses were not so high then. I milled around the Vic for many years. I stayed in a bed and breakfast place in Sussex Gardens because it was cheap . . . it was a decent place. And I got a flat for a while. But I wasn't playing in London all the time because we never actually lived in London; our home has always been in the Stamford area because my wife has strong links in Stamford.'

In the early days at the Vic he was constrained by resources. 'To play in the big games I needed a bankroll and that was the thing I had to fight for all along, because I had no capital and no help from anyone.' He built his bankroll up gradually, but 'I remember being nervous about going up to the £250 game and I was kind of backing off with fear. If you're afraid of losing money you're affected not only in your confidence but in your logical process, and therefore you turn into a different player.

'I believe that we have two minds, one that thinks and one that feels. But unfortunately the part that feels evolves prior to the logical part of the brain and it can be extremely dominant once it's triggered, to a point where it pushes the logical part of the brain into a corner where it counts for nothing. So all that's left is this emotional part dictating.'

'Does that mean when you're playing you have to cut the part that feels right out?'

'I don't think you can turn yourself into a machine, but what you can do is realize what you are made of. Self-control is essential to success in poker. Without it you will lose. And if you have fear, like fear of losing money, you'll lose.'

I ask him about how other players play their cards and how that affects his decisions.

'You are playing a situation. The situation is the combination of the cards and the people and their skill and their state of mind at this precise moment. Somebody can make a raise and you lay your hand down; another time the same guy can make a raise and you call him. You interpret the situation differently. So really it's a battle of wits. Whoever is the sharpest in there, whoever can manoeuvre his way around more effectively, is going to come out on top more often. And you have to be extremely competitive because that is the fun of the game. What originally pulled me towards the game was how competitive you could be – how you were allowed to be as devious as possible during the pot, and ruthless – because if you want to really succeed in the game you're going to get your opponent on to the floor and then kick him. I don't mean that in an unkind way at all . . . but that is the game. Otherwise, you've got to sit back when he's made a mistake and not capitalize on it. You can't do that. You go right to the ultimate and you're killing him to the maximum point – and that is how you get the maximum units for yourself. You're not having a go at them . . . rather, your challenge in the game is to increase the maximum money you make in an hour for yourself.'

Ben is a real professional in the sense that he knows how

much he has to earn and what for and makes proper provision for his family the priority. 'I need to make £150K the way things are right now . . . the equivalent of $250,000 if I was paying tax. So now I have to go out and I have to deliver £150,000 every year. So really I want to play in more tournaments but before I can enter any tournament I need to win this money.'

For the same reason, he doesn't care much about profile.

'Going for glamour hasn't been my number one thing in the past and I have no regrets about that. But I'm really happy to see what is happening with other people who have become celebrities. I think it's fantastic and it's good for the profile of the game.'

These days he's playing for big stakes, in games with £200–£400 blinds that require around £25,000 just to sit down.

I ask him about playing in the Western and for the first time he appears evasive.

'I haven't played there for a while, because I'm travelling around a lot. Over the last few years I've been travelling round the world trying to find the best routine to follow. And it took me a few years to find it. That means in January starting with Tunica. Mississippi is the place if you're looking for good poker games. What you can do is go and check in, unpack and then forget about time for three weeks. You go down and play, and if you don't want to play you go and eat or talk to your friends and it doesn't matter what time you wake up, the game is always there. And I love that. So, Tunica in January, then the Commerce in LA for the whole of February is a great place to be, especially as it's been improved and it has a good no-limit game – $5,000 games are commonplace now. It's like a mini Bellagio now and everything there

is designed for poker players. It has the biggest card room you'll ever see anywhere and there are games going all the time. March, generally I come home. Beginning of April, the Bellagio in Las Vegas is normally very good for two or three weeks. Then the World Series and another six weeks in Las Vegas. Around Europe I do very little; I go to Amsterdam in November for a couple of weeks.'

What's the most he's won in a game?

'I won $150K in a tournament when I reached the final of the World Series in 1998.'

And in a cash game?

'I've had many wins of $100K. One time I won over $150K but with the $200–$400 games normally you're dealing with wins and losses around $20K, $40K, $60K and if you lose $100K it's an unusual night . . . and if you win $120k it's unusual.'

Has he played with that famous group, Doyle Brunson and Co., who play for huge stakes in Las Vegas?

'Yes, I did and in fact my biggest loss in a cash game happened in that game. I had winnings to spare so now I was looking for an opportunity to increase this by getting my foot into even bigger games and either maximize my winnings or lose and retreat. So I put $100K down and I played in this game and one of the reasons was George 'the Greek' was playing and he's been a huge loser over many years. Chip Reece was in the game. But I lost. It took me about three hours to lose that $99K.'

And the money that he's now playing for . . . doesn't it affect his game at all? 'I mean, most people will be astonished that you can walk in and put £20K on the table.'

'But remember, I'm not a businessman who takes £20K out of the till and puts it on the poker table, and if I lose it

I'm not going to have enough money for my business. This *is* my business.'

'If we put two people to play each other and one is a professor of mathematics and one is a professor of psychology, who will win?'

'I believe the psychologist. I think mathematics is a must. I'm not saying that you can do without it; you must know that when you have a pair it's 8–1 to make trips on the flop, so when you're calling a raise you weigh up whether you're getting 8–1 on your money or not. But it pretty much ends there and there is an ocean left and that is the game.'

Now he's teaching his son Jamie to play. What are the fundamental principles that he's laying down?

'What I tell him is when you lose at poker it is OK. It is OK when you lose. It is fine. It really comes down to fear of losing, and the effect of it on your brain, and the change of chemistry in you, altering your whole personality so the quality of your decisions drops and you're in no-man's-land. Fear of losing is the biggest danger to any player.'

I found Ben a bit of an enigma. I wondered whether there was more to him than met the eye. Then I decided it was probably the opposite – that what you see is what you get, and what you see is a charming killer. At the poker table, of course.

It's time to go back across the road to the Vic. The sponsors of the big event have imported their two American stars, the two who qualified for the World Series on the Internet and went on to win, Chris Moneymaker in 2003 and Greg Raymer in 2004. These were life-changing wins. But how have their lives actually changed? This is my chance to find out.

Well, for one thing, Chris Moneymaker has lost weight, tidied up his appearance and looks great. But there's a lot more that's changed, too.

'One, I got divorced, remarried. Two, I quit my job. I'm a full-time professional poker player now. I only play about four or five tournaments a year. The reason for that is I do a lot of endorsements. I'm working with *Playboy*, with Canadian Club whisky and with PokerStars. I'm starting a company and spend a lot of time getting that up and running, and then I spend half the year at least on the road.'

But has he changed himself – as a man?

'I don't think so. I was an accountant before and I had a desire to own my own business, so winning the money gave me the ability to do that. And I'm still in the same area that I lived in before. Still have the same friends.'

He wrote a lot about his wife in his autobiography. Did winning the World Series cause the break-up?

'When I got married, I travelled 80 per cent of the time. I was on the road a lot and my ex-wife complained constantly that I travelled too much, so I left that job and got a local job being a comptroller at a restaurant group. So I never travelled and I was home every night. When I won the World Series I went back to work for nine months and stuck it out, and then the money just got too big in the poker area, so I started travelling to earn it and she said, "If you travel again, we're going to get divorced." Well, things hadn't been going great at home anyway for a long time, so I said, "I've gotta do it, you make your decision whether you want to stay or not." That was it.'

I wonder if it will ever be possible for someone else – say, me! – to do what he did and spend $40 on the Internet and end up winning the World Series.

'It can be done; I'm not going to say it can't be done but you've got to be good. I mean, everybody for two years now has been telling me how bad I am and how lucky I was and that's OK with me. I want people to think I'm bad. It makes it easier to win. The reality is, I'm a very good poker player and I know I am. Greg (Raymer) is a very good poker player. Whoever wins that thing has to be a poker player of some sort. Anybody can do it, but you have to spend time and learn the game and play properly, and you have to have the necessary skill sets. You have to be able to have a sense about someone's hand, or be mathematically inclined, or have a good memory to remember what someone did four or five hours ago, or last week. That's part of what a good poker player is. I can remember what every guy did in the World Series in 2003, so when I play with them now I still remember how they played a hand.'

He says his book, detailing every single World Series hand, was straight from memory. 'That's how my mind works. I can't remember what I had for breakfast, or what I did last week, but I can remember a poker hand, I have a photographic memory when it comes to poker hands. How it all went down, how the board played out, what the turn and the river was, how they reacted. Bits of stuff, I just remember. I can't explain it, but it's a good thing to have.'

He wanders off. Other poker players glance at him, pretend not to be impressed. 'Chris Moneymaker – he was just plain lucky.'

Except that he lasted five days, from noon till the early hours every day, and played hundreds of hands and beat every top poker professional in the whole world, *and won*. Won $2.5 million.

Well, I, for one, am not pretending. I *am* impressed.

As I am with Greg Raymer. But then I've met him before, at the World Series and I was impressed then. This is an intelligent, articulate, gentlemanly guy who has handled himself like a champion. He, too, has suffered from the 'just plain luck' syndrome, except that he came back to the World Series main event this year and was the chip leader two days out, and finished higher than most of the big names. He may not have won this year, but it was good enough. In terms of proving himself at the highest level, he's done it twice. And if that doesn't convince the doubters, then nothing will.

This year's result must have given him considerable satisfaction?

'Well, most people give me credit for being at least a decent player. But there are a small handful of people that are always going to try and put you down, try to malign you, try to say you're not a good player, so I guess it was good to come back and show I really do deserve to be up there with the others. But I've always been comfortable with my game. I know how much I've played and that I'm a good player.'

And has his life been changed by winning the $5 million?

'From the feedback I've got from my family and close friends, apparently I am the same guy. That could be because my ambition isn't just to win. What I've always guided myself towards, including all this year, is improving my game. What I've convinced myself of intellectually, and what I'm still working on convincing myself emotionally, is that what matters is making good decisions.

'I try to make the best decisions I can on each hand, and I'm happy if I make the right decisions. I'm always disgusted with myself when I know I've played poorly. Take the British Poker Open I played last time I was in London. I played great to win my heat of six, but once there were twelve of us in the

semi-finals I played terribly, but lucked my way to the finals. Then in the finals, six-handed, I finished third and I was lucky not to be out sixth because I played terribly in the finals as well. That normally would be a good result that you should be happy with, but since I played poorly for most of the tournament, I was very disappointed.'

He keeps stressing that results are meaningless and any one tournament, even the World Series, is a short-term result.

'I guess I've become a bit of a perfectionist. I just hate to play badly and I'm on a constant quest to play by making the right decisions. It's not losing that upsets me, it's playing badly. If I get knocked out of the tournament and I know that I played one or more hands badly, then that's what I'm disappointed about – with the way I've played those hands. I'm unhappy with myself, with the way I played those hands. Even the World Series, even when I got knocked out this year, having gone so deep in the event, I knew I played all the key hands quite well. The only thing that bothered me was a couple of hands when I lost a few chips before the key hand that crippled me. I thought, I'm not sure I played those hands too well; I could have saved more chips, and then when I lost the big hand I would have had more left in my stack and I might have been able to make a comeback. I had less regrets about the big hand where I lost a $4 million pot, than the couple of hands prior to that, where I maybe lost a couple of hundred thousand in a couple of pots. Because I played those badly.'

Shortly after talking to these famous names, I have a lesson in the value of celebrity.

I've asked my friend Mike Atherton, the former England

cricket captain, to come for the day. Mike is writing a book on gambling. As we stand chatting in the midst of the pre-start chaos, Mike is spotted by a PokerStars executive who promptly offers to come up with a £3,000 buy-in so that Mike can play in the main event. They believe that Mike in a PokerStar's shirt will add some glamour to their television coverage. So now I, who would have cheerfully cut off one of my own hands to play in the event, am left standing there while *my guest* gets a free buy-in. Can you believe it? I tell him I hope he gets busted out on the first hand in a humiliating debacle that keeps the TV audiences amused for years. Mike just laughs.

So the whole thing gets under way. I wander around the tables for an hour or so. It strikes me, as he weaves his way between the tables, that you can't go to any major event in Europe without seeing Tony 'Tikay' Kendall here, there and everywhere; when he's not playing in the event himself, he's rushing around with a notebook coordinating the Internet coverage on Blondepoker.com. He reminds me of White Rabbit in *Alice in Wonderland*, always on the move, never time to talk. But if you can pin him down, it's an amazing story. There were family difficulties when he was a kid, the result being that he couldn't read or write at fifteen, then a miracle occurred . . . He woke up one day and he could do both perfectly. He says he must have been absorbing all he'd been taught all those years but there was a psychological block that prevented him using it. He began reading books that day and has read at least one a week ever since. He did well in business until he retired shortly after turning fifty to concentrate on poker. He's teamed up with Dave Colclough to create one of the best poker Internet sites. He's always got

time for the young and the up-and-coming players, and while he's not won an event of any note yet himself, he's a good player. At one point he tells those who tune into the website, 'I try to lose with dignity, and win graciously. Well, I will if I ever bloody win . . .' The man is pure gold.

Back at the bar I'm joined by Mike. Oh dear, out already? What a shame. Tee hee. What happened?

'I had a king-10, the flop came 10-king-queen and I raised, and this young American went all-in. He had a straight and I didn't improve.'

So go on then, what was it like?

'Well, I enjoyed it. But I can see it's a monumentally difficult game. The first forty minutes I was kind of finding my way . . . After I won my first hand I was much calmer and played better after that. There was an American woman at the table who was playing wildly and that disconcerted me; I made some bad decisions as a result. I actually had bad cards when I was in a good position and good cards when I was in a bad one. But I made some bad decisions. But there we go . . .'

And there go several of the Usual Suspects – Jeff Duvall, for instance, now knocked out of the main event, too. 'My table looked like I was at primary school. The oldest one didn't look older than fourteen. I felt so old. They were so young. You wouldn't have believed they could get into a casino. They're obviously Internet players because they couldn't handle the chips properly. But they played OK.

'I don't feel bad. I've had a decent week, anyway. I won every day in the cash game and shared the win in the opening tournament so I'm probably £20K up. Not a bad week at all. I bet you'd like to do that every week.'

Quite so, I think, wondering why it was me and not him who paid for dinner earlier. I clearly still haven't got the hang of this business.

I catch Liam Flood and Carlo Citrone in a classic confrontation. Liam has gone all-in with pocket 10s and is standing. Carlo is sitting, lost in thought. The television cameraman moves in, sensing drama, knowing this is where poker is at its most exciting. This is the gunfight from a thousand westerns, the veteran sheriff (Liam) and the young gunfighter (Carlo), eyeball to eyeball, one, in poker terms, about to die. Liam tries to talk him out of the hand. 'What have you got?' he asks. 'Jacks,' replies Carlo. 'Not good enough,' says Liam. But Liam has made a rare mistake; Carlo interprets the exchange as a sign of weakness. Why would Liam try to talk him out of the hand? He takes his time while Liam's sun slowly sets, calls, then he turns over the jacks and Liam is out.

Gradually all the Usual Suspects and other big names are eliminated and, for the umpteenth time this year, the tournament is won by a relative unknown, a young Londoner called Mark Teitscher, who takes away the £280,000 first prize.

So, a last chance for the Usual Suspects to win one of the big ones and it doesn't happen. And it's my last night on the circuit. Mike Atherton, Tony Holden and I celebrate it in the Vic restaurant, with John Duthie as our guest.

Ah, John Duthie! Now there's another name to conjure with.

This is the guy who came from nowhere to win the first Poker Million in an event televised live from the Isle of Man. I remember watching it. He looked as calm as if he was playing at the kitchen table, perhaps because he felt he was

destined to win. 'I went there to win. I had just won £20,000 coming third in a big tournament at the Vic and I had a feeling I would win the Poker Million so I decided to invest £6,000 in it. My wife Charlotte had organized a dinner party for the Saturday night and said, "There's no way you're going to go and waste this money on a poker game" but I said, "I've got to go. I know I'm going to win. It's my destiny."

'There were 170 or so. They were all there, Johnny Chan, Phil Hellmuth, Howard Lederer . . . everybody, all the serious players. It lasted about seven days. I was very near the bottom of the field on the first day, very near. But I played solidly and gradually built my stack up. Then on the third day I had this very significant double-up with pocket aces so I'd immediately reached my daily target in that one hand. After I won that I could just sit back and wait.

'I did have this game plan, that if I played solid for four days and if I got to the final table I was going to turn the whole thing upside down and just go for it, and I did, and it worked. I went into the final table second to bottom. You're in such a strong position when you're down there – you expect to get fifth so you can just play really, really aggressively. The real piece of luck I had was that I made four huge bluffs and never came up against a big hand when I made them, and that was the only reason I won really. It was all timing, that was the luck I had, and then I got a little bit of luck towards the end with the cards.'

John is not a typical pro. He's always maintained a career as a television director, and he's now running the European Poker Tour. He also seized the chance to invest a considerable sum in a trust fund for the family, keeping a relatively small percentage for playing poker.

And he's well in control of his ego. 'It was just a moment

of pure clarity of thought. I'm a modest player, I don't consider myself a great poker player. I have my moments . . . it's a form thing.'

He looks to Mike Atherton. 'There must be days when you go out, where everything about your whole life just feels great . . . your timing, etc. . . . you just know you're going to perform and you dominate it?'

Mike says, 'But what separates really good players from the not so good players is how you play when it's not going so well. I'm talking batting here, not poker. If you can get fifty or sixty at cricket when you feel horribly out of nick, your feet aren't moving and your head's going all over the shop, you feel low on confidence . . . if you can scrap out fifty or sixty then, that keeps you in the side for the next game and the next game and suddenly your form will return. There may be an analogy for poker – how you mentally cope with a series of bad hands, bad losses. Whether you can keep your equilibrium . . .'

John agrees. 'It's really difficult when you're constantly taking those knocks. I had a six-month bad run at the end of 2003, where everything I did was wrong. If somebody had to hit just one card to win, they would hit it. You could feel it coming, it felt terrible. By Christmas, I think I'd lost about £250K in that six-month period. I thought, Right, I've got to take a break, so I took a break and worked out a few ways that I could get back this £250K. And I did.'

I'm coming to the end of my poker odyssey, so I run over some of the questions that have kept coming, starting with the luck factor. After all, John acknowledged he had luck when he won the Poker Million.

'It's actually a more complicated question than you may think. It totally depends on the player. There are some players

where the percentage of luck will be 20 per cent or 30 per cent because they're very specific about the hands they play, they're very solid cash game players, and they will tend to always win in the end because the skill factor is much higher. There are people like me; I still consider myself a recreational player. I will take risks with hands which I can probably go broke with so the luck factor is probably about 50 per cent with me, you know, 50–50. So it all really comes down to the individual and what kind of person they are. You can't say that poker is 80 per cent skill and 20 per cent luck because it just isn't. If you play every single hand it might go down to 30 per cent skill and 70 per cent luck, you know. It all depends on the player; it all depends on the player's state of mind at any given moment and that's what makes the game so fascinating. I can play a very solid poker game if I'm in the right frame of mind. You know, the World Series, for instance. I always play incredibly solid, so the skill factor goes up a great deal more, whereas when I'm playing a cash game at the Vic I come partly for the fun. I play far too many hands and the luck factor changes.'

We talk about the rising Internet generation. 'I think Sweden is probably the strongest poker country, there are so many of them playing and they're incredibly aggressive players. They are very well practised. The thing about these young Swedes is, they have managed to amass the poker experience in three years what has taken the majority of professionals a lifetime to amass. I was talking to a guy yesterday who's played a million hands online, and this kid is probably about twenty-two or twenty-three years old, but what he does is he plays eight tables at a time on the Internet. He is playing so many hands that he gets a lifetime's experience in a short time.

'Having said that, even though they're incredibly good

online players, I'm not convinced that they match the experi-
ence of the live action that the old pros have.

'It's totally different. The Internet players tend to be stat-
isticians and very good on probability, but the real players are
the ones who bring psychology to the game. In a live game
there's so much more information, particularly the body
language, just the general composure of an individual as
they're betting, as they're calling. It's much easier. You've got
much more information there, whereas on the Internet the
only information that you have is really the size of their bet
and the speed in which they make that bet. Sometimes that
can be deceptive . . . somebody may be on a dial-up modem
and it might mean that their bet comes in slower but it has
no relation to what is going on. The live game is much, much
more interesting because there's much more information.'

John thinks the younger players have a much more suici-
dal approach to the game. 'They haven't got a lot to lose. If
you're aged between eighteen and thirty, you don't have
the responsibilities that somebody of my age has. You have
families, you've got mortgages; you need to have an income.
These kids, they've got no sense of the value of money. They
just throw all their money in, they might have $1 million
one week and then nothing the next. I'm convinced that a
lot of these Internet players who've come from the age of
fourteen up and are playing poker, they don't see the value
of their currency . . . they just have no idea. They're buying
in, and to them it's just like a virtual currency until they cash
out and buy something with it.

'Somebody else said to me in Barcelona that there was a
young Internet player who'd won like $500K and he didn't
think anything of it until he'd actually gone into a bank and
withdrawn $20K to go to Barcelona and when he was holding

the actual physical cash he was shaking. He couldn't believe that he had this much cash in his hand.'

I ask him, 'Is there a dark side to the game?'

'One is the potential to collude on the Internet, players playing with each other. There will be three or four people sitting at a game on the Internet talking to each other. I think that the online sites are developing software and ways that can spot the collusion. It's not in their interest to have players that collude, for obvious reasons.

'But for me the main dark side is the danger of addiction. It's nothing like back-room gangsters and corruption, robbery, things like that. I think the danger is money mismanagement by individuals. People have to be very cautious about maxing out their credit cards or putting themselves in debt, because this to me is personal misery and you should be very careful if you're doing that.

'I think that the online sites in the poker community have a responsibility to individuals who don't have the willpower to be able to control their finances. I think we need to educate and say, "Great game, really good fun, but play with money that you can afford to lose."

'I don't think anything in life should ever take over your life. Whatever you do, it should never, ever dominate your life, you should always try to have a balance in life.

'My advice to people is, by all means play it, but keep it in perspective, and play within your means. Then it's a good game.'

This advice will, I know, be rejected without a second's thought by everybody in this building; the pros wouldn't even recognize it as being spoken in the English language.

Yet for me it's good advice. It's time I got out of this place. It's time to go. My journey's over.

13 / Journey's end

No hand is impervious to cracking, no card holdings are insulated by immunity to assault or defeat . . . those that win . . . are simply possessed by the supreme confidence (and secured) in the knowledge that over the long grind of poker they will prevail and be ultimately triumphant . . . This is what sustains them in the darkest hours of a bad poker day, or after a bad-beat. They are unaffected. They merely sleep it off, or better still, go into partial hibernation, poker twilight sleep . . . when these giants wake up, someone will be clubbed in the skull many times over . . . even after a stiff bad-beat these players still aim the gun in the same old way, pull the trigger in the same old way, and the enemy who charges in the same old way will be killed in the same old way.

Ray Michael B, *Poker Farce and Poker Truth*

I leave the Vic about 3 a.m. on a Saturday night/Sunday morning. The Edgware Road is still alive with late-night revellers. As I enjoy the fresh air and look around me, I feel like a stranger . . . I realize that for weeks I haven't really been living in this world, I've been living in a place without breakfasts and mornings, without sunshine, without rush hours and desks and filing cabinets, without newspapers

(except for the racing pages) and without tax; in a tight community paradoxically made up of people dedicated to individuality, where it's within the rules, expected, even necessary, that you deceive and lie to take others' money, and yet, possibly within minutes of doing that, you trust a fellow player enough to lend him thousands of pounds without so much as a handshake.

As I walk London's streets I find myself reviewing what I've learned about professional poker and, above all, about these players who I first saw on *Late Night Poker* what seems a lifetime ago.

I wonder if the phenomenal growth in the game is likely to continue. Or is it already coming to an end? I recall having dinner in Las Vegas with Tony Holden, American poker writer Michael Craig and a British gambling consultant, Joe Saumarez-Smith, who argued strongly that the Internet poker bubble was about to burst.

Michael and I couldn't see it. We cited the doubling of the number of WSOP main event players every year and the big 'industry' exhibition there, the explosion of Internet sites and the fortune being spent promoting them, the rapidly increasing number of tournaments all over the world and the number of poker programmes on television every night.

Joe was unimpressed. OK, all this was happening, but for how long? 'In any given gambling sphere, there's a limited number of customers you can chase. What's happening is that everyone is suddenly discovering this great game. It's very exciting. It gives them a chance to be aggressive, to prove themselves, to win, but inevitably a lot of people are not going to win. In order for there to be winners, there have to be losers, and a lot of them. Probably it's a 95–5 split. Most people do not win at poker.

'People will fool themselves for a long time. They'll say, "Oh, actually I'm winning at this game." Or, "I'm breaking even and I'm getting better so I'm going to win," but when they sit down at the end of the year, they'll find their finances are not adding up.

'The other thing is that it does take up a horrendously large amount of time. If you're sitting there playing six or seven hours a day, after a time it gets less exciting, it becomes a bore, and you begin asking yourself what you did before. Either that or your partner starts to complain that you've become addicted. And so you decide to get on with the rest of your life. I think there are signs of that happening.'

So what was Joe really saying? That it's nearly over? 'No, I don't think I'm that pessimistic. I mean it's still a big industry. And the status of the game has changed dramatically. I first went to the World Series thirteen years ago. Saying that you played poker was like admitting you took crack cocaine, whereas now it's respectable. I'm just less optimistic than all the cheerleaders. All I'm saying is the rate of growth is unsustainable.'

In all the excitement of the World Series at the Rio, I found it hard to take Joe's view too seriously. But now, a few weeks later, Joe is beginning to look like a genius as Party Gaming, floated at around $5.5 billion, falls in value by a third as its Party Poker website warns that the growth in online games appears to have significantly slowed.

My guess is that there probably is a ceiling to the number of potential online players and that we're not far away from it. This will lead to mergers, with the major sites consolidating and a lot of the smaller ones disappearing. And there will probably be greater specialization in either cash play or tour-

naments, with tournaments becoming increasingly the way to go.

Thinking further about this, I realize it's actually reflected in my own experience. While I had enjoyed some good days on the Internet, I had been reconsidering the time spent on it, compared with other things I liked doing, and with the percentage return. I had become more attracted to tournaments. First, there's the single-figure buy-in, a relatively small sum compared with the prize if you actually win. Second, there's more of a sense of playing competitively. Third, if you get knocked out, you can say, 'OK, that's that for today – another one tomorrow,' and get on with other things. And I've noticed that on my preferred site the number of people playing cash games has gone down, but the numbers playing tournaments has gone up. Others obviously feel the same.

Tournament poker is a good thing. Because cash games on the Internet can be dangerous for the inexperienced. I shudder sometimes at the thought of a legion of anonymous young university graduates, all over the world, locked away in darkened rooms, fixated with images on flickering computer screens, as they devote their lives to taking the money of other anonymous people playing Internet poker. It's bad enough when you crush someone you can see in a poker room, but to do so to someone who exists only as a name, and whose name suddenly disappears from the screen as they go under, without you, the winner, having any knowledge of who you've damaged, how much or what the effect will be . . . well, it's a bit frightening.

I'm convinced inexperienced players should concentrate on tournament poker, both on the Internet and in live play. This is so much a healthier form of the game. Relatively

inexpensive to play, good value for money and effort, easier to regulate, and probably not as addictive.

In the meantime, what's happening to the old-school pros?

Poker Europa lists the European rankings monthly and at the time of writing, the names at the top are all recognizable, several of them the Usual Suspects. The Devilfish may not be there, but that's because he's playing mainly in the US, but still high on the list are Dave 'El Blondie' Colclough, Stuart Nash, Bambos, Willie Tann, Simon 'Aces' Trumper, Mickey Wernick, Ram Vaswani, as well as others who could equally be on my list of Usual Suspects – England's Keith 'the Camel' Hawkins and John Falconer, France's Pascal Perrault and Holland's Rob Hollink and Marcel Luske. These are still the consistent performers. But the *winners* of the big events are increasingly the Unknowns, most of them Internet qualifiers. Just as the World Series has been won four years in a row by the Unknowns – i.e. not established stars – so it's happening in the big European tournaments, too. And all sorts of people are winning small fortunes, even in obscure tournaments. For instance, twenty-eight-year-old Lee Biddulph, a trainee chef from Blackpool, who entered a cheap free-roll on the Internet, outlasted 4,000 competitors, and ended up winning $1 million in the final in Costa Rica. I think of a recent edition of the US publication *Poker News*. On the back cover it listed recent winners of its online tournaments. Someone called 'Panella8' won $577,342 in a no-limit Hold'em tournament. Someone called 'Snow Leopard' won $306,200 in another. And there was a whole list of them. Fortunes are being won this way every week.

So what are the Usual Suspects to do?

Some will count on winning just the occasional tourna-

ment, calculating that the prize money from one alone will carry them through a lengthy drought. This, of course, depends on them not having a 'leak' and losing the lot on the dice or the horses the same day.

Some will move increasingly to the Internet, as Julian Gardner and John Shipley have done.

Some will seek to make their money from commercial interests, from sponsorship or involvement in websites or other business activity, as the Devilfish is doing, and as the Hendon Mob have done.

The majority will probably have to gravitate back to the cash games and grind out a living by day-to-day combat with their peers and by exploitation of the innocent.

Will they survive? Some will do better than that, because they are very, very good, disciplined, skilful, they don't go on tilt and they don't have leaks. And the rest? Well, in a way, they will survive too, because they're survivors by nature, and because surviving is what they do. It's their skill. But, unlike the big winners, surviving is *all* they'll do . . . for another day, another game.

And, of course, they'll survive as long as there are fish in the sea. This is the downside of the game. At their worst, in the cash games in the spielers or casinos, the cash game professionals can be exploitive and ruthless predators, seeking out and preying on the weak, enticing them into the game, with only one thing in mind – to strip them bare, of money, usually of dignity too. They don't care what damage they're inflicting; their defence is that if they don't get you, you'll get them, except you rarely stand a chance. There's no middle ground. They're without mercy. When you go all-in at poker and lose the hand, or when you just run out of money in a cash game, you have to stand up and walk away. That's the

way it is. You have no money – you're out. Not a word is said. Within minutes of your departure someone takes your place and you're forgotten. No one is wondering how you'll get home, what you've done to your finances, whose trust you may have betrayed to play and lose in the game. It's not relevant. You came, you had money, you took them on – it's not for them to reason how, who or why.

But, they will argue, this is, after all, *their* world. They pay the dues in downs as well as ups, they take the risks, not once a week or once in a while or once a year, but every day. It's their place – enter it at your peril. *We don't have to go there.* It's a fair defence.

And, of course, they're not all that ruthless. The reason many prefer tournament play is because they've seen the hurt caused in cash games and they don't want to know; they prefer the straightforward healthy competition of tournaments with controls on how much you can lose. Whereas cash game players are market traders dealing in cards and money, often at the same table night after night, tournament players are more like professional golfers or tennis players, travelling the world to compete.

But it's a hard life. Only a tiny handful don't go broke from time to time. It's a mystery how some keep coming back, always with money. In fact, it's probably better in some cases not to ask where it comes from. But a lot of it is about borrowing. The pros have conflicting feelings about this; some remember when they were in a fix and were helped, and lend readily. Some have strict rules about whom they lend to and how much. Some won't lend at all. But, generally speaking, poker players are their own bank, the whole structure built on the knowledge that if you get a reputation for not paying your debts, the well will dry up.

And if things get tougher as they get older, is there any way they can stop? Can they retire? On the whole they live for today, this hand, this game. Tomorrow can wait its turn, next week is next year, next year is next century . . . so who thinks about pensions or old age? Yet one leading pro in his sixties not only doesn't have a pension or any savings, but can't get the state pension because he's living under an assumed name for reasons you don't want to know. What will happen to him when his eyesight goes, when his brain begins to wind down, when his legs won't carry him to the poker room? There are no old soldiers' rest homes for poker players.

I care about this because actually I like the pros . . . OK, they're ruthless, but that's the jungle they're in. I've also found them friendly and fun, helpful and trusting. The best of them have courage, determination, discipline and skill. They're clever. They're resilient. They fight back from appalling setbacks . . . Who knows what lonely and painful hours they endure after suffering crushing blows to bank balance or ego in the early hours of countless mornings. Poker players have to be able to live with defeat and disaster as everyday experiences, and put them in some kind of context, and draw on extraordinary self-belief. They're free spirits who pay a price for freedom – namely, in uncertainties and insecurity and loneliness. And boredom – because sometimes they have to spend hours sitting on poor cards, hanging on in there, waiting for the one break that will make the day profitable.

I like their eccentricities. They're night people. Ask a poker player to have lunch at 1 p.m. and he'll think you've gone mad. Possibly 2.30 p.m., not before. Even after spending six weeks in Las Vegas for the World Series, they're all deadly pale. No one sees the sun. While most have a taste for good

food and wine, their diet is appalling, because apart from breakfast/lunch in the early afternoon, the food has to be snatched during the brief breaks of play. On the other hand, few of them have a drink problem. No serious poker player drinks before play, or at the table, and that doesn't leave a lot of drinking time. It helps that smoking is banned from nearly all the card rooms during tournaments; this, together with limited alcohol, is a healthy positive. Outside the card room, they tend to be innocents abroad. If you compare them with professional golfers – and there *are* parallels in the sense that they lead a nomadic life, plying their trade or practising their skills wherever the latest tournament is – they have no management, no long-term plan. They book their own hotels, buy into tournaments themselves and take life as it comes, confronting 'the slings and arrows of outrageous fortune' with the occasional whinge but otherwise world-weary acceptance. The hours they lead and their lifestyle means that they can travel the world, day by day, with little awareness of what's actually happening in it. Undoubtedly, being at the World Series for six weeks is like being on a passenger ship, far away from land, with no awareness of what's happening back on shore. At the World Series of Poker, everyone was asked to stand in silence in tribute to those who died in the 7 July 2005 London bombing. But this was three days after the bombing; it took that time for news of what had happened to permeate the closed world of the poker players.

Despite the fact that a considerable number left school at fifteen or sixteen, and have no educational qualifications, they have, generally speaking, an extraordinary facility for figures – mathematical skills that enable them to instantaneously work out the odds as each card is dealt, the remaining 'outs' (cards in the pack that can help their particular hand)

and the odds of winning with a particular hand, and the value of the hand compared with the money in the pot. And they have an extraordinary memory for hands they've played – sometimes going back years. Hang around in the bar and you'll hear it scores of times: *'I had ace-queen, off-suit, and he had a pair of 7s. I raise, he calls. Flop comes down ace-queen-10. I raise, he calls. Turn card is a 3. I raise, he calls. River card is a 7. I figure the aces and queens will stand up, so I go all-in. He calls and turns over a 7 . . . What can you say?'* Another bad beat. A 'bad beat' happens when you lose a hand that on all the laws of probability and poker sense you should have won. It either happens because another player has an outrageous stroke of luck, or plays a hand so outrageously that they achieve a result, by accident, that they never should have. The players love to describe their bad beats, but they hate to listen to anyone else's. They *will* listen, but with a glazed look in the eyes. It's never said, but the basic rule is, 'Don't bother me with your bad luck stories, I've enough of my own.'

For them, there really is 'No such thing as society'; they don't pay taxes, taking the view that if they pay taxes on their winnings, then they should be compensated for their losses. Paradoxically, they're nonconformists who play by the rules. They pride themselves on their independence but at the tournaments they're like lambs – they queue to register, do what they're told by the card room manager, keep to the laws of the game and, on the whole, are courteous and friendly to others.

They simply don't think about money the way anyone else does. They'll bet sums of money on a card that their neighbours will spend weeks considering whether to spend on a kitchen, or a new car, or a family holiday. One of the clichés of poker is that 'the man who invented gambling was

clever, but the man who invented the chip was a genius', and it's true that chips become a measurement of performance and they confront the financial consequences afterwards.

Finally, they've found a safe way of living dangerously, war without gunfire and where few of the injuries involve actual blood. And all this makes them fascinating to be with.

Yet, I feel sad as I walk away from the Vic for the last time, because I believe life is going to get harder for the Usual Suspects. As they emerge from their darkened rooms, there will be more and more bright young things chasing the money, it will become even more highly competitive, it will require even greater powers of concentration and stamina just as the Usual Suspects are getting older.

I hope I've got this wrong. I definitely don't want to wish it upon them. But at the end of it all, I'm glad I'm going back to my world, if only because, though they nearly all deny it, I just know they have some bad nights, lonely nights, unforgiving, self-damning nights, and those I can do without.

And yet I envy them, too. The big moments that can only be experienced by those who have bad moments. The excitement that comes every time the dealer throws those two shiny upside-down cards in front of them. The freedom. The exclusivity of the club ... the humour and the strange combination of individuality and solidarity with the other pros.

In what other business do you go out in the morning knowing that at the end of your working day there's a 50–50 chance you'll come back poorer?

How many wealthy businessmen, approached by a colleague and asked whether he'll lend him thousands of pounds, will do so without recording it anywhere or asking for a receipt?

In what other business can you work for six days, taking careful decisions, marshalling resources, doing everything right, then, at three in the morning, after fifteen hours' play that day, apply all your years of experience, knowledge and talent to one hand, push all your money on to the table and see those six days of care and caution fall apart because the last card is a 10 instead of a jack, or a spade instead of a club?

Would I like to be one of them? Yes and no. I would love to sit down on day one of the World Series main event with 10,000 chips in front of me. I would love to be able to jump on a plane and fly to Paris and Barcelona and Las Vegas and Los Angeles and eat and drink with the Usual Suspects and sit down at the table and play the cards. But I can't do it. It's out of the question. Because I'm not one of them and never will be. I'm not enough of a gambler. I care about the money I've worked for too much.

And I want to do other things. And if you're a poker pro that's virtually impossible.

And I want to see sunlight.

But, thank you, Usual Suspects. It's been great.

Oh, and how did I do? Overall, in those twenty-one weeks I lost £530.

For that I played in the World Series, and became, for a short, unforgettable time, one of the Usual Suspects. I shared a brief part of the lives of Bambos and Willie 'the Diceman', Joe 'the Elegance' and Andrew 'the Monk', Paul 'Action Man' and Neil 'Bad Beat', El Blondie and Roy 'the Boy', Tom and Lucy, Carlo and Liam and . . . well, all the rest.

That £530 was my buy-in to their world.

And, as the poker pros would say, it was good value.

Endnote

Since the first edition of this book Dave 'Devilfish' Ulliott had a difficult run at the poker table before taking the $266,000 first place in an event at the Five Diamonds Classic in Las Vegas in December 2006. During that year he was involved in launching Devilfishpoker.com amid a flurry of commercial deals. His marriage to Amanda finally ended in an amicable divorce.

Mickey Wernick achieved his ambition to top the European rankings in 2005; John Gale went back to the World Series in 2006 and won the gold bracelet he so narrowly missed the year before; Vicky Coren became the first woman to win an EPT event, taking £500,000 first place in a 2006 tournament at the Vic; and Paul Jackson came second in the 2006 Monte Carlo Millions, winning $600,000.

Simon Trumper lost his sponsorship deal and the Hendon Mob changed theirs to become part of the Full Tilt operation.

The Western finally opened its doors to a wider clientele and Roy Houghton also opened a new poker club in the City of London. As this edition went to press the poker world was awaiting the outcome of a test case involving the Gutshot Club.

The 2006 World Series was won by Jamie Gold from California. The author of this book was knocked out after three hours, when his pocket Aces were beaten by two pair in

an all-in showdown. Phil Hellmuth won a record-equalling tenth gold bracelet and twenty-one-year-old Jeff Madsen made a sensational World Series debut, winning two gold bracelets and making four final tables.

The name of the game – a simple guide to Texas Hold'em and Omaha

Texas Hold'em can be played head-to-head (or **heads-up**, as it's known) by two players, but is usually played at tables of six, or nine or ten.

Let's assume you are one of those players.

You are dealt two cards, face-down. Only you can see these two 'pocket' cards. They are, for you, **the** key cards. Their potential to develop into a winning hand, when joined by the shared, **community cards**, yet to be dealt, will decide whether you play the hand and if, and how much, you bet.

The first round of betting is based on these two cards.

Two players, those to the left of the dealer (identified by a button that moves clockwise round the table – hence the term **on the button**), have no option – they **have** to start the process with compulsory bets. Because these bets are made before the players have seen their pocket cards, they're called **blind bets**. The first is the **small blind** and the second, usually double in size, is the **big blind**.

The purpose of the blinds is to get the game going by getting some money in the pot.

Assuming you are not one of the blinds, you have at this point just three options:

1) If it's weak, you can **fold** your hand at no cost.

2) You can **call** the bet by matching the big blind.

3) You can **raise** the bet. The other players now have to match your bet or fold.

When this round of betting is complete (sometimes with further raises – or reraises – by other players), three community cards are dealt, this time face-up for all to see. These are called **the flop.**

You – and also the other players – now link them to your two face-down cards and judge whether the chances of a winning hand have been strengthened or weakened. You will then decide whether to fold your hand now, or participate in a second round of betting.

When that round is concluded, a further community card is dealt. This is called the **turn** card – or **4th street.**

Another round of betting takes place.

Finally, one more community card – the fifth community card – is dealt. This is called **the river.**

So, if you're still in the hand, you will now have your own two pocket cards and five community cards from which to make up the five-card hand that you can now either (a) discard by folding, or (b) bet as the strongest hand at the table.

And that's what it's all about – either avoiding losing money with a weak hand or, preferably, winning money with the strongest hand. (There is one other option: you can **bluff** the other players out of the hand by convincing them you have the strongest hand. Bluffing is a big part of Texas Hold'em.)

Omaha is a variation of Texas Hold'em.

The main differences from Texas Hold'em are:

1) The player's final five-card hand is usually created from a choice of nine cards, not seven (there are variations on

this). This is made possible because each player is dealt **four** cards in the pocket – not just two – to add to the five community cards.

2) Each player **must** construct their hand **from two cards out of those initial four pocket cards**, and then from **three cards out of the remaining five community cards**.

How poker hands are ranked . . . and the odds

1. **Royal flush** – Ace, king, queen, jack and 10 of the same suit. *649,739–1*
2. **Straight flush** – Any five-card sequence in the same suit. *64,973–1*
3. **Four of a kind** – E.g. four aces, four kings and so on. *4,164–1*
4. **Full house** – Three of a kind, together with a pair. *693–1*
5. **Flush** – Any five cards of the same suit, but not in sequence. *508–1*
6. **Straight** – Five cards in sequence, but not of the same suit. *254–1*
7. **Three of a kind** – E.g. three aces, three kings and so on. *46–1*
8. **Two pairs** – I.e. two different pairs. *20–1*
9. **One pair** – Two of a kind, e.g. two aces, two kings and so on. *1.25–1*
10. **Highest card** – The highest single card, the top card being an ace. *Evens*

Glossary

All-in – When a player bets all his chips in 'one go', either because he's convinced he has the winning hand or to frighten everyone else out of the pot.

Ante – A small initial compulsory bet sometimes required from all the players in the game; a way of kick-starting the hand by getting money on the table.

Bad beat – To lose a hand you should have won because of really bad luck.

Bankroll – The money you have available to play with.

Big blind – The larger of the two compulsory bets at the beginning of the hand; another way of kick-starting the hand. The blinds increase as the tournament goes on, and in the later stages become a critical factor in the game. A player on a short stack can be literally bankrupted by the blinds and is therefore often forced to play with weak hands.

Bluff – To pretend you have a better hand than you do.

Board – The community cards, when laid out in front of the players.

Buy-in – The sum you pay to get a seat at the tournament. A $1,000 tournament means a $1,000 buy-in. Prize money comes from buy-ins.

Button, the – A small disc placed in front of the player who would normally be the dealer; to be 'on the button' is to be the last player who bets, and is known as being 'in position'

– i.e. the ideal place, because you can see what every other player is doing before you have to make your own decision.

Call – You call when you match a bet already made.

Check – This is where you pass, but reserve the right to call or raise at a later stage.

Check-raise – To check, then raise after opponents have bet.

Chips – At the beginning of the game the player changes money for chips of different values, e.g. from £1 chips to £1,000 chips), and these become the currency of the game.

Fourth Street – The turn card in Texas Hold'em.

Fifth Street – The river card in Texas Hold'em.

Fish – The 'sucker' in the game, the one the pros expect to make their living from. Also known as 'the star' or 'dead money'.

Fixed limit – A game in which the sum you can bet is predetermined.

Flop – The first three community cards dealt; they come together, and are followed by the turn and the river cards.

Fold – To leave the hand by surrendering your cards.

Gold bracelet – Given to winners of events at the WSOP; much coveted.

Hole cards – Another name for pocket cards, the two dealt face-down at the beginning of the hand.

In the money – Any player who gets a share of the prize money in a tournament.

Inside straight draw – A hand with four to a straight, missing one card in the middle of the hand instead of at either end.

Kicker – The highest ranked 'support card' in a hand, e.g. if you have pocket cards ace-king, your hand is stronger than someone with ace-7 because you have the highest support card to the ace – the highest kicker.

Leak – A weakness for other forms of gambling (e.g. at the dice

table or on the horses) that leads to the player's profits from poker being subsequently lost.

Limp – To call, rather than raise, in early stages of betting, known as 'limping in' to the hand.

Loose – Where the player or players are betting freely or fairly freely, or even unwisely.

Low hand – The worst hand according to the hand rankings.

Muck – To discard your cards. The muck is the stack of discarded cards.

Nuts – The best possible cards – unbeatable – at any stage of the hand, e.g. if two players have a flush, the one with the ace has the 'nut flush' because it can't be beaten by any other flush.

Pot – The total of all the bets. The pile of chips in the centre of the table is the pot. To 'bet the pot' is to make a bet equal to that total.

Open-ended straight – Where you have four in a row, e.g. 3-4-5-6, with opportunities at each end of the row to make a straight

Outs – The number of cards that in theory could still come on the board to strengthen your hand.

Position – Where you sit in relation to the button.

Pot limit – A game in which bets can be no greater than the sum already in the pot.

Prize pool – The total of buy-ins for the tournament from which prize money is produced.

Quads – Four of a kind – four cards of the same rank, e.g. four aces.

Rags – Irrelevant or unplayable cards, e.g. if you're going for a straight and have ace-king-queen-jack, and a 3 comes on the board, that's a rag.

Raise – To call and then increase the previous bet.

Rake – When a card room takes a percentage of each pot it's called raking or the rake.

Represent – To bet in such a way that suggests you have a better hand than you actually have; e.g. if an ace appears on the flop and you immediately bet, suggesting you already have an ace in the pocket, you are 'representing the ace'.

Re-raise – To raise a pot already raised.

Satellite – A smaller-stakes tournament, the prize for which is the buy-in fee for a bigger tournament, e.g. the majority of players in the $10,000 buy-in World Series main event win their entry via a satellite, either on the Internet or in a card room.

Set – Three of a kind (also known as trips), e.g. three aces make a set.

Seven-card stud – Another popular poker game in which players make up the best five-card hand from seven dealt, three of them 'pocket' cards.

Small blind – The smallest of the two compulsory bets aimed at kick-starting the game.

Stack – Your pile of chips. If you have the smallest pile, you are on 'short stack'; if you have the most, you're the chip leader.

Starting hand – The first two cards dealt to each player. In Texas Hold'em these are the pocket cards.

Steal – Where you try to, or succeed in, winning a pot with a weak hand by bluffing the others out; usually refers to a player in a late position bluffing out the two blinds and thus stealing the pot.

Steaming – Similar to going on tilt. You've had a bad experience, you're unnerved by it and you begin to bet wildly or otherwise behave in an extreme way.

Suit – One of four types of cards – clubs, diamonds, hearts or

spades. 'Ace-king suited' means they're both of the same suit; 'ace-king off-suit' means they are of different suits.

Tell – Something you do that gives away the strength of your hand, e.g. if you get two aces in the pocket and immediately ask the waitress for a glass of champagne, that would be a tell.

Tilt or 'on tilt' – Going 'off the rails' by playing poorly after a bad experience, e.g. a player suffers an appalling bad beat or a losing night and begins to bet wildly in the hope of re-establishing his/her position. This is going on tilt.

Trips – Three of a kind, e.g. three aces are trips or 'a set'.

Turn – The fourth community card, triggering off the third round of betting.

Under the gun – The first player to play after the two blinds is said to be under the gun – a weak position because he/she has no information from the other players on which to base a decision.

WPT – World Poker Tour, a series of major events forming part of a television series.

WSOP – World Series of Poker; the annual festival of poker in Las Vegas, in effect the world championships.

Further reading

My thanks to the following authors (or their representatives) for permission to quote from their books, all of which I recommend:

Anthony Holden, *Big Deal*, currently available in Abacus paperback, originally published by Bantam (UK) and Viking Penguin (US) (1991)

Richard Sparks, *Diary of a Mad Poker Player: A Journey to the World Series of Poker*, Russell Enterprises Inc. (2005)

Ray Michael B, *Poker Farce and Poker Truth*, Two Plus Two Publishing (1999)

Michael Craig, *The Professor, the Banker, and the Suicide King*, Warner Books (2005)

Jesse May, *Shut Up and Deal* (a novel), No Exit Press (2005)

Rick Bennett, *King of a Small World* (a novel), Arcade Publishing (2004)

Other books I found helpful and also recommend are:

Aces and Kings, Michael Kaplan and Brad Reagan, Wenner Books (2005)

Poker Nation, Andy Bellin, Yellow Jersey Press (2003)

Positively Fifth Street, James McManus, Picador USA (2004)

One of a Kind: The Rise and Fall of Stuey 'The Kid' Ungar, the World's Greatest Poker Player, Nolan Dalla and Peter Alson, Atria Books (2005)

Moneymaker: How an Amateur Poker Player Turned $40 into $2.5 Million at the World Series of Poker, Chris Moneymaker, HarperCollins (2005)

Acknowledgements

I am immensely grateful to Tony Holden for his advice and encouragement, to Vicky Coren and Michael Arnold who both helped get me 'off the ground' with their insights and introductions, and to Nic Szeremeta and *Poker Europa* – both he and his magazine were invaluable.

Also, to . . . Gary Whitaker for talking to me about his time with the Devilfish (and especially for suggesting the title); Chris and Megan Stuart of Presentable Productions and Nolan Dalla and his team at the World Series of Poker for much practical support; all those poker players interviewed or quoted or whose stories are told in the book, and especially those who helped beyond the call of duty, including Liam Flood, Lucy Rokach and Tom Gibson, Dave Colclough, John Duthie and Neil Channing; Mike Sexton, Stewart Reuben, Ray Joseph, Colin Kennedy, Roy Houghton, Joe Saumarez Smith; the authors I quote in the book, whose works are listed under Further Reading; Andy Langley, that splendid poker photographer, who generously supplemented my photographs with his own; Richard Milner and his highly professional team at Macmillan; my friend Clare Francis for bringing publisher and author together; Steve Delaney for much practical help; and last but not least, my wife Jane, who is much cleverer than I am and whose advice always makes the difference.

Des Wilson

Index

extracts reading groups events
competitions books new
discounts extracts extracts discounts
competitions new
books new books
events reading groups extracts
events new books extracts events
extracts reading groups
interviews events new
events extracts extracts books
discounts reading groups extracts interviews new books
new books events books
events new interviews new books extracts
discounts extracts discounts
www.panmacmillan.com
extracts events reading groups books
competitions books extracts new

Printed in Great Britain
by Amazon